Vampire Art Now

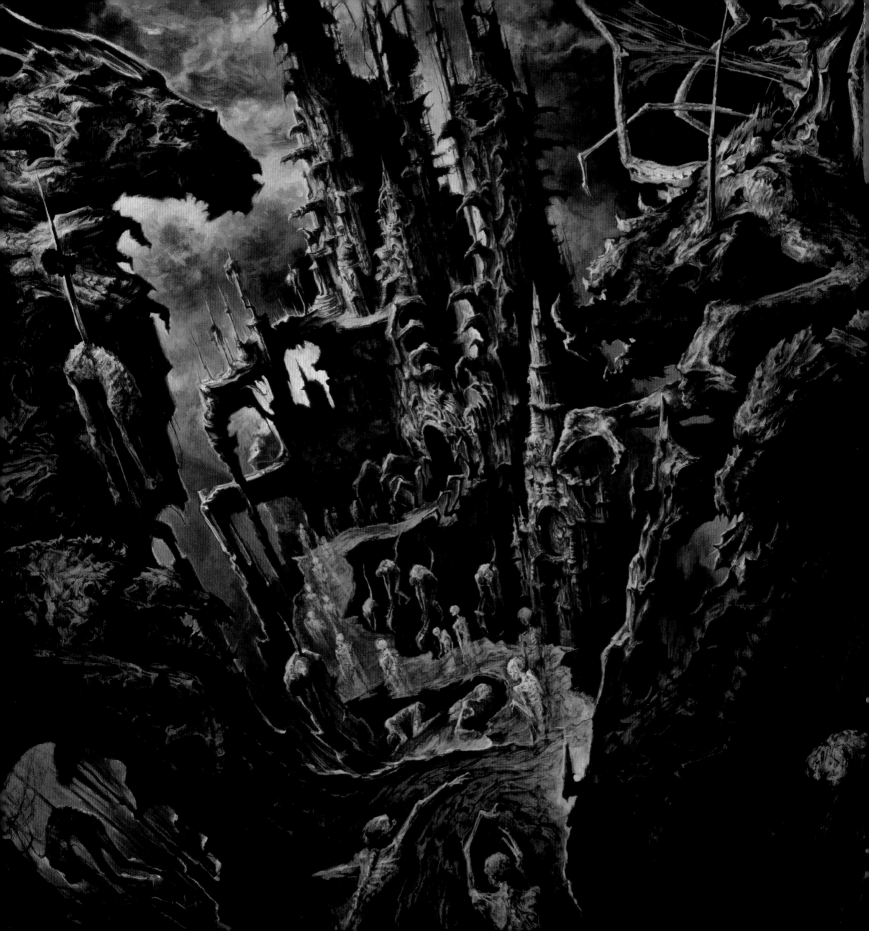

Vampire Art Now

JASMINE BECKET-GRIFFITH
& MATTHEW DAVID BECKET

HARPER
DESIGN

An Imprint of HarperCollinsPublishers

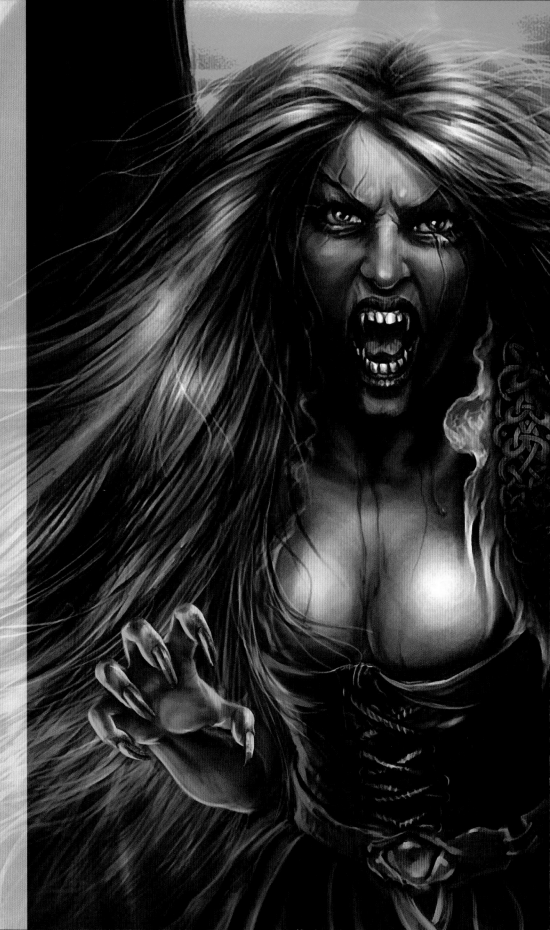

HarperCollins books may be purchased for educational,
business, or sales promotional use. For information,
please write: Special Markets Department,
HarperCollins*Publishers*, 10 East 53rd Street,
New York, NY 10022.

First published in the United States and Canada in 2011 by:
Harper Design
An *Imprint of* HarperCollins*Publishers*
10 East 53rd Street
New York, NY 10022
Tel: (212) 207-7000
Fax: (212) 207-7654
harperdesign@harpercollins.com
www.harpercollins.com

Distributed throughout the United States and Canada by:
HarperCollins*Publishers*
10 East 53rd Street
New York, NY 10022
Fax: (212) 207-7654

This book was conceived, designed, and produced by
I L E X
210 High Street
Lewes
East Sussex BN7 2NS
www.ilex-press.com

Publisher: Alastair Campbell
Creative Director: Peter Bridgewater
Managing Editor: Nick Jones
Editor: Ellie Wilson
Commissioning Editor: Tim Pilcher
Art Director: Julie Weir
Designer: Simon Goggin

Library of Congress Control Number: 2010941981

ISBN: 978-0-06-202571-5

Printed in China
First Printing, 2011
Color Origination by Ivy Press Reprographics

Main title font set in A Charming Font
© Graham Meade
http://www.moorstation.org/typoasis/designers/gemnew

Intro images:
p2 *Suffocation* by Dan Seagrave
p4 *Camilla* by Inessa Kirianova
p6 *The Widow* by Michael Park
p8 *The Coming of Tears* by Samuel Araya
p10 *Vampyre Portrait* by Charli Siebert
p11 *All in Vein* by Matt Dixon

Contents

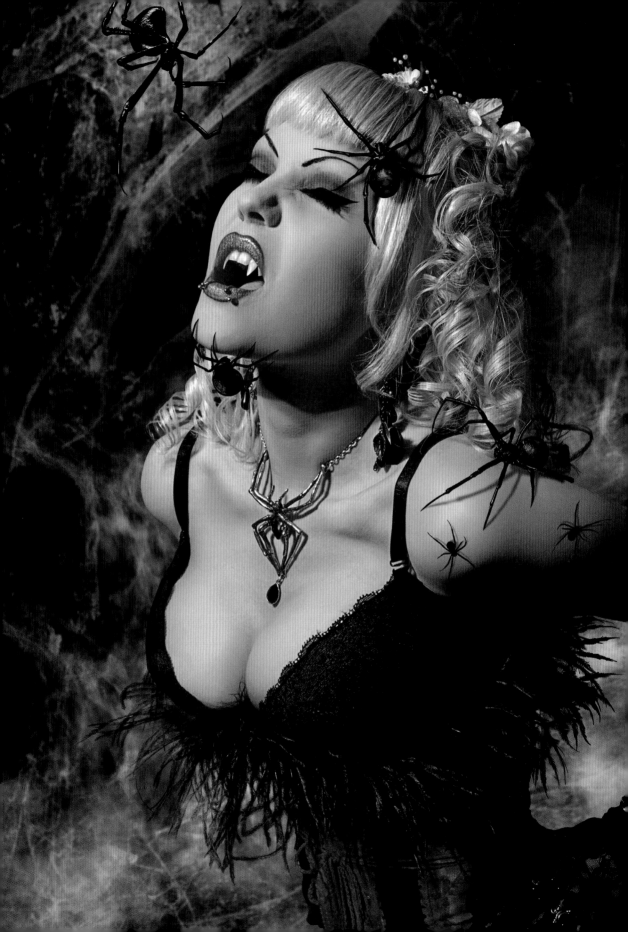

There's just something about vampires that won't die.

From the first whispers, drinkers of blood have haunted our dreams—creatures who wore the faces and bodies of those we knew and loved, and preyed on the unsuspecting. And from those early days, vampires were creatures to be feared, avoided, or hunted.

A funny thing happened to the vampire during the Age of Reason . . . once the nightmares became accepted as fictional stories, vampires began to take on new depths. New meanings.

Instead of reflecting our atavistic fear of night and death, they began to represent hidden longings and desires as poets and novelists began to reinvent the monster. The arrival of film changed vampires yet again, giving them human faces and emotions. Film began to fragment the legend and send it careening in new and interesting directions, such as monsters (*Nosferatu*, 1922), nobility (*Dracula*, 1931), predatory hunger (Hammer Films, such as *The Brides of Dracula*, 1960), elegant seduction (*Count Dracula*, 1977), humor, action, and adventure (*The Lost Boys*, 1987), romantic anti-heroes (*Interview with the Vampire*, 1994, *Twilight*, 2008), and back again to monsters (*30 Days of Night*, 2007). The films were very different from one another, yet all were interpretations of what has become one of the most powerful avatars of our fears and our dreams. Like film, visual art has shaped our perception of what

vampires are, how they look, how they hunt, how they die— and that typically has little in common with the ancient legends. Nonetheless, the new image of vampires remains faithful to the basic spirit of their original legends: that they are seductive, unnerving, dangerous, and beautiful.

In these pages, you'll see all these characterizations, and more. From the pens, brushes, and digital wizardry of some of today's most amazing artists, you're about to meet the very soul of today's vampires—from romantic to grotesque, haunting to terrifying. You'll be seduced into a world that may never, ever let you go . . . and even if it does, you may not want to leave.

Rachel Caine

Rachel Caine

About Rachel Caine:
New York Times *bestselling author Rachel Caine is the author of the internationally popular* Morganville Vampires *series, as well as several other vampire novels and short stories. She has been a fan of vampires since her well-meaning mother forbade her to watch* Dark Shadows *and took away her* Vampirella *magazine. Once she discovered the Stephen King novel* 'Salem's Lot, *her seduction to the dark side was complete. Luckily, the dark side has cookies, and fun vampire fiction.*

www.rachelcaine.com

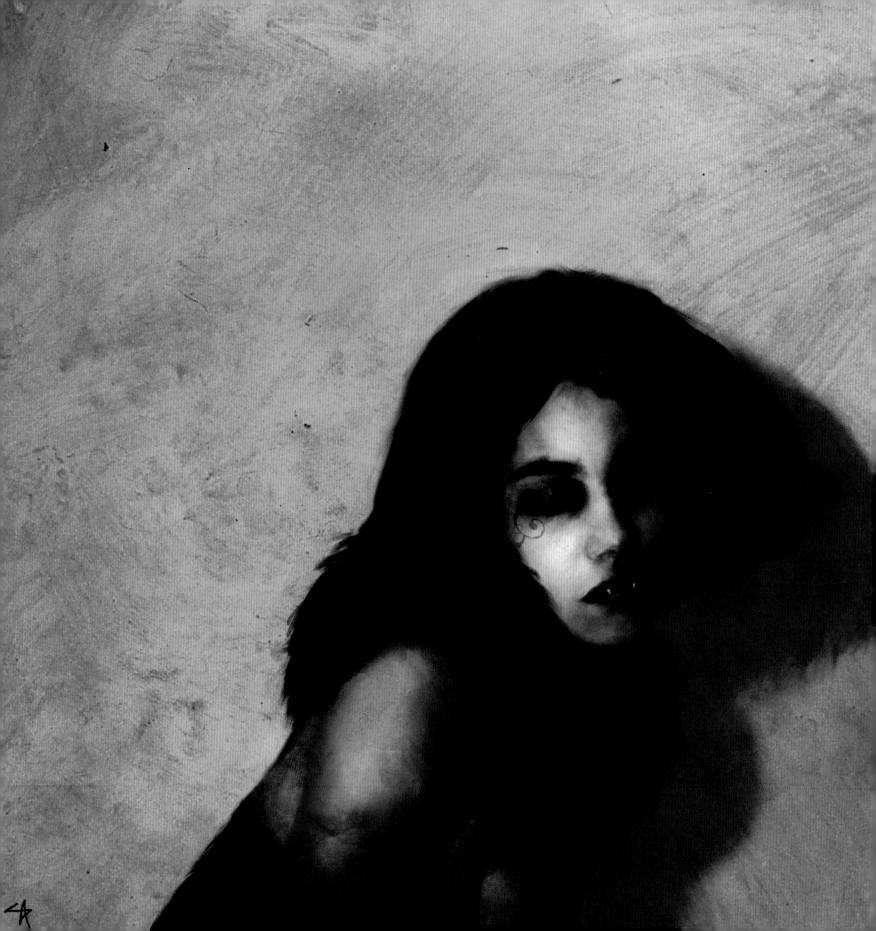

Introduction

What took so long? Why has *Vampire Art Now* only now beat its wooden coffin open and declared to the world, "I'm here!"

This was the question we asked ourselves when we took on this project. We have both been fans of the genre since before we met. In fact, our first meeting was at a bookstore right in front of a row of vampire novels. She, being the ever-spooky girl always interested in the supernatural, and me, the same little boy who used to curl up on the couch watching Bela Lugosi movies; we knew this book was right up our alley. We dove right into the vampire world head first and returned a bit changed. Together we discovered art and artists on a global level, each with his or her own take on the vampire. This fantastic journey presented us with hideous and beautiful images from artists just starting out to others already very familiar to the public.

The term "vampire art" doesn't require a lot of explaining. Take the average man, for example; he goes to the local grocery store, walks down the cereal aisle, and finds a portrait of a toothy villain right on the box. He turns on the television and sees a commercial for the latest vampire thriller. He sits next to a teenage girl who has her nose in a book filled with vampire romance. Delighting in the undead is secondary to human nature and represents our darkest dreams, as well as haunted rooms, hallways, and figures in the back of our minds. It is no surprise then that seeing these icons is an everyday occurrence. So many people imagine vampires, and each one has a different vision for how they should be depicted.

Vampires have lived with us on the silver screen since its invention and there is no end in sight. From the very first silent film classics to the blockbuster hits of today, this dark character has enjoyed the limelight and continues to steal the show. Literature is no different, with vampires often the subject of bestselling books, comics, and graphic novels. And not to be overlooked, the video game industry has taken the action of bloodsucking and put it in the palms of your hands. This broad use of vampires pushes the genre to shock and remain fresh. So deep has it penetrated society that some individuals dress as vampires and follow a lifestyle designed with them in mind. Some go as far as sleeping in coffins and getting fangs implanted. Others claim to be "psychic vampires" that feed off the life force of others rather than their blood. These cultural extremes demonstrate how potent and powerful the allure of these dark creatures is.

Above and beyond campy horror films and mainstream popular culture, a cold tide pool of something very pure remains; this is what *Vampire Art Now* is about. This collection of images begs the viewer to look into the very heart of this creature; to see not only a hideous night-stalking murderer, but perhaps an eternal romantic, a soul filled with sadness, or just a creature with too much time on its hands. The pages ahead will reveal a haunting stare, a victim left to rot, and a forbidden romantic relationship. They will make you laugh and shudder. Each artist has his or her own idea of what makes up a vampire, ranging from a loner on the fringes of society to an armored warrior in a science fiction nightmare. This is something we humans and vampires share, our ability to be unique. The scope of artists displays this capability and the result is quite captivating.

Visually superb, this book holds some of the most technically brilliant artwork around today. The tools of the trade vary from some of the oldest traditional techniques to cutting-edge technology—whether it be digital photography, sculpture, oils, or scratchboard, or other mixed media. We've pulled together a massive amount of talent from all corners of the world. Artists from different backgrounds and cultures share their versions of the vampire in their chosen medium. There is no wrong way to show the beauty, corruption, and sometimes quietness of the vampire.

Now don't get us wrong: many of these creatures would probably love nothing more than to get their nasty fangs sunk into that delicious vein on the side of your neck. They've just never done it so beautifully before. This is *Vampire Art Now* after all!

Matthew David Becket and Jasmine Becket-Griffith

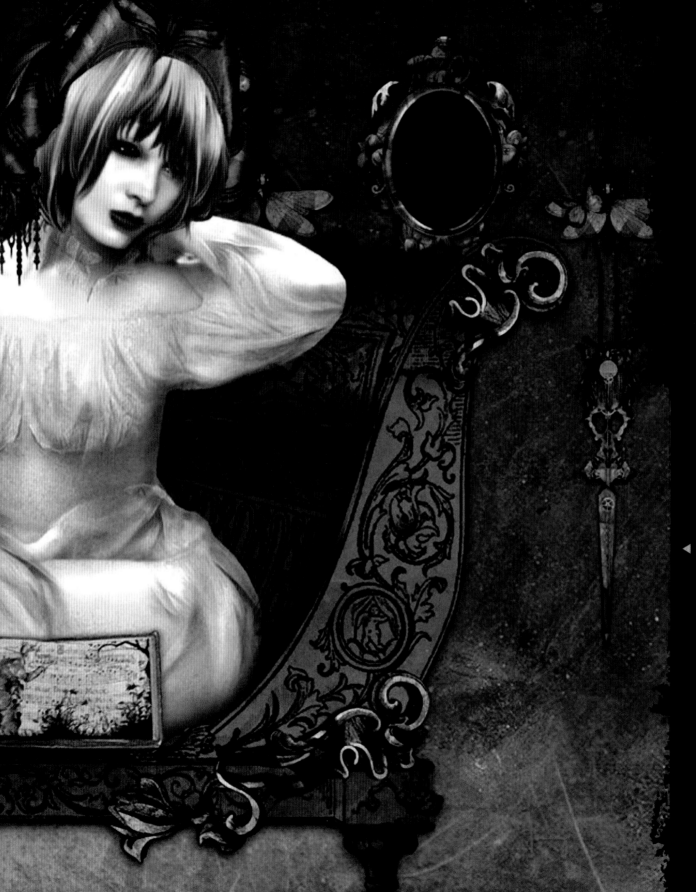

◄ **The Lounge**
Bethalynne Bajema
Digital painting
www.bethalynnebajema.com

*A pink-haired spook enjoys
solitude and thoughtfulness
while casually looking at sheet
music in this digital painting
by Bethalynne Bajema. "The
Lounge is a full illustration
for the story featuring the
character Bex. This artwork
was also used in my Sepia
Stains Tarot Deck for the
Magician card. This image is
one of the few pieces that I did
through digital painting, with
the exception of the insects on
the wall. Those are from my
mechanical insect illustrations."*

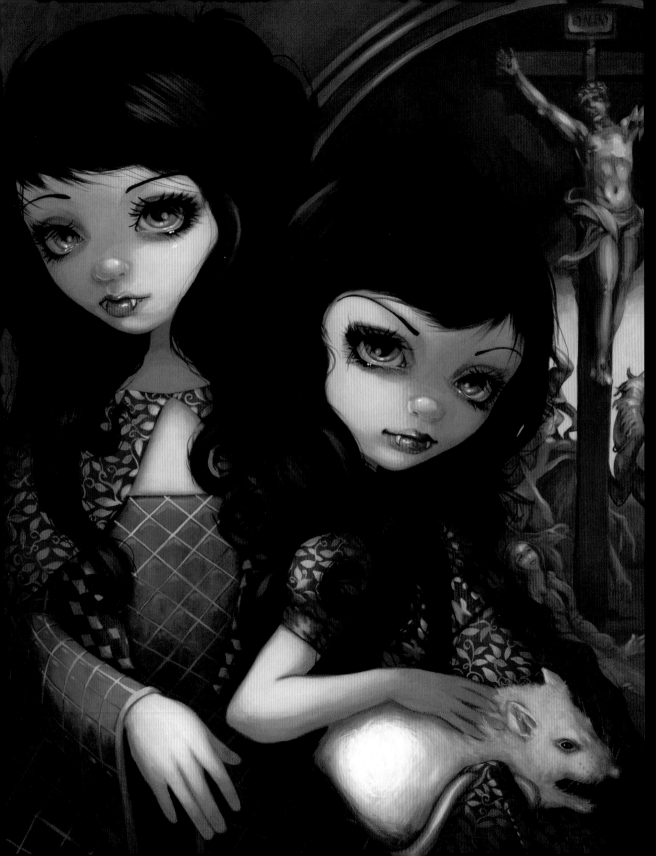

I vampiri: La Sorelle

Jasmine Becket-Griffith
Acrylic on Masonite panel
www.strangeling.com

"This is the fifth in my series of paintings called I Vampiri *(Italian for 'The Vampires'), in a line of paintings of vampire beauties inspired by Italian Baroque and Italian Renaissance themes and aesthetics (many of which I have been hired to create for my upcoming* Vampire Tarot/ Oracle Deck). *In* I Vampiri: La Sorelle — *meaning 'Sisters' in Italian — two vampiric sisters, with darkly beautiful eyes and shimmering black hair, stand in front of a Renaissance crucifixion painting that recalls Maerten van Heemskerck, who though not Italian is considered part of the Italian school of painting, and helped introduce the Italian Renaissance to the rest of Europe. The younger sister is cradling a pet rat — an animal frequently appearing in vampiric tales."*

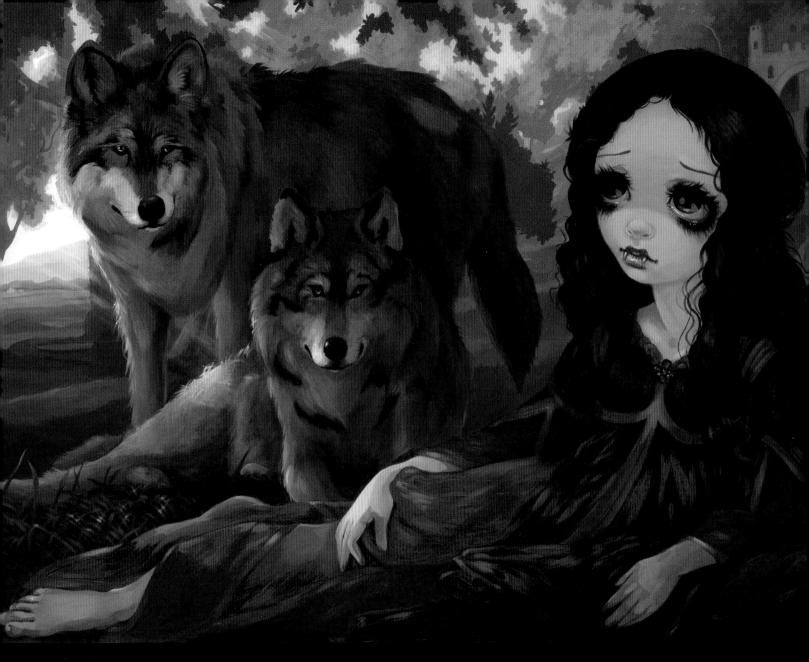

I Vampiri: I Lupi
Jasmine Becket-Griffith
Acrylic on Masonite panel
www.strangeling.com

"The sixth in my series of paintings called **I Vampiri** *(Italian for 'The Vampires') — a new line of paintings featuring vampire beauties with Italian Baroque and Renaissance themes. This is called* **I Vampiri: I Lupi**, *which translates into 'The Wolves' in Italian. I LOVE WOLVES and they often feature prominently in my paintings. Since they have*

long had a relationship with the vampire mythos, I decided to dedicate this painting to them, the howling children of the night. To stay with my Italian Renaissance theme, the dress and pose are a Botticelli reference. If you look in the background you'll see a lovely Italian sunset scene, complete with a ruined castle."

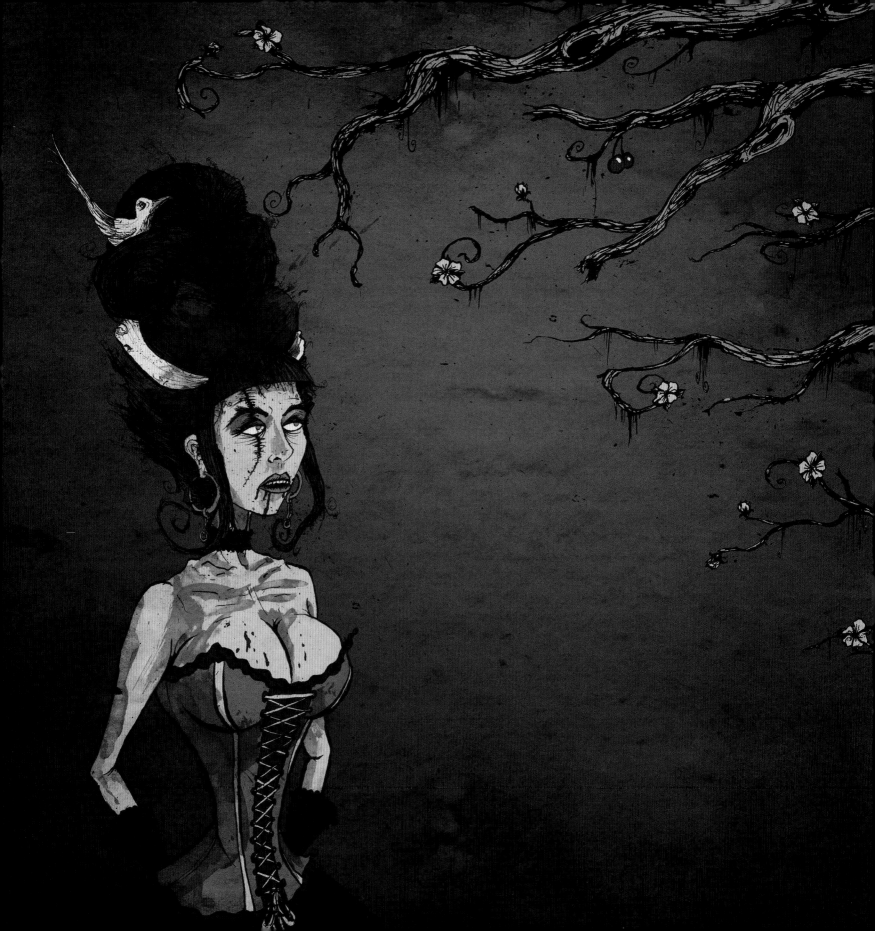

◀ Look At Those Cherries!
David Procter
Mixed media
www.david-procter.co.uk

A vampire ponders the sole fruit
of a rather bare cherry tree in
Procter's charismatic and comic
illustration. His character
imagines, "Those are the ripest,
juiciest cherries I've ever seen.
I can't wait to sink my teeth
into those."

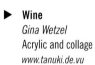

▶ Wine
Gina Wetzel
Acrylic and collage
www.tanuki.de.vu

An aristocrat enjoys a glass
of curious liquid. Wetzel gives
us the background: "The young
duchess with the amber eyes
invites you to her castle for a
delicious glass of dark wine. But
is it really wine? The painting
is the left part of a triptych, in
which all three pictures show
mysterious young ladies with
a strange black liquid. I used a
collage technique in three layers
and various paper grades to give
it a more three-dimensional look,
and I am very happy with the
end result."

► **Ending Sun**
K.E. Myatt
Adobe Photoshop
www.hismajestyintears.com

"I have often been intrigued by the tragedy surrounding vampire characters. In this painting, I wanted to depict a vampire who has had enough of eternity and has thus returned to the castle of his childhood. He is standing on the battlements waiting for the sun to rise; he turns from the blinding light as his skin begins to smoke. This piece was painted using Photoshop and a Wacom Intuos tablet. I used my own face and hands as references to get the pose and expression right. I painted in black and white before applying a color wash over the top, using Gradient Map set to Soft Light and a series of color layers in Overlay. I then flattened the image and worked it into a completed painting on a single layer, working as one would with physical paint."

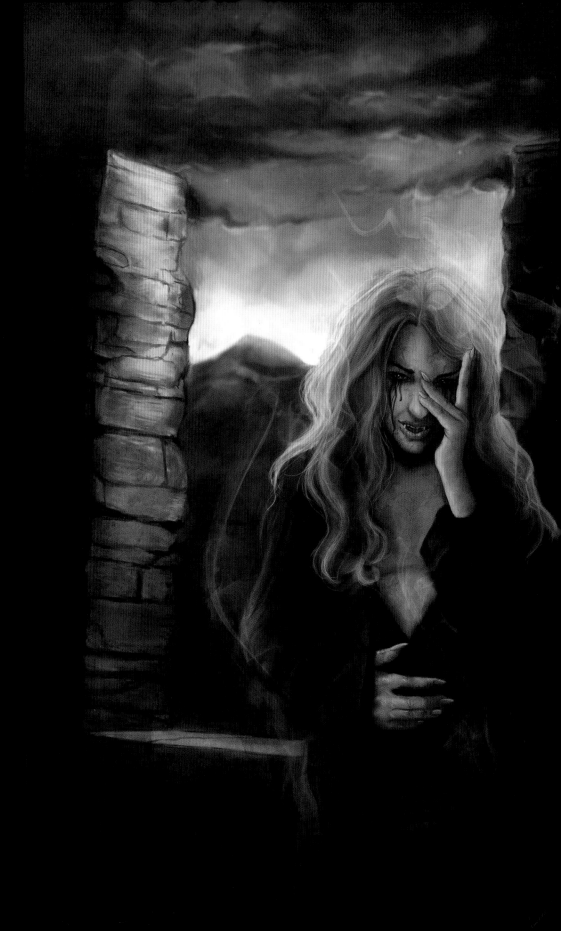

▶ **Lon Chaney as The Vampire**
Thomas Webb
Gouache and ink resist
on illustration board
www.webbitup.com

*Webb shares his technique
in this homage to the late Lon
Chaney: "I painted these with
a process of gouache and ink
resist. The technique, when done
most successfully, should have
elements of both painting and
printmaking, but the technique
should not be in the forefront.
I often employ unconventional
tools and mediums — such as
torches, lighters, alcohol, and
glue — to apply subtle or not-
so-subtle texture and tonal and
spiritual qualities to my work."*

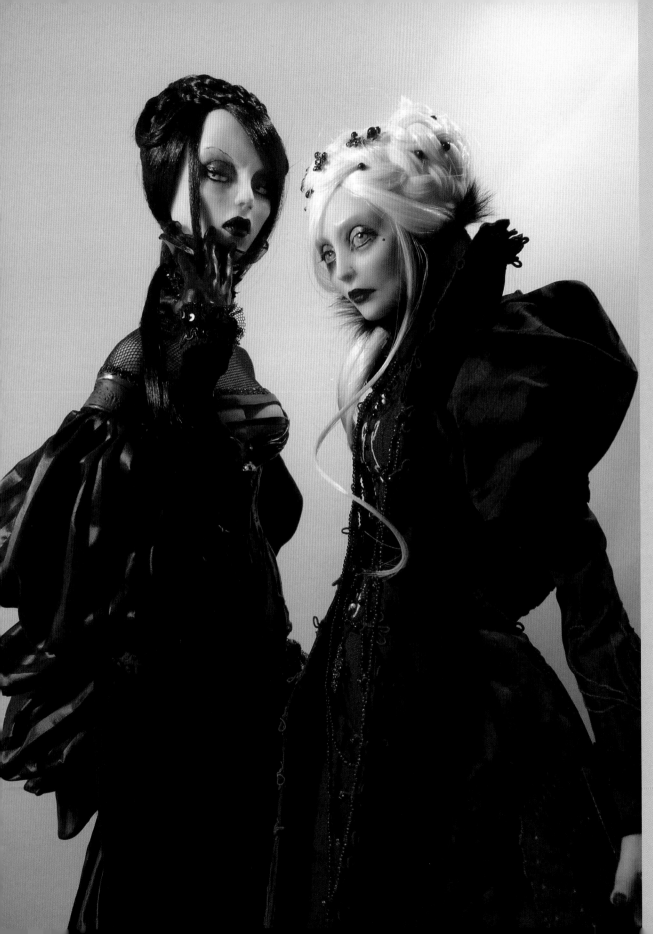

◀ **Carmilla and
The Queen of Spades**
Virginie Ropars
Polymer clay and mixed media
http://vropars.free.fr

*A beautifully hand-sculpted duo.
"Carmilla (on the left) is inspired
by the character in the J. Sheridan
Le Fanu novel* Carmilla. *I thought
about an adult Carmilla (in the
story she is a teen). I'm pretty sure
she would have been a terrible
vampire fatale. The Queen of
Spades is a completely different
creation, but those two make a
great couple. In contrast, Carmilla
seems fragile. The corset of
Carmilla is fully sculpted too,
and a lot of other materials are
used on the pieces like different
sorts of fabrics."*

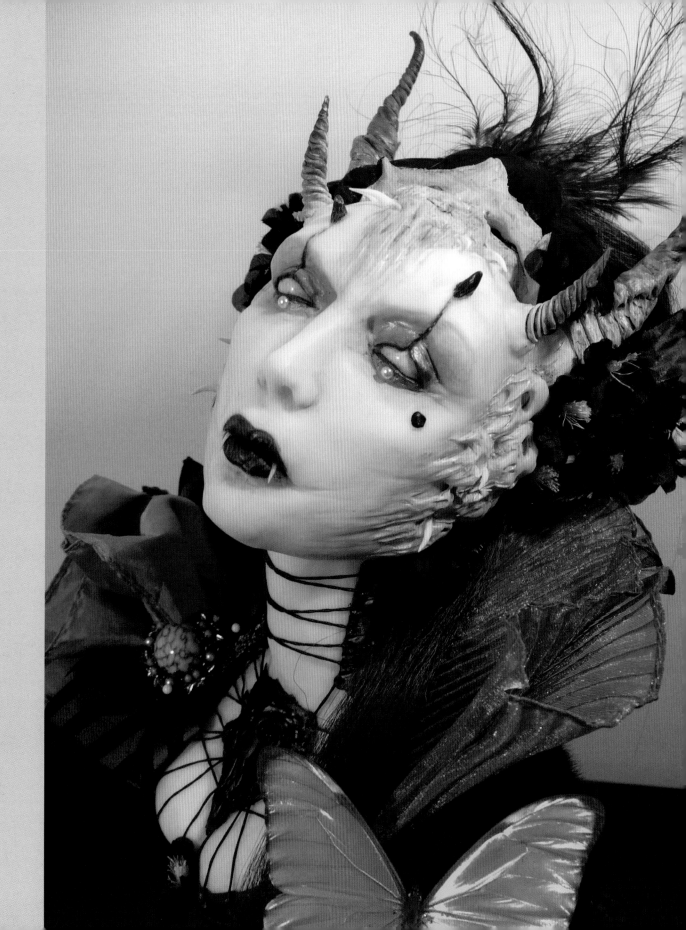

► **Victorian Succubus**
Virginie Ropars
Polymer clay and mixed media
http://vropars.free.fr

Intricate and lovely, this adorned demoness creates a creepy atmosphere. She seems thoughtful and aloof in Ropar's Victorian Succubus. *"This character is a sort of vampiric succubus, with a fantasy inspiration mixed with a Victorian look in the way she is dressed. I thought of a lady revealing her true nature to someone. It is a bust; I create these at times, as a way to research atmosphere and characters without working on a full body work."*

▶ **Scarlet Heart**
Virginie Ropars
Polymer clay and mixed media
http://vropars.free.fr

"I started this work with two colors in mind (red and white), like blood on white snow (and the heart shape). I wanted to make a sort of Czarina that could be found in a fairytale. She is a fading, soft vampire, she is too white, her eyes are like washed blood. The polymer clay I used for the skin tone gives this piece a white marble finish, it's very useful for the 'ethereal' look of the character. The corset is fully sculpted and a lot of other materials are used like different fabrics, feathers, glass pearls, and antique jewelry."

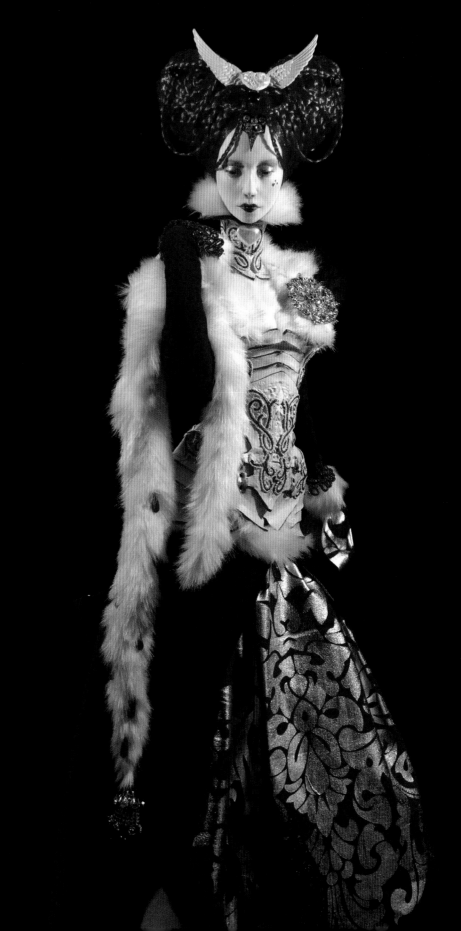

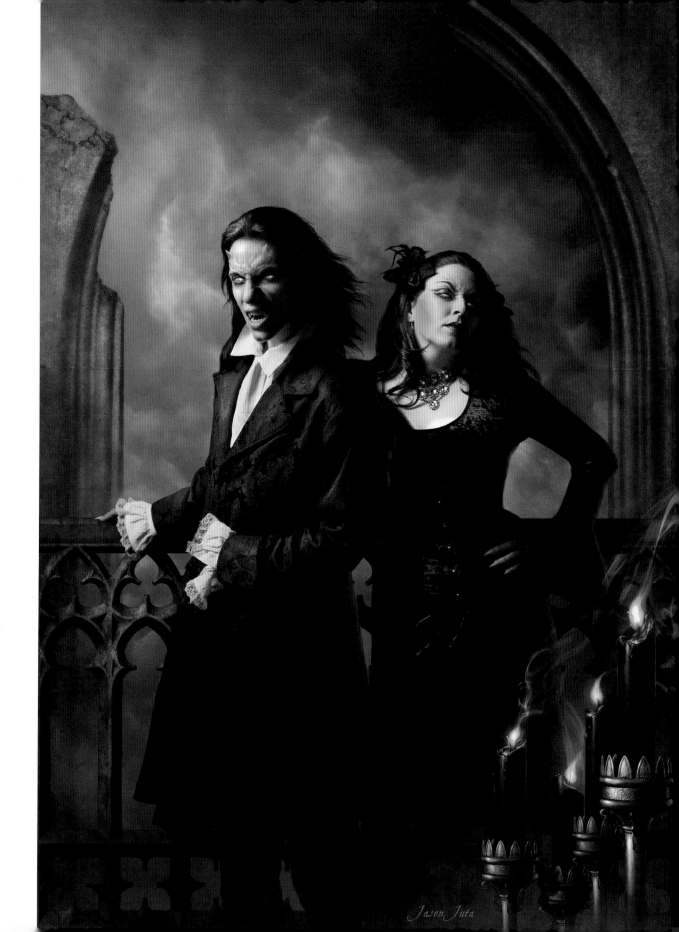

▶ Vampiric Nobility
Jason Juta
Photography and Adobe Photoshop
www.jasonjuta.com

A growling male beast and
his female counterpart stand
proudly in this scene complete
with gothic imagery. The candles
glow a supernatural blue color,
casting light on this monstrous
couple. Juta describes his digital
technique: "A Lord and Lady
of the undead, photographed
in my studio. I processed the
image extensively in Photoshop,
creating the background
and foreground props from
personal photography and
painted elements."

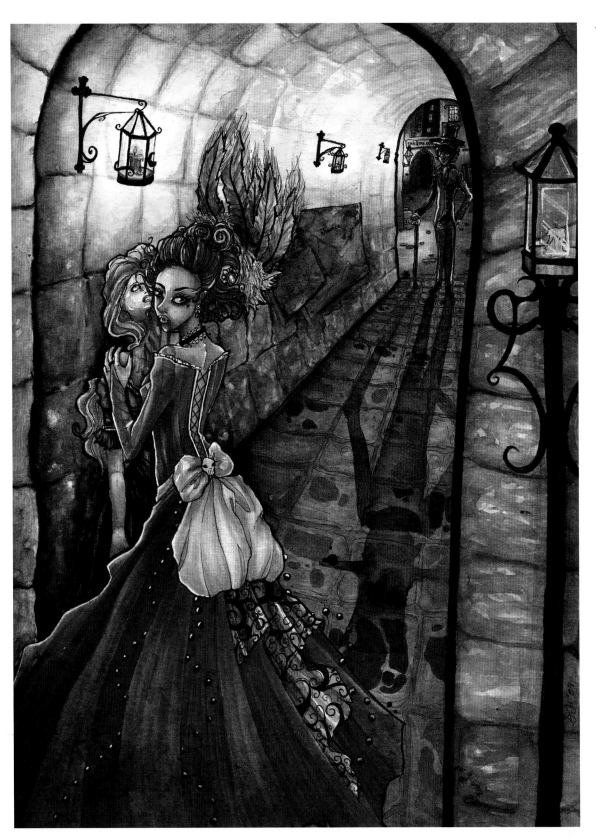

◀ **Dinner and a Show**
Sasha Fitzgerald
Watercolors, ink, and markers
on Aquarelle Watercolor Paper
http://sashafitzgerald.com

"A girl, separated from her party, wanders the intricate streets of Paris stalked from the shadows by a pair of cold blue eyes. She walks past a secluded tunnel, and is pulled in by a swift figure wearing a green gown, and told 'not to struggle too much' as the vampire will be late for the theater. I wanted this piece to tell a story. Though tedious to paint, I really love the effect of the long tunnel, and the shadowy figure at the end of it. A really important part of this piece was lighting. I wanted a warm glow to bounce off tunnel walls and the figures' faces."

▶ **Midnight Stroll**
Sasha Fitzgerald
Watercolors, ink, and markers
on Arches Watercolor Paper
http://sashafitzgerald.com

"A weary aristocratic vampire wanders through the woods with her wolf companion under a full moon. Vampires were said to control the nocturnal beasts of the woods, likely because they themselves were 'King Beasts' of the night. For this piece, I wanted to create an intriguing figure in a mysterious, moody atmosphere. I really like the effect of the trees silhouetted against the icy blue moon, which gives a spooky, cold, and barren sense to the landscape. The vampire herself is dressed in an intricate, blood-soaked gown, wandering the edges of the forest, with her wolf companion."

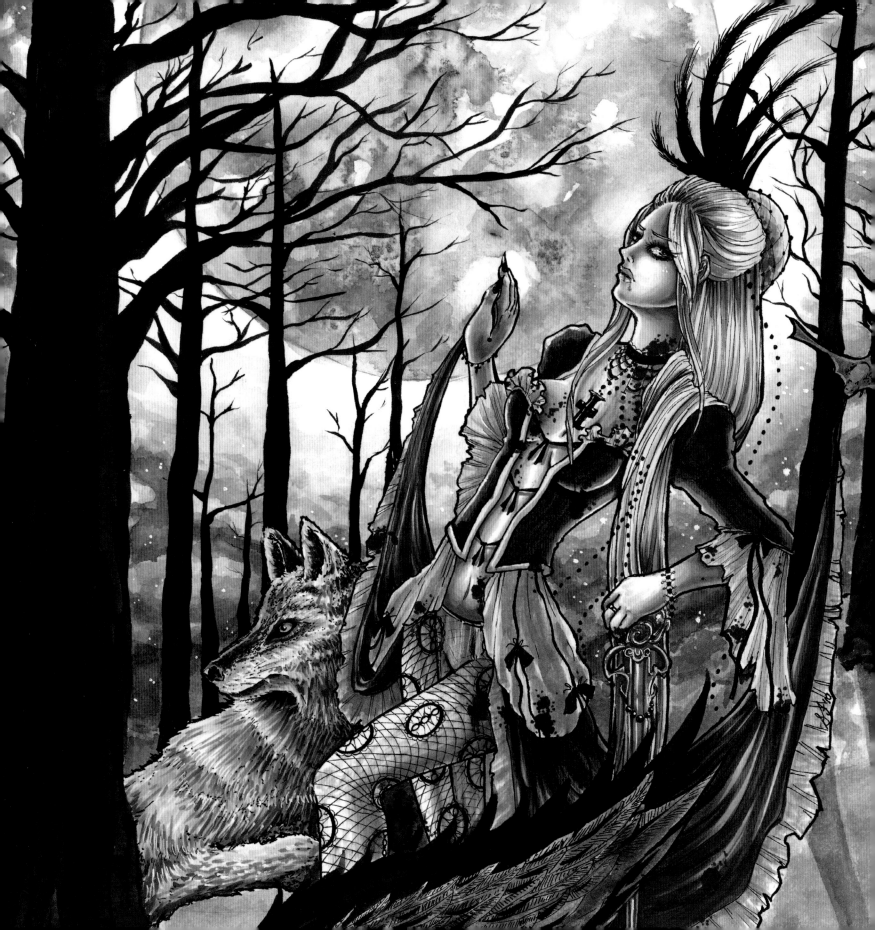

◄ **Le Portrait du Vampire**
Delphine Lévesque Demers
Acrylic, ink, and colored pencils
on watercolor paper
www.zerick.com

Both strong and elegant, Demers'
Le Portrait du Vampire *not
only represents the power, but
also the overwhelming sensuality
associated with vampiric nature.
A potentially dangerous assassin
luring victims through the
decadence of high society.
"Inspired by 19th century
portraits, a beautiful, mysterious
aristocratic vampire is captured
in a Victorian frame."*

Le Portrait du Vampiress
Delphine Lévesque Demers
Acrylic, ink, and colored pencils
on watercolor paper
www.zerick.com

*No time in history is more
closely associated with the
vampire than the Victorian
era. Aristocrats often opted
to immortalize themselves in
commissioned paintings and,
as seen in* Le Portrait du
Vampiress, *our fanged
superiors were no different.*

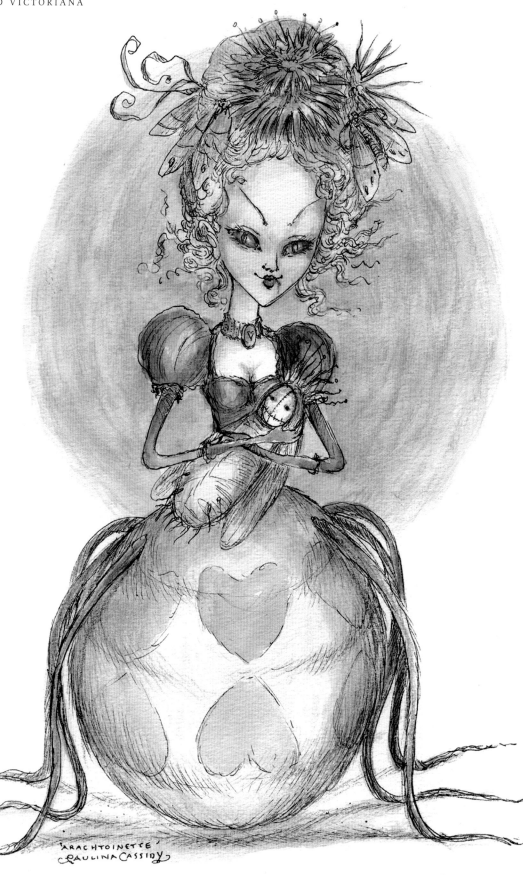

▶ **Arachtoinette**
Paulina Cassidy
Watercolor and ink
on watercolor paper
www.paulina.ws

*This destructive beauty is
a different type of assassin,
complete with royal flair.*
Arachtoinette *is both a cute
and disturbing little piece.
Her heart-shaped lips, red eyes,
and spider parts charm in this
painting by Paulina Cassidy.
"Queen Arachtoinette is vampiress
and spider combined into one
delicioiusly dangerous little
package. Watch out, boys—
she'll chew you up! Created
using watercolor and ink on
watercolor paper."*

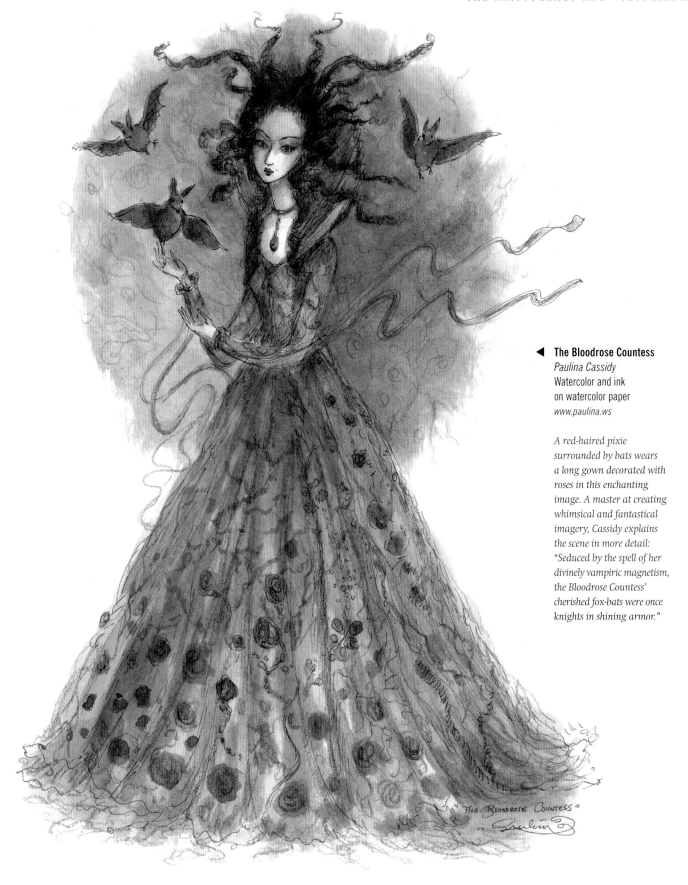

◀ **The Bloodrose Countess**
Paulina Cassidy
Watercolor and ink
on watercolor paper
www.paulina.ws

*A red-haired pixie
surrounded by bats wears
a long gown decorated with
roses in this enchanting
image. A master at creating
whimsical and fantastical
imagery, Cassidy explains
the scene in more detail:
"Seduced by the spell of her
divinely vampiric magnetism,
the Bloodrose Countess'
cherished fox-bats were once
knights in shining armor."*

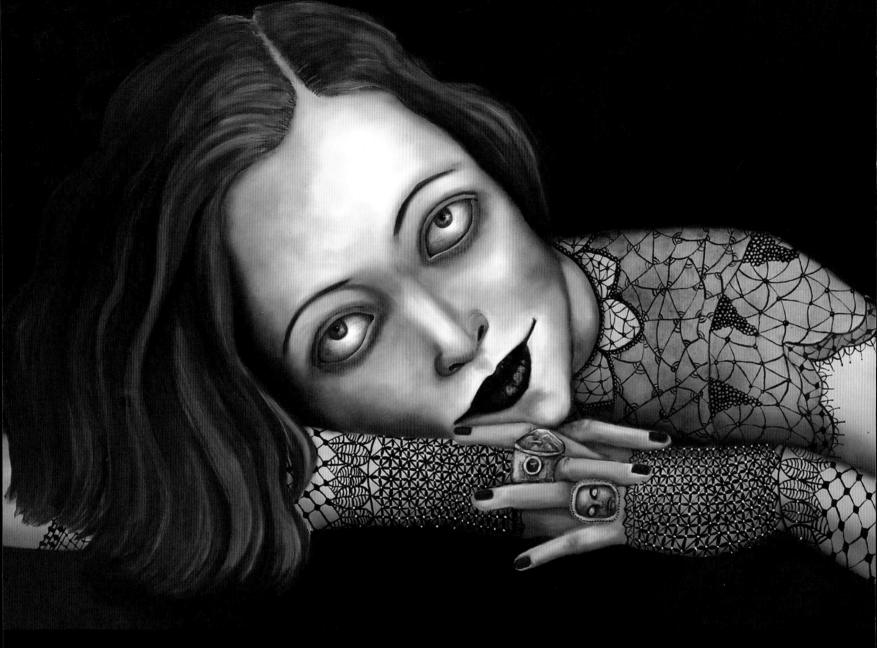

▲ **White Witch**
Ann Harper
Oil on canvas
www.harpershanks.com

"This painting started with the basic premise that we all have an incredible ability to survive almost anything. We do that through fantasy and by creating our own worlds, early in our lives. In these worlds, instead of losing or being powerless, we win, we're strong and we're in charge. Those worlds that we created when we were children were so powerful that they seemed magical and very real.

They were real enough to allow us to survive the world of adults. Then somewhere along the way we forget how to survive, we forget how to use the magic we used to know. We forget how to overcome even the daily obstacles we face and many times we learn to become destructive instead of creative. My work is about remembering who we really are."

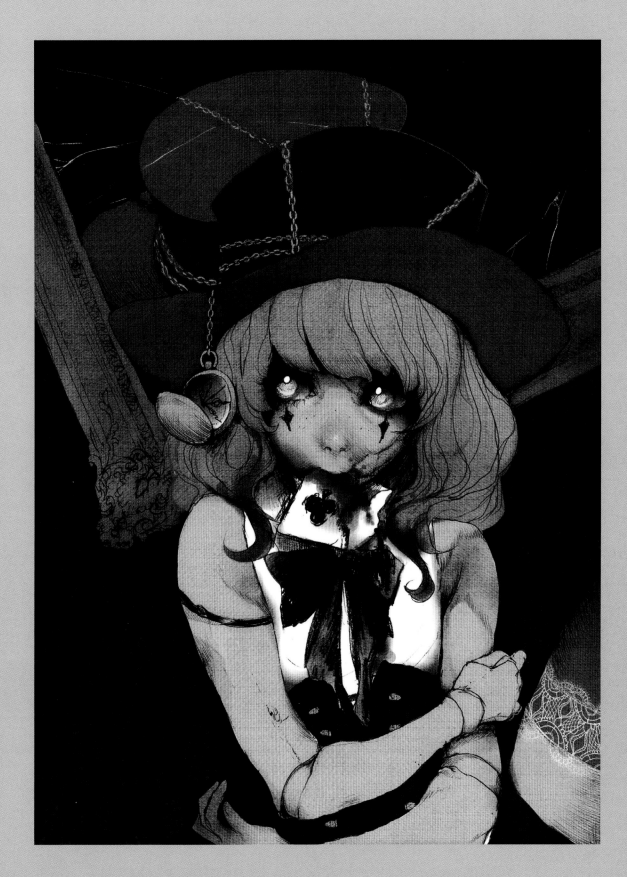

► **Give and Take**
Ein Lee
Pencil, PaintTool Sai,
and Adobe Photoshop
http://einlee.net

*Donning Victorian gear, a little
urchin clamps down on a playing
card. The imagery surrounding
her along with the position of her
arms evokes a cold, lonely feeling.
"A little soul — clearly not of this
world — looking for something.
It was created using pencil on
paper, with colors added in
PaintTool Sai and post-
processing in Photoshop."*

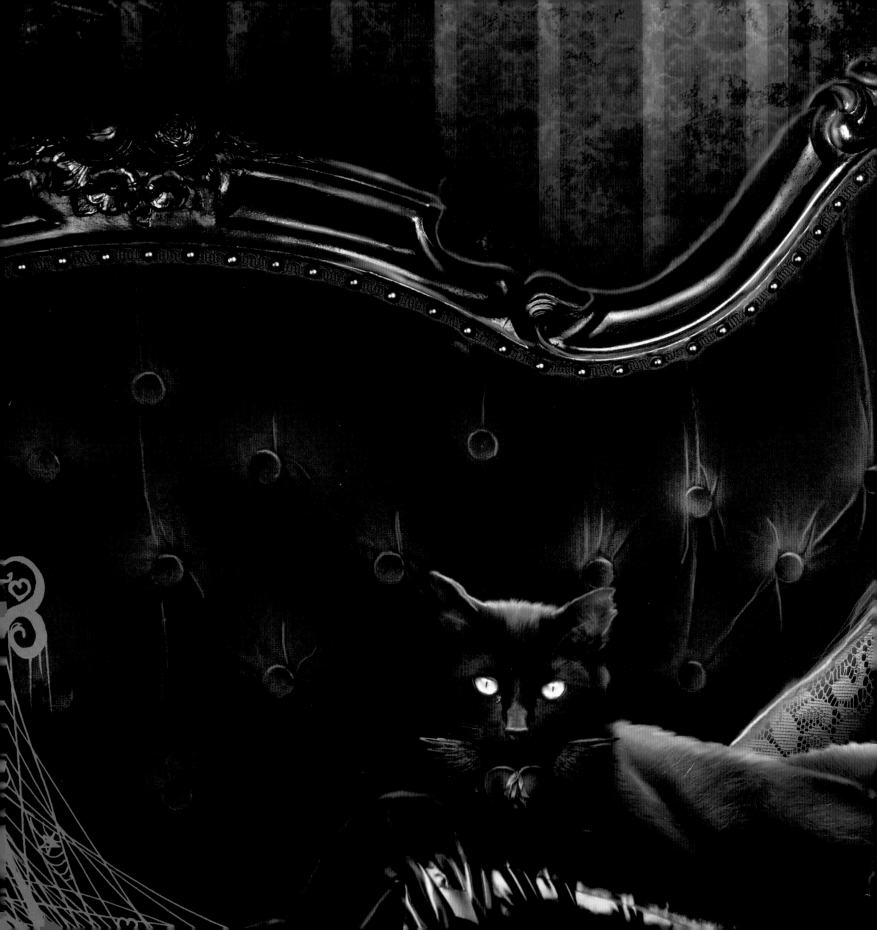

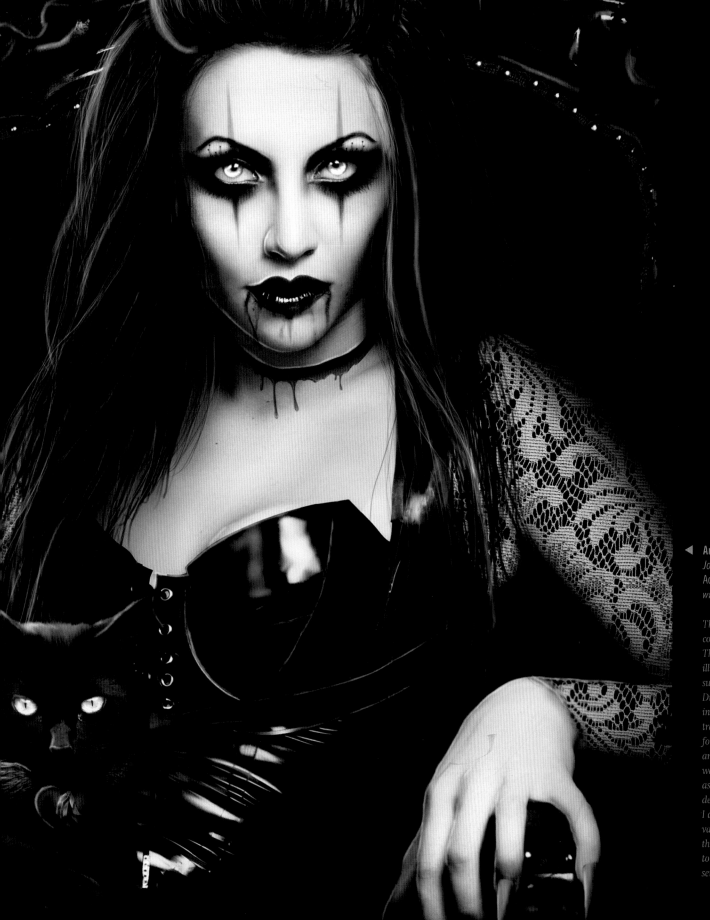

CHAPTER 2

VAMPIRIC VIXENS

◄ **Anima Vorax**
Joana Dias
Adobe Photoshop
www.shinobinaku.net

Three black souls share a couch in this dark digital piece. They all stare forward with illuminated eyes, as cobwebs surround the background. Joana Dias shares her thoughts and inspiration: "Soul Eater is the translation from ancient Latin for this work. I felt like I needed an empowering vampire; and so was inspired by the goddess Bast, as she was known as a female devourer and matriarch of cats. I do also enjoy combining vampires and felines since they have always appealed to me as mysterious and sensual creatures."

▶ **Queen of Darkness**
Fernando Casaus
Pencil and acrylic on board
and Adobe Photoshop
http://fercasaus.deviantart.com

*A lovely figure admires her
beauty as her behemoth pet
gawks. "The Queen of Darkness
thinks that she is the most
beautiful, heartless, and
powerful creature. She enjoys
her vanity in her cold kingdom
of darkness. She controls and
manipulates life and death.
She is both the animals' and
the humans' judge. A green
environment with cold colors
contrasts with red brushstrokes
reflecting a hunter's patience
and violence."*

▶ Rainy Day Dinner
Jhoneil Centeno
Adobe Photoshop
www.jhoneil.net

This blood-drinker doesn't appear the least bit phased by her recent gory ordeal. Her arrogance speaks volumes as we notice she has the fortitude to wear a smoking crucifix around her neck. "This image, inspired by some great memories while living in the west side of Los Angeles, was created using Photoshop. It is based on a picture I took of my friend Jazmine who was relaxing in my apartment."

▶ **Nightfall**
Michael Calandra
Airbrush, acrylic, and colored
pencil on Crescent hot press
illustration board
www.calandrastudio.com

*Imagery associated with
the undead surrounds this
blonde-haired tease. What could
be a window in the background
is hidden by mist, while creatures
of the night frolic and flitter
around the central figure. In the
foreground, two impaled skulls
are ominously displayed. Poised
and ready, the vampiress looks
ahead hungrily. "The artist,
summing up the work, says:
A stunning female vampire is
depicted as a legion of bats escort
her on their nightly hunt."*

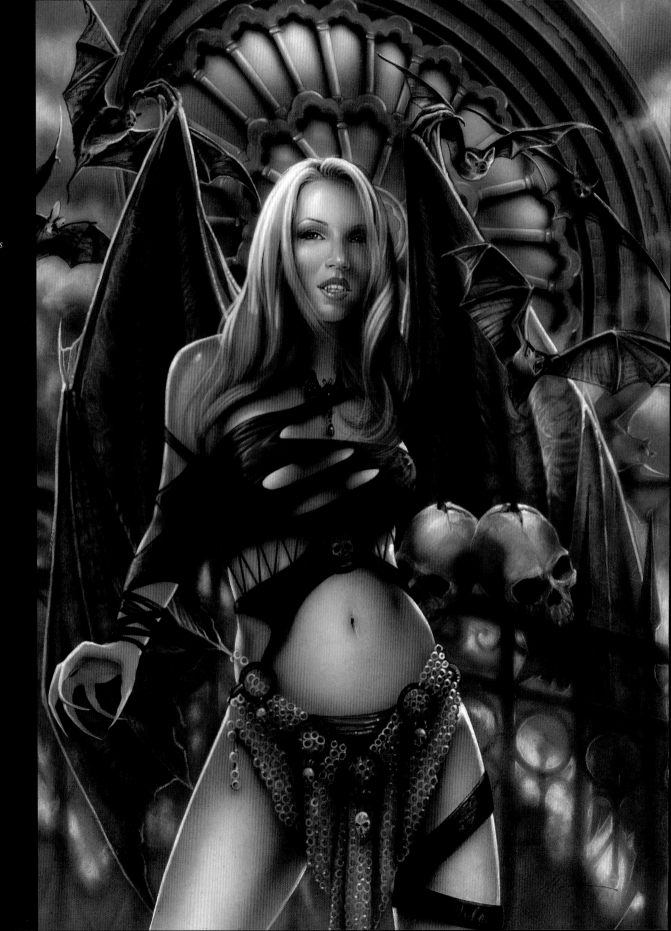

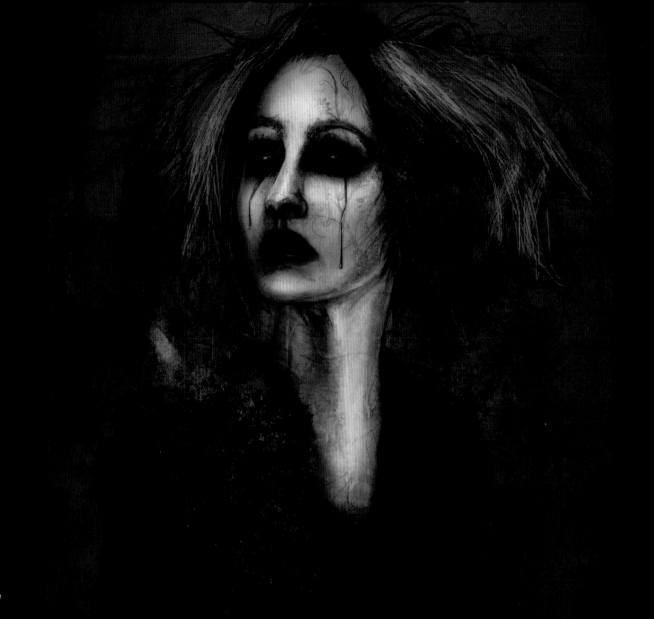

▶ **La Diabolique**
Mark Pexton
Pencil, Corel Painter X,
and PaintShop Pro
http://mark-pexton.daportfolio.com

*The artist wanted to create
"a surreal otherworldly
sensibility," and he certainly
accomplished that in this piece
titled* La Diabolique. *The
vampiress' crimson tears of
blood falling from her lifeless
eyes are a mockery of something
humans do every day. Her
upward glance conveys a
hopeless feeling. The piece gives
off a sense of overwhelmingly
pessimistic acceptance.*

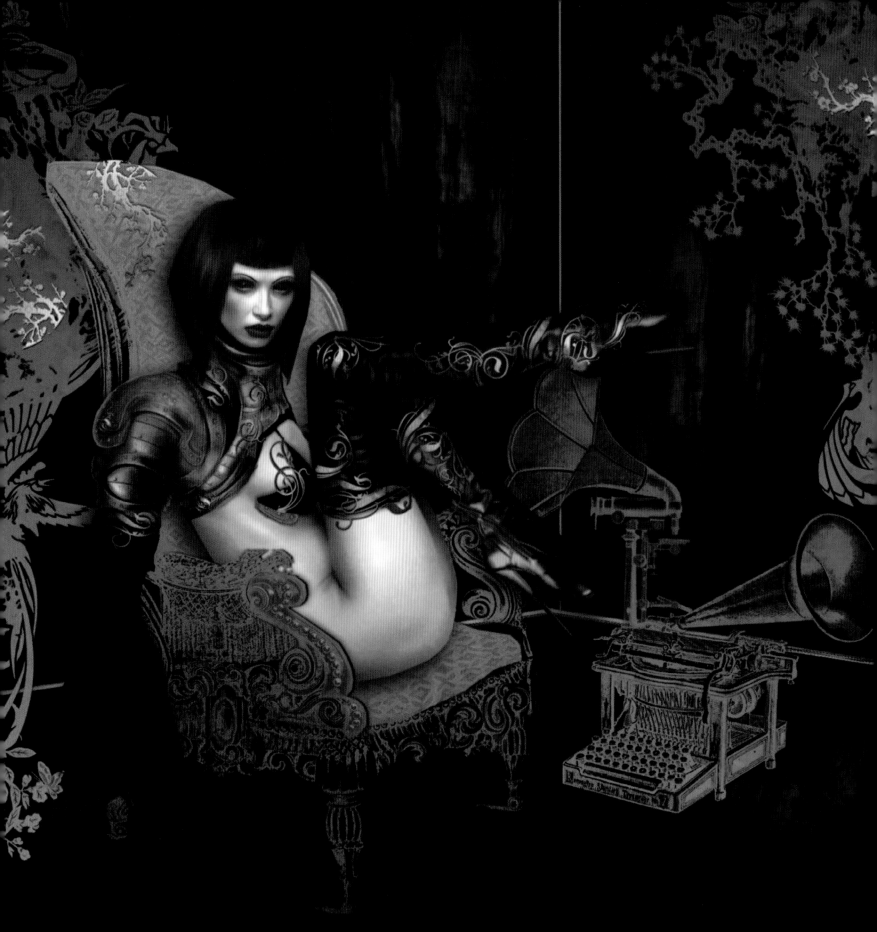

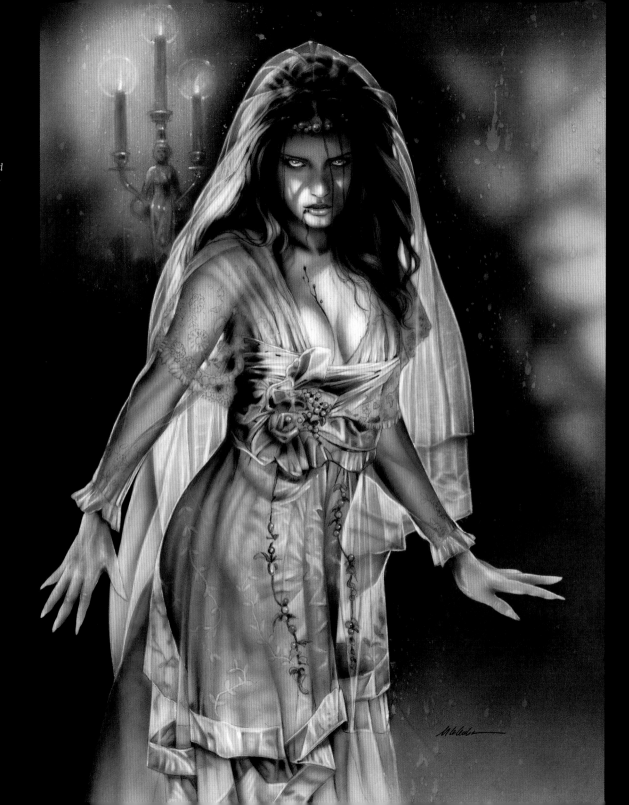

Music Room
Bethalynne Bajema
From an illustrated short story
called *The Dollhouse*
Digital collage
www.bethalynnebajema.com

A seductive siren lounges in a chair next to a Victorian-inspired music machine. "Music Room *is part of an eight-piece collection that is a part of a short, illustrated story called* The Dollhouse. *This is a full illustration for the book featuring the character Li. The woman in this image is from an original oil painting, and many of the designs and objects in the room are from old pieces of ink illustrations that I modified with ink and pencil. I scan all of these images and bring them together and finish the image with digital painting."*

Bloofer Lady
Michael Calandra
Airbrush, acrylic, and colored
pencil on Crescent hot press
illustration board
www.calandrastudio.com

Always a creepy effect, we see a spooky bride dressed in white—but what's this? She has fangs and claws, but still retains all of her feminine wiles, a very dangerous combination! Calandra created this haunting image as a homage. "Bloofer Lady *is a tribute to Lucy Westenra from Bram Stoker's* Dracula *novel. The character has always been a source of horror and inspiration to me; I specialize in gothic horror depicting beautiful women."*

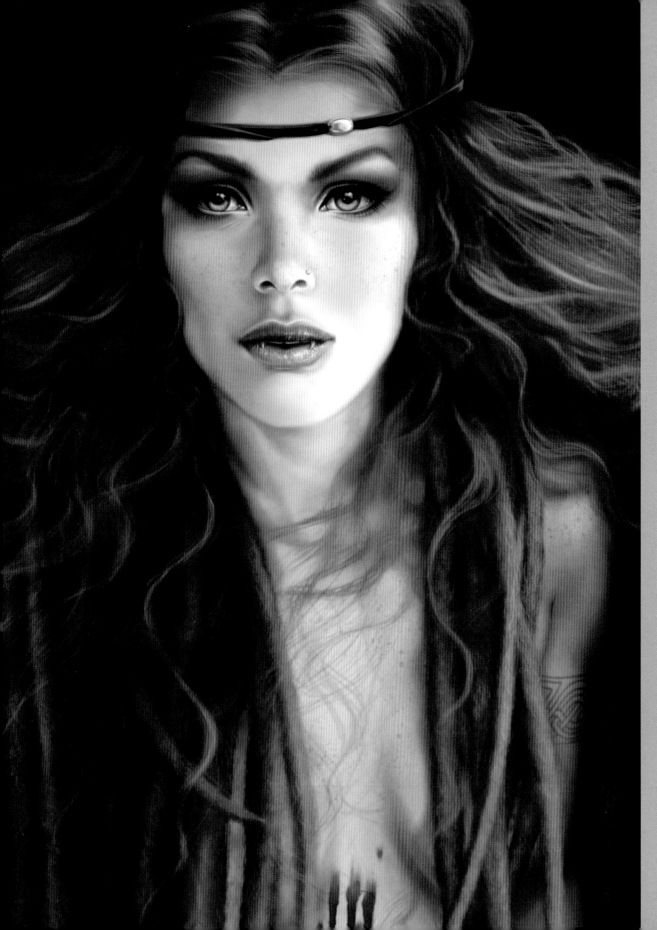

◄ **Beauty to Die For**
Christine M. Griffin
Adobe Photoshop
http://christinegriffin.artworkfolio.com

Christine M. Griffin demonstrates one of the vampire's greatest weapons: beauty. "Not every vampire must be monstrous, or even goth. With subtle cues, like a peek of a fang or the merest smear of blood, you can imply the nature of the beast. This particular piece required a great many layers because I was trying to be as photorealistic as possible. As a rule, however, I flatten whenever possible. It helps to keep things from looking too much like individual elements, cut and pasted atop each other."

▶ **Serpent Queen**
Andrew Dobell
Photography and digital painting
www.andrewdobell.co.uk

"This wicked monarch snarls hungrily and is no doubt not satisfied from her previous meal. She looks forward, wearing a serpentine symbol of power that she perhaps understands too well. This artwork actually started life as a photo of a model that I took. I overpainted the photo and then changed her expression from a grin to a growl and added the hair, headband, blood, and side lighting. I used the photo purely for a likeness."

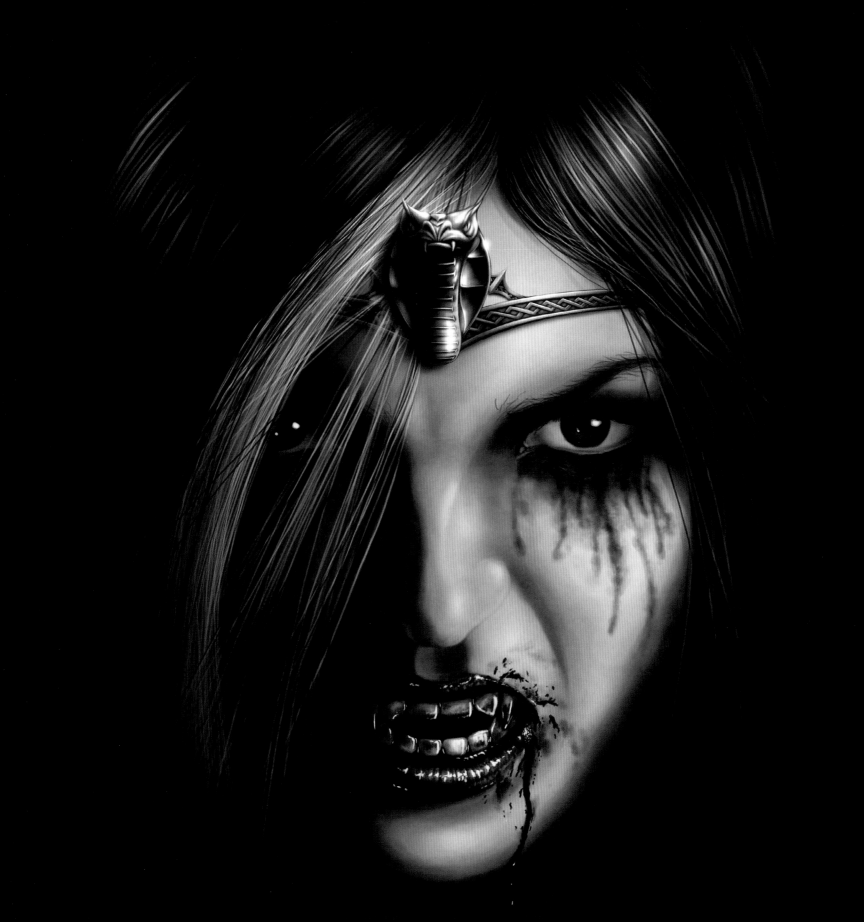

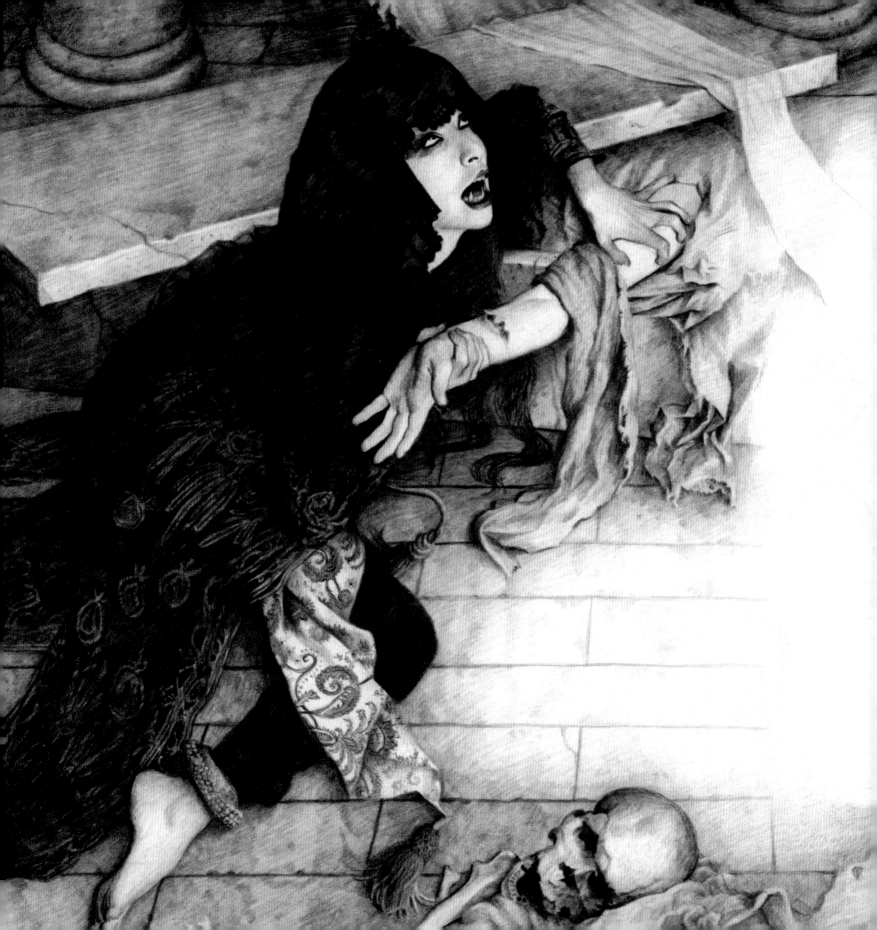

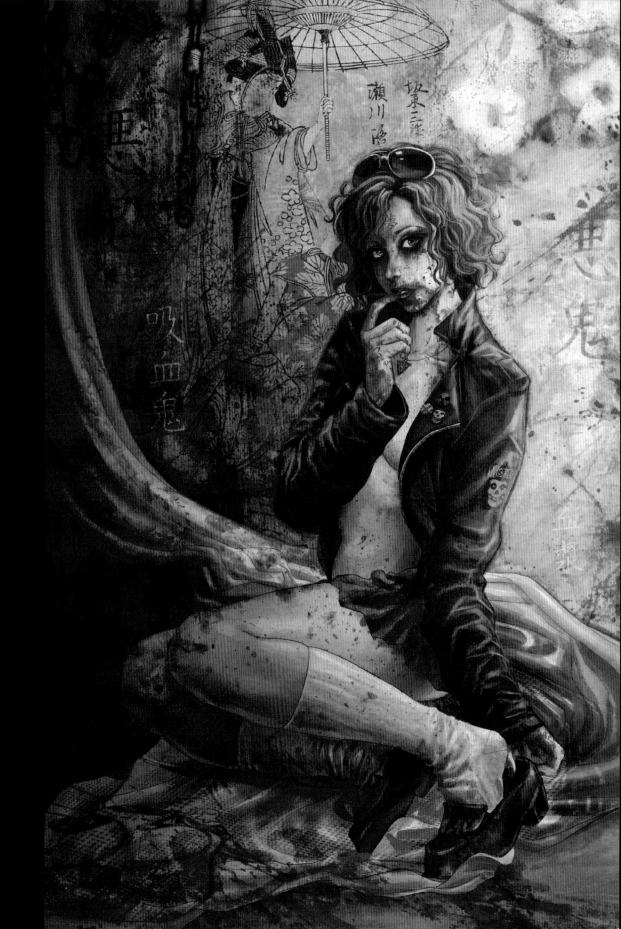

Arabian Vampire
Anne Yvonne Gilbert
Featured in *Ghosts and Monsters*
published by Time-Life Books
Colored pencil on paper
www.yvonnegilbert.com

A striking image with an Arabic theme by Anne Yvonne Gilbert. "The story called for a vampire of Middle Eastern origin, clearly different from the Transylvanian type in appearance but still recognizable at first glance. She had to be beautiful, but at the same time, scary—a tall order! I decided if I dressed my model in a costume vaguely reminiscent of the Arabian Nights, as opposed to a modern style, this would make her more decorative, therefore more attractive—in my mind anyway."

Bloody Innocence
Fernando Casaus
Adobe Photoshop
and Corel Painter
http://fercasaus.deviantart.com

"She is young, and she has enjoyed this for many years. She seduces new victims everyday with her sweetness and innocence. They discover then that she is the most aggressive, merciless, and bloodthirsty of nature's predators. Red brushstrokes dominate the bloody environment to obtain a mixed portrait of zen-innocence and bloody violence."

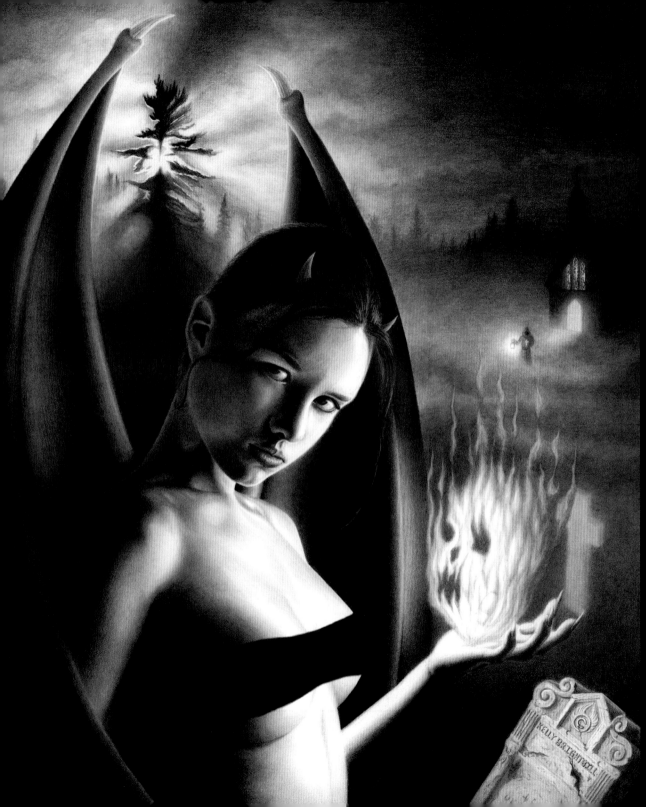

Moth To The Flame
Kelly Brightbill
Graphite on paper
www.kellybrightbill.com

A demonesque vixen summons up something quite hellish. "Moth To The Flame was created with the basic good vs. evil theme," Brightbill says. "I left the end of the battle up to the viewer. Does the priest stay true to his faith and overcome the evil or does he fall for this seductive beauty? This piece was created with graphite on Strathmore's Bristol Vellum paper."

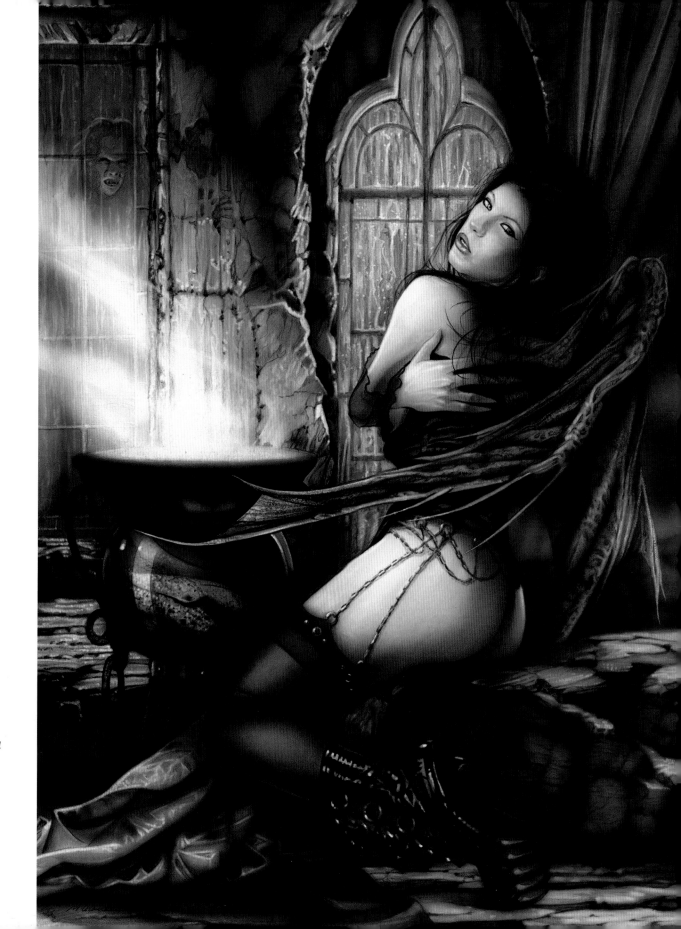

▶ **Siren Song**
Michael Calandra
Airbrush, acrylic, and colored
pencil on Crescent hot press
illustration board
www.calandrastudio.com

*This black-winged beauty is
cooking up something rather odd
in her black cauldron, while a
sinister-looking creature watches
from outside. Calandra explains
the true meaning of this piece:
"Siren Song depicts a sensual
vampiric siren luring an
unsuspecting victim. Either
character could be seen as
the hunter or as the prey."*

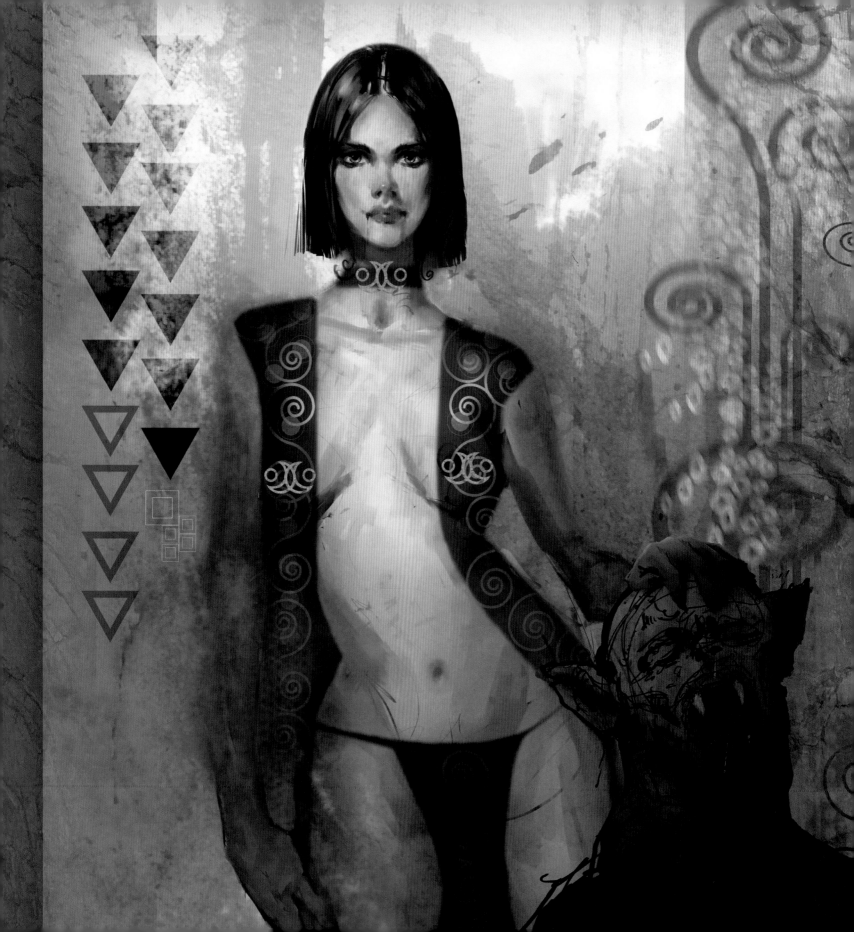

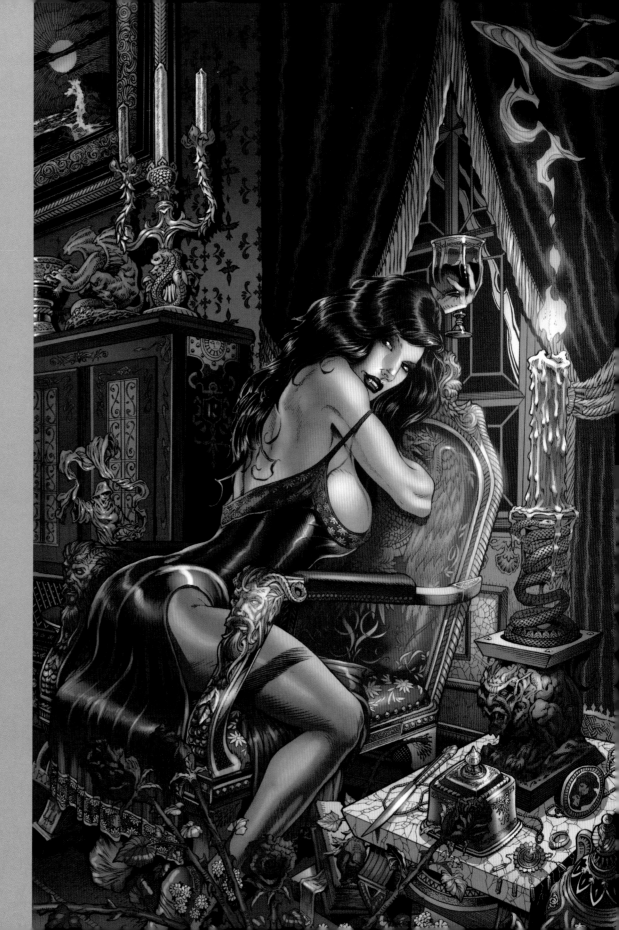

◄ **Seine**
Armand Baltazar
Pen, ink wash, and digital finishing
www.armandbaltazar.com

A dark image full of multilayered imagery showcases a cool, calm, collected (and half-dressed) pixie with a demonesque monster in the palm of her hand. His contorted face is unpleasant and horrid. This painting was created using pen and an ink wash, and finished off digitally. Baltazar sheds light on his inspiration for the image: "This piece was inspired by the painting of Gustav Klimt titled Judith. This painting is a dark homage!"

► **Bloodwine**
Tim Vigil and Nei Ruffino
Pen, ink, and digital coloring
http://rebelstudios.proboards.com

Whoa! This one is a foul seductress! Vampires use every trick in the book to snatch their prey; some go on animalistic hunts, some go for the weak and elderly, but this one is using good old sex appeal. She has decorated the room with roses, candles, a lovely armoire, and a magnificent chair she has mounted backwards. The aura she gives off is seductive, but she remains powerful. It may be wise to refuse this succubus and her blood wine.

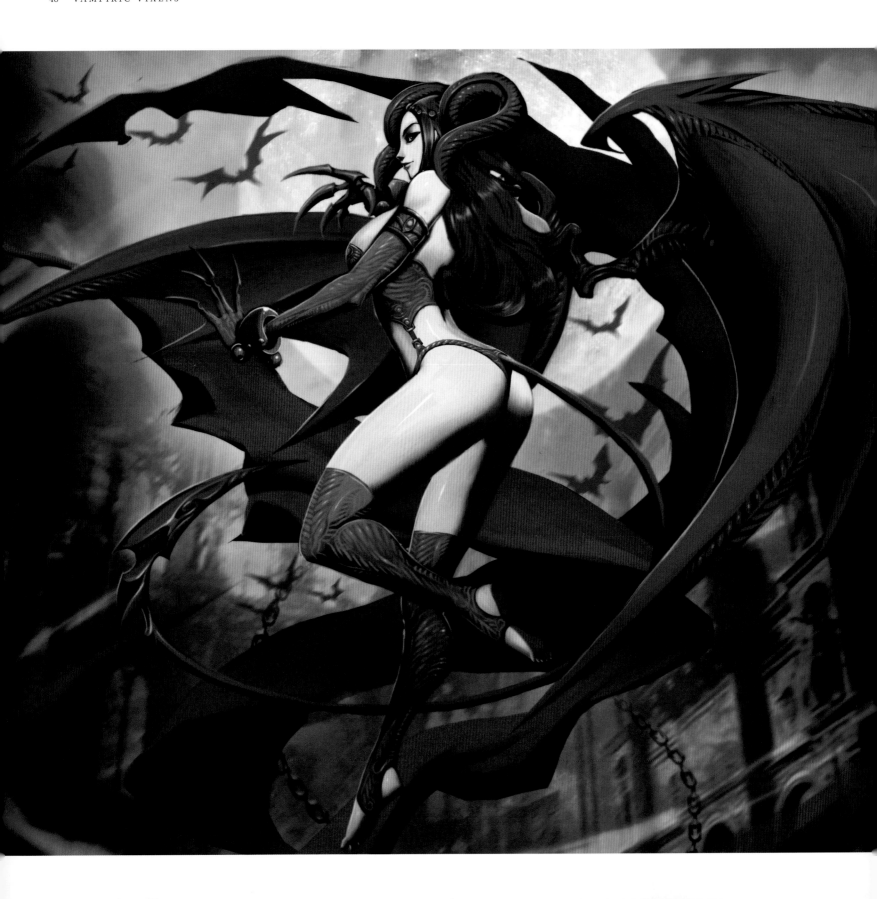

◀ **Lilith**
Gonzalo Ordóñez Arias
Adobe Photoshop
http://genzoman.deviantart.com

"I created this image looking for a new approach to this mythological character. I drew her a couple of times with different results: in one version I was trying to stay more close to the source, more related to the succubi myth, but on this one I was trying for a more vampire-related version. Some legends claim she is maybe the role model for the classical succubus but at the same time one of the early vampires in myths and history."

▶ **I Vampiri: Pietà**
Jasmine Becket-Griffith
Acrylic on Masonite panel
www.strangeling.com

"The third in my I Vampiri *series, called* I Vampiri: Pietà *(which means 'Pity' in Italian). Obviously, 'the pietà' means more than just 'pity' when it comes to the art world — Michelangelo popularized the pietà as a pose, which has been repeated throughout the centuries (from his original statue at St. Peter's Basilica in Vatican City to the covers of horror movies and comic books). So of course, the marble figure in this painting is none other than Michelangelo's statue of the* Pietà. *Can't get more Italian Renaissance than that! The vampire queen cradling him on her lap does appear to show pity in her sad, glowing eyes. This was so much fun to paint, and I think it turned out great. "*

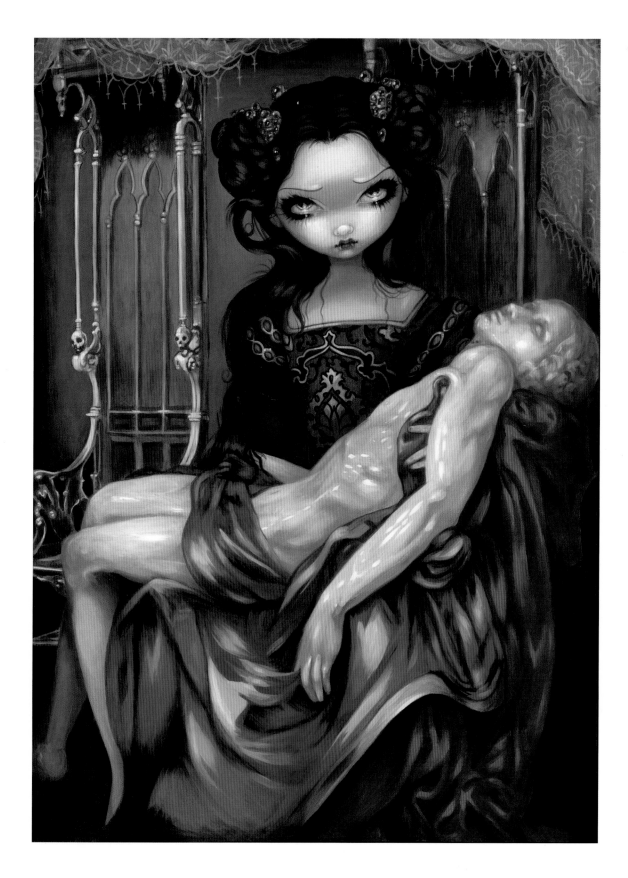

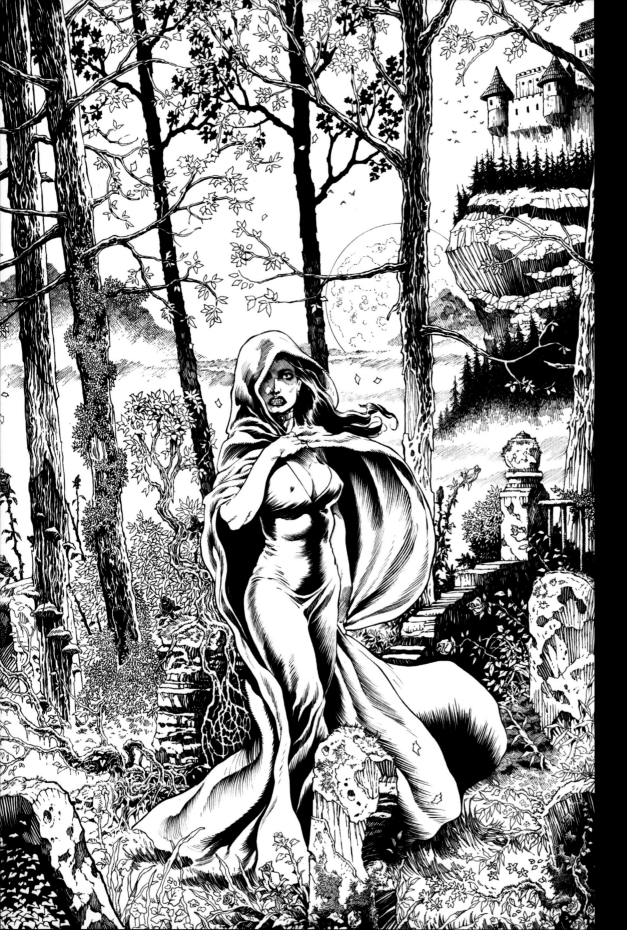

◀ **The Countess**
Tim Vigil
Pen and ink on paper
http://rebelstudios.proboards.com

In Vigil's The Countess,
*an ancient castle sits high atop
a hill and the moon looms very
low as if spying on the toothy
royal maiden. She stands in a
broken cemetery while wind blows
her cape open to reveal her curvy
figure. The drama of the scene is
matched by her vicious, scowling
manner. This is altogether a
gloomy stage, the perfect place
for a denizen of hell.*

▶ **Eternity in Hunger**
Jarno Lahti
Photography and Adobe Photoshop
www.kaamos.com

*A wild-looking, corrupted
nymph is hungry and getting
geared to hunt. The scarlet hues
are reminiscent of blood, always
a symbol of the vampire's
neverending thirst. This piece
was made using a Wacom tablet
with Photoshop and heavy photo
editing. Artist Lahti gives us a
little insight on this demoness'
mindset: "I'm ready! Time to rise
and to take a first step as an
immortal creature of the night.
This hunger I can't hide. I'm
ready for the BITE!"*

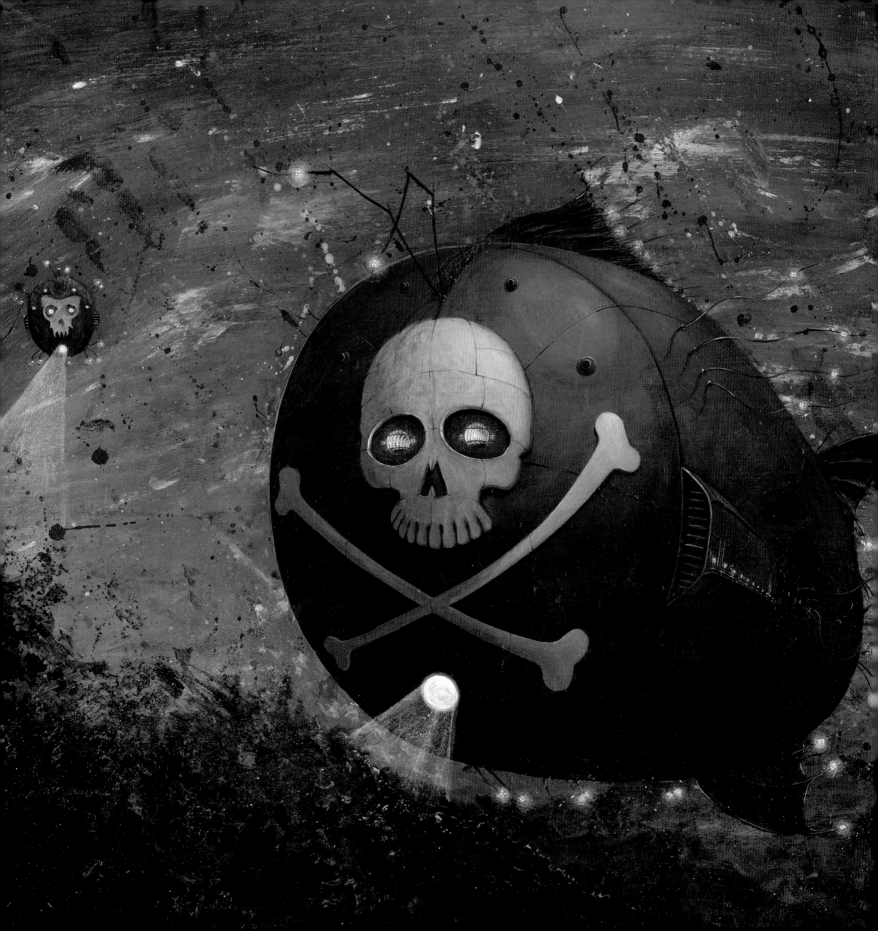

CHAPTER 3

CONTEMPORARY GOTH AND URBAN UNDEAD

◄ **Red Queen**
Myke Amend
Acrylic on birch panel
www.mykeamend.com

This piece by Myke Amend was painted with sponges, toothbrushes, feathers, fingers, and hands. He describes a bit of the backstory to the piece: "It was then that she began to wail, in a terrifying and unearthly tone; and it was then I realized that the sirens ringing loudly throughout the valley were not sirens at all, but the sound of other fleeing humans, their spirits trapped by the seeking lanterns of the floating leviathans above."

◄ **Candyapple Vampire**
Ein Lee
Pencil, ink, and Adobe Photoshop
http://einlee.net

This image, done digitally with sketch and inks processed in Photoshop, begs the question: Trick or treat? It isn't easy to tell if that is blood or candy syrup on that green apple, but one thing is for sure—this tattooed little rascal is enjoying it! Lee explains her inspiration behind Candyapple Vampire: *"It's a Halloween picture with some motifs that I'd always wanted to try drawing, including vampires and radioactive apples."*

▶ **The Vampyre**
Mark Pexton
Pencil, Corel Painter X, and PaintShop Pro
http://mark-pexton.daportfolio.com

The Vampyre is a character study for a graphic novel character that Mark Pexton is working on. This bloody fop is dressed for success—never mind the gore everywhere! The character straightens a red tie and it is unclear whether this was the tie's original color or, perhaps, it has just been used as a napkin. Save for the tie, the man favors black and white as seen by his suit and trendy hairstyle.

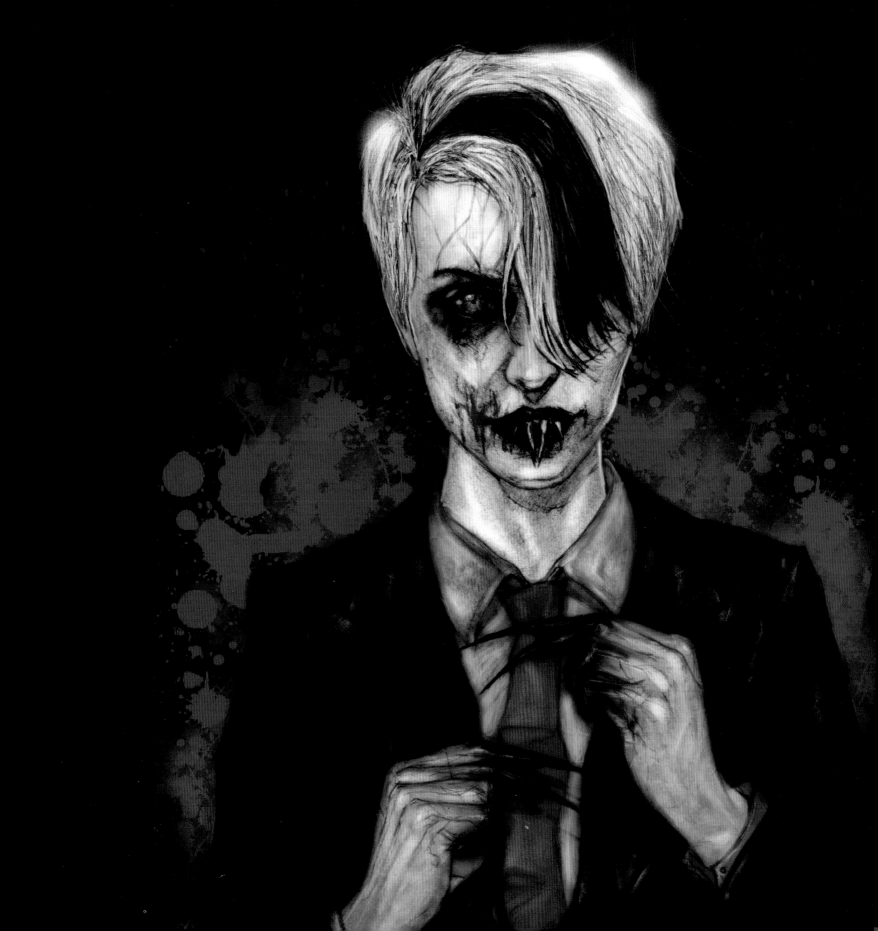

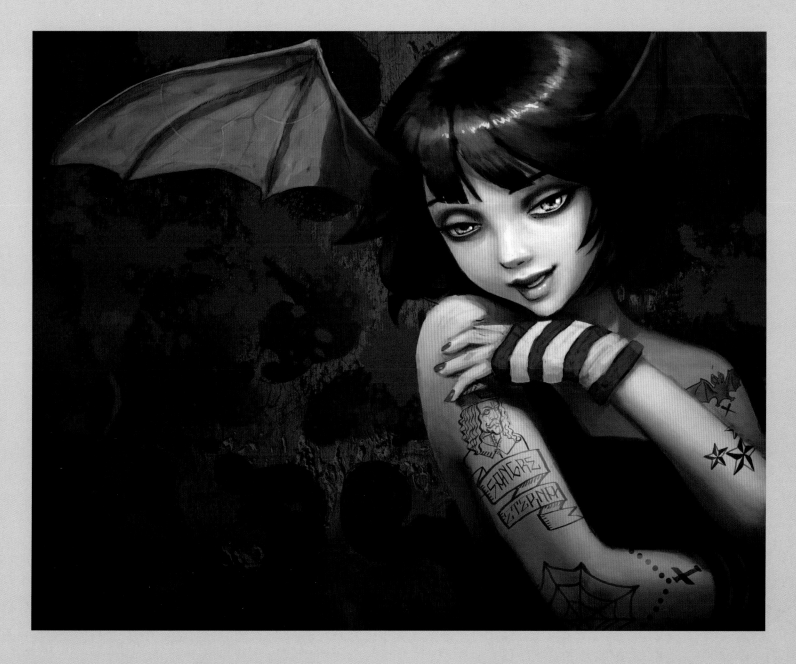

◄ **Molly**
Charli Siebert
Poser and Adobe Photoshop
http://pharie82.deviantart.com

A gothic, vampy piece by Siebert. "This piece was created digitally
in Poser and Photoshop. I created the base human figure in Poser,
along with some of the clothes, skin, and eye textures. Then I imported
the rendered image into Photoshop where I added and refined the
clothing, hair, and other details (rose, fishnet textures, border
details, etc.). I completed the piece with a few blurring, coloring,
and texturizing layers."

▲ **RRRR**
Deseo
Pencil and Adobe Photoshop
www.deseoworks.com

Deseo's digital piece features a lovely tattooed undead girl with bat
wings. "I wanted to take a more anime approach to the vampire idea.
But because I'm also a pop-culture fan, I thought it'd be fun to mix in
a bit of tattoo art. The direction of the wings, arms, and use of light
all lead to the eyes and smile of this beautiful, but merciless predator.
I drew the face using mechanical pencil on paper, scanned it, and
rendered the rest digitally."

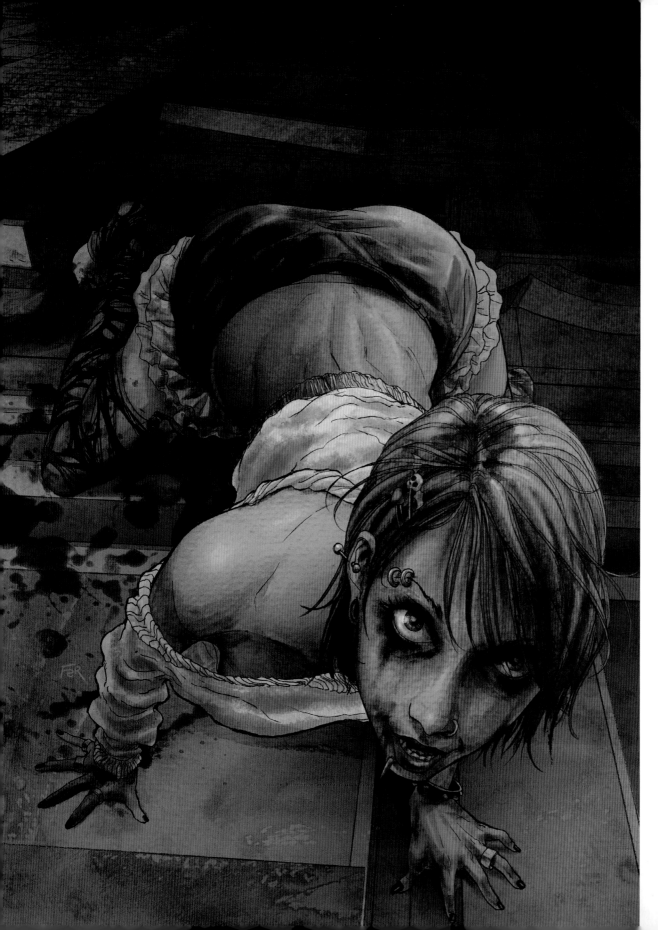

◄ Animal Instinct
Fernando Casaus
Pencil, watercolors,
and Adobe Photoshop
http://fercasaus.deviantart.com

*This wall-clinging vamp has
quite the appetite in Casaus'
Animal Instinct. "A young
punk gothic girl recently
converted is testing her new
powers and abilities while the
city is covered in darkness. She
is hungry and she is looking for
fresh food. I wanted to obtain
a fusion between traditional
techniques (pencil and watercolors)
and digital painting (Adobe
Photoshop) to get an 'alive'
tone in the illustration."*

▲ **Immortal Beloved**
Avelina De Moray
Photography and Adobe Photoshop
www.avelinademoray.com

"Many of my previous artworks have captured the aggression and domination of the vampire. In my latest piece, I wanted to express the softer, romantic qualities of the vampire, which are equally as important. The background lighting has been enhanced in Photoshop, and many filters have been added to remove the bright colors from the artwork. I decided to leave the blood and lips red to draw attention to the center of the artwork. Using my Wacom tablet, I drew over the photograph to enhance its details and clarity. The background was deliberately placed out of focus to increase the depth of field."

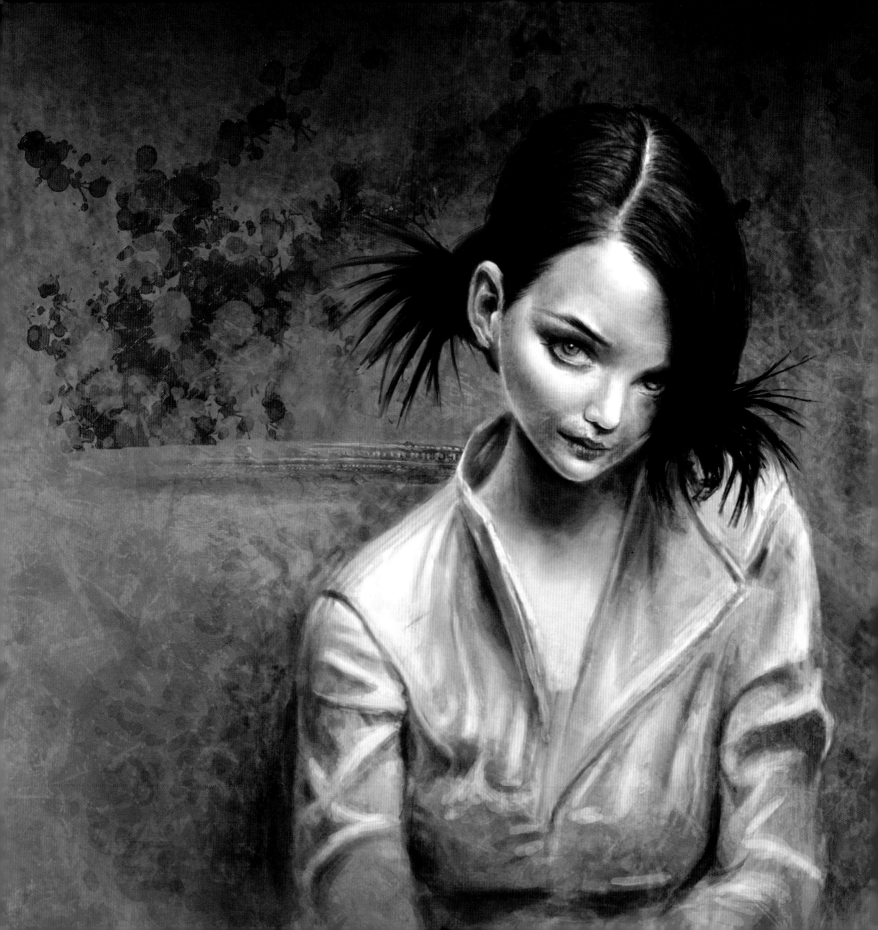

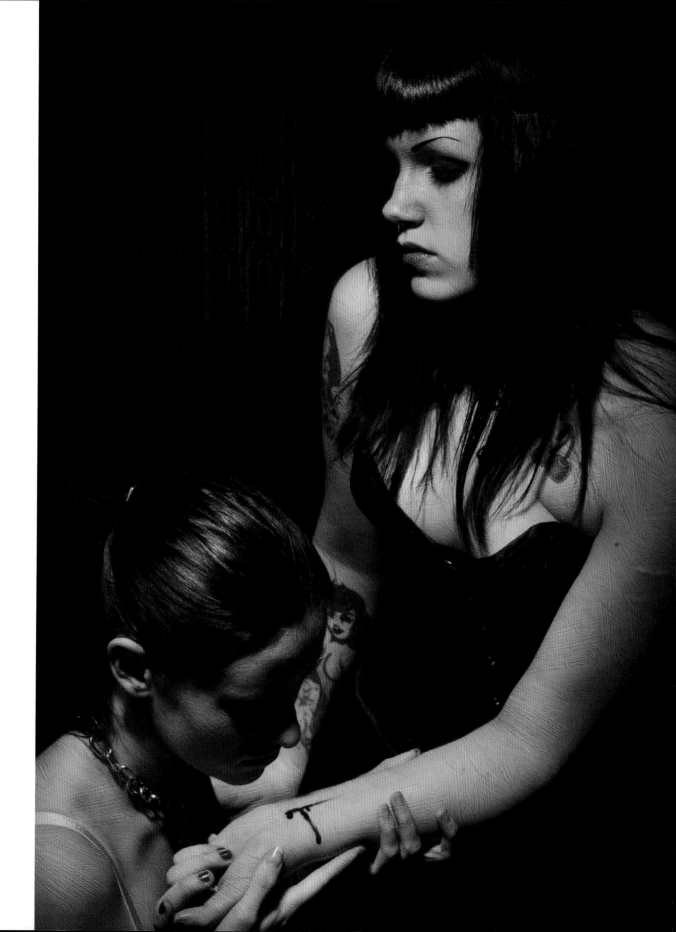

◀ **It's Oh So Quiet!**
Eric Scala
Adobe Photoshop
and Corel Painter X
www.ericscala.com

*Blood is splattered all over
the wall and is smeared on a
seemingly innocent girl's face.
This lovely little vixen has clearly
been up to no good! Scala created
this doe-eyed creature in Photoshop
and Painter X. He explains the
scene, "It's called* It's Oh So
Quiet! *(Like the Björk song.)
But could you just imagine
a few minutes ago?"*

▶ **Bathory**
Jason Juta
Photography and Adobe Photoshop
www.jasonjuta.com

*Without a doubt the most
notable female vampire ever
to grace fiction's history books,
Elizabeth Báthory was a true
castle-dweller who indulged in
blood; a story that has set the
stage for many a legend. Juta
portrays Bathory lovingly. "An
infamous noblewoman who
used the blood of innocents to
stay young. Although caught,
perhaps she survived to this
day . . . This was photographed
and post-processed in Photoshop.
My main aim was to accentuate
the different skin tones between
the vampire and her slave."*

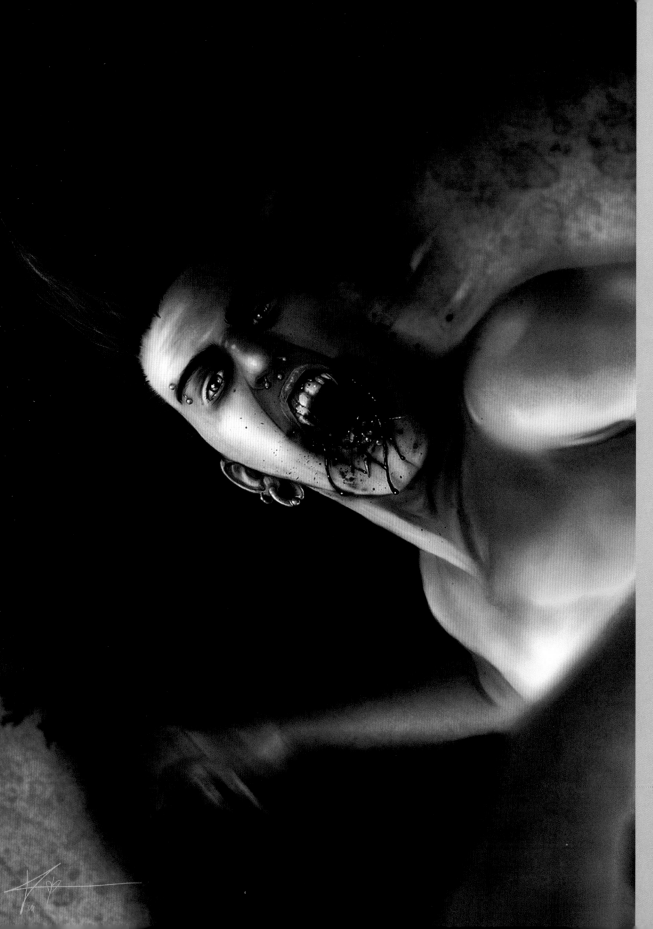

◀ **Frenzy**
K.E. Myatt
Adobe Photoshop
www.hismajestyintears.com

"For this piece, I wanted to make a modern vampire character and have his appearance match a dynamic and vicious pose. I also wanted to mix a more energetic comic-book style with my usual way of working. I very much enjoyed this process and look forward to doing it again. I used some photographic references I found on the web for the pose and sketched my character from the basic shapes of the figure. I worked this into a black and white image and then laid a color wash over it using Gradient Maps set to Soft Light for the shadows and highlights, and then a series of color layers set to Overlay and Multiply. I then flattened the entire image and worked on one layer to create the finished product."

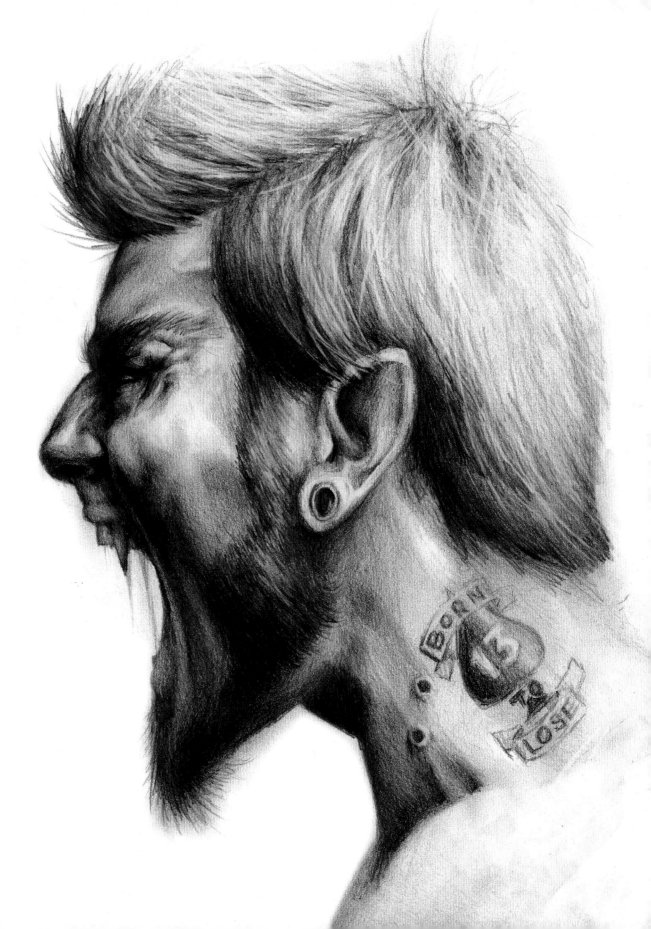

▶ **Born to Lose**
Billy Tackett
Graphite on paper
www.billytackett.com

This modern immortal bears two kinds of marks on his neck; one was afflicted by a creep of vampiric origin and the other, although a blatant foreshadowing, is assumed to be on purpose. His mouth agape in a cry to the air, it is easy to tell that this poor individual was indeed "born to lose." Tackett reveals the amusing location where he created this piece: "Drawn during some down time on the set of a zombie movie, it's basically a study of a more beastly style of vampire."

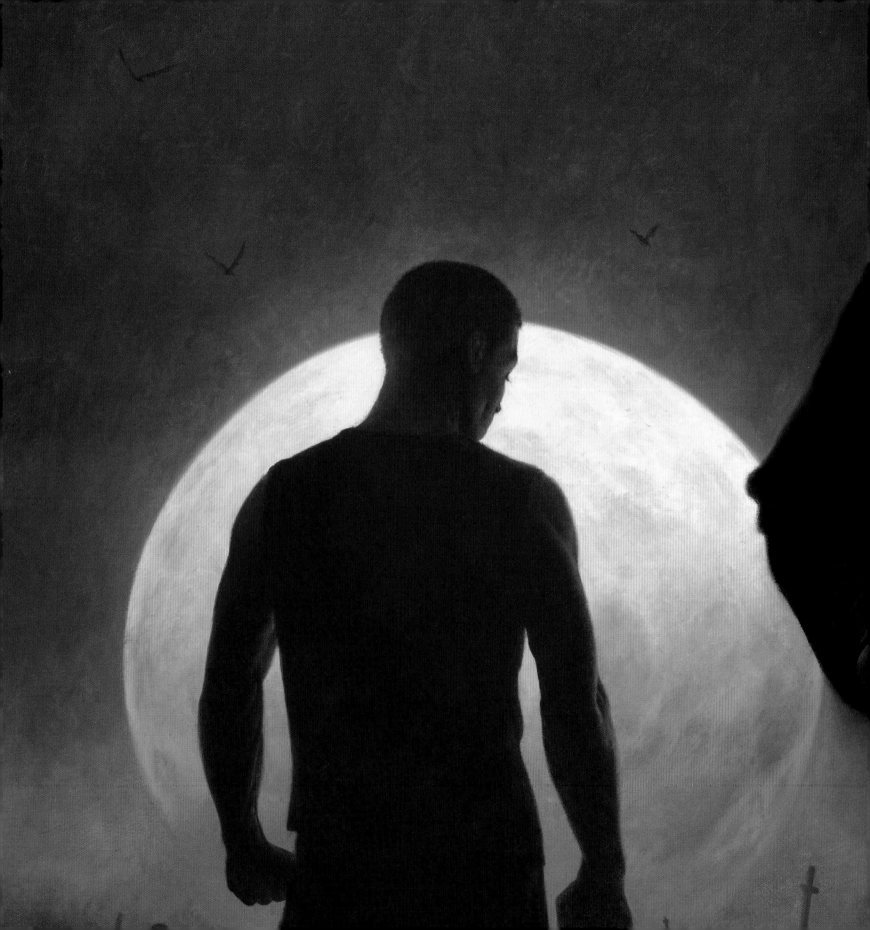

CHAPTER 4
GRAVEYARD GROTESQUE

◄ **The Damned**
Vince Natale
Book cover
for the *Vampire Huntress*
series by L.A. Banks
Oil on gessoed board
www.vincenatale.com

"The main character, Damali, is somewhat of a hip-hop Buffy the Vampire Slayer. In this instance she's struggling with her feelings for her 'boyfriend,' who turns out to be a vampire, the very thing she's supposed to be hunting and exterminating. After gathering reference materials for background elements, clothing, hairstyles, etc., models were photographed for poses and lighting. These elements were incorporated with each other in a detailed drawing, then transferred to a gessoed board and painted in oil."

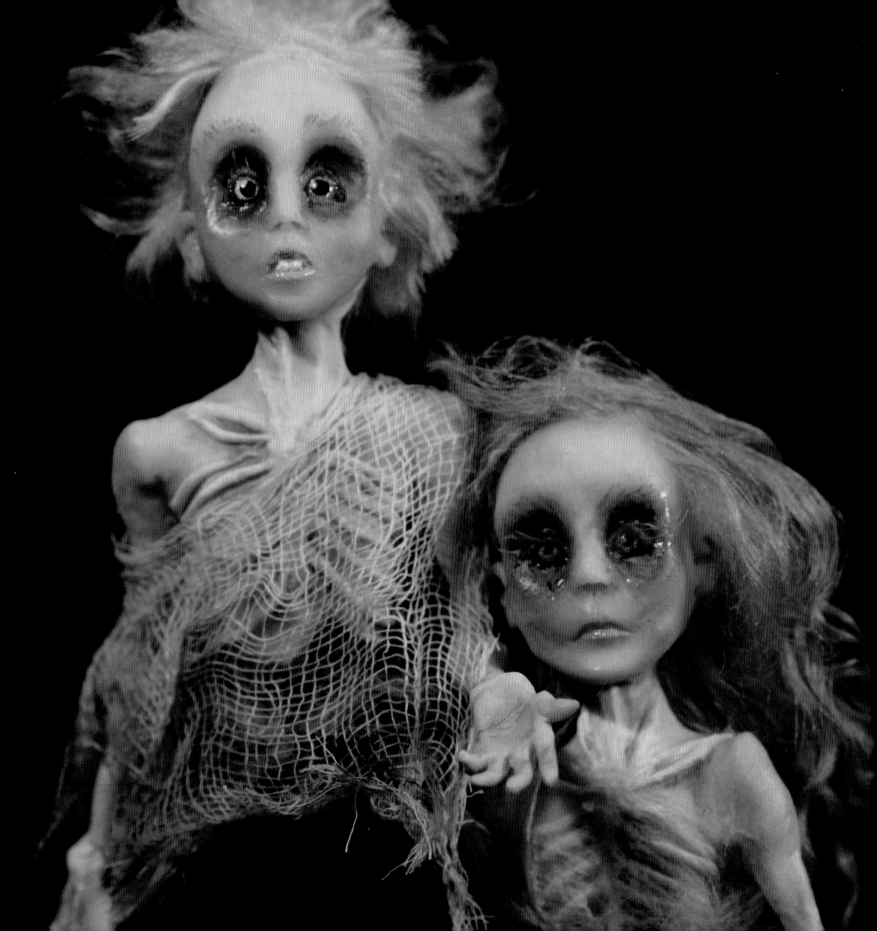

◀ **Children of Nosferatu**
Pam Morris
Polymer clay, acrylic,
heat-set oil paints, and fabric
www.labyrinth-creations.com

*Two starved children of the
damned with haunting eyes
evoke pity in this sculptural
piece. Conceived from a classic
tale, Morris tells us more: "This
piece was inspired by antique
images of Dickens' 'ignorance'
and 'want' in the Ebenezer
Scrooge story. As the sculpture
progressed, their innocent faces
but emaciated and ghostly
appearance led me to the idea
of Nosferatu's children — little
victims the vampire didn't kill
but abandoned to their fate;
never teaching them how
to feed."*

▶ **Angelica**
D.L. Marian
Recycled doll: repainted,
resculpted, and redressed
www.darkcreation.com

*A disheartening feeling arises
when peering into the red eyes
of Marian's Angelica. Her glossy
lips are coated in red and her
black hair hangs unkempt. She
stares lifelessly, hypnotically, at
nothing in particular. A true doll
of the undead! "My inspiration
for this life-size girl is classic
horror movies. There is nothing
more frightening than your
own imagination."*

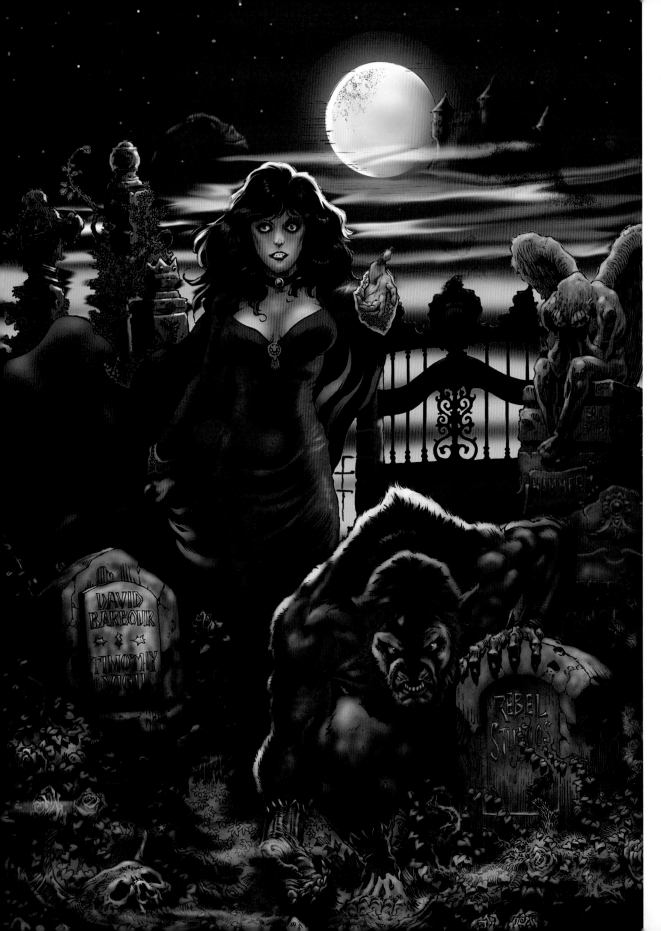

The Welcoming
Tim Vigil
Watercolor and digital coloring
http://rebelstudios.proboards.com

The night sets the scene for mischief in this image. A hunched werewolf looks ready to leap as the moon casts a glow on the lycanthrope's back. Unkempt tombstones and a weeping angel form a circle around the central figure of a bloodsucking she-devil. Her hand stretches forward welcoming the viewer in. Although warnings abound that this place may be a little too dangerous for a mortal, her countenance still greets us rather warmly.

◀ **Vampire**
Nathan Rosario
Digital painting
http://ancientearthstudios.com

*"Vampires are hard to kill.
That was my concept for this
illustration. We see a vampire
that has survived an attempt
by some villagers to end his life.
The vampire, however, has turned
the tables on his attackers and
feasted on them. Even if they are
almost dead, a good feeding can
usually bring a vampire back
and that's whats happened
here. The attempt to take his
life having failed, he extends
a hand towards viewers
as if to lure them in."*

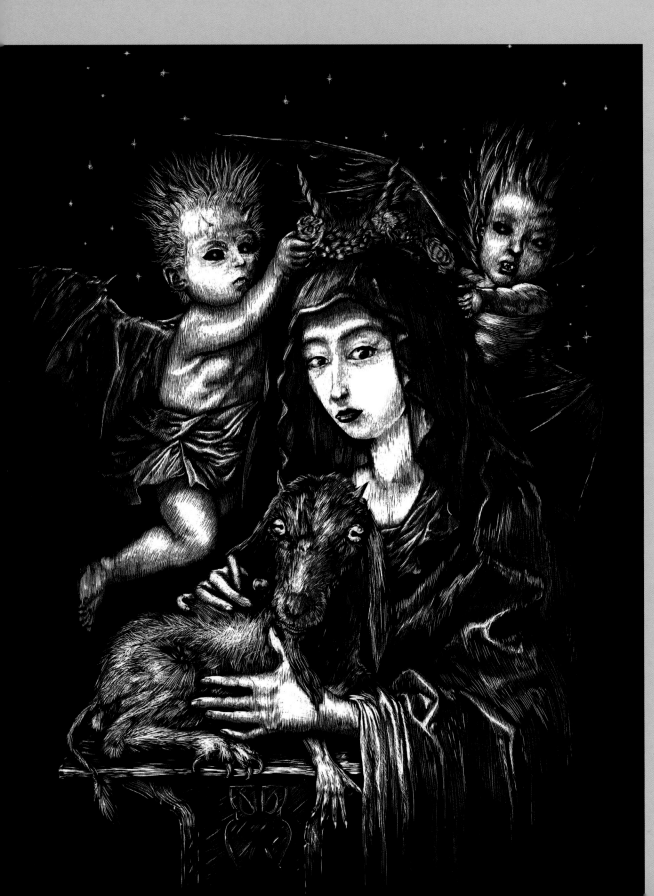

◀ **ID**
Myke Amend
Engraving on Ampersand Claybord
www.mykeamend.com

A symbolically heavy engraving on clayboard from Amend. The artist writes, "For her we sacrificed mortality – cheating ourselves of sunrise and of sunset, cheating ourselves of death and of life. Through centuries unaging we have worshiped Sophia, with science and with secrets . . . shepherding humanity in her name and in ours. The lambs we slaughter die for the good of the flock; who would keep the fold from the cliffs if we were to wither?"

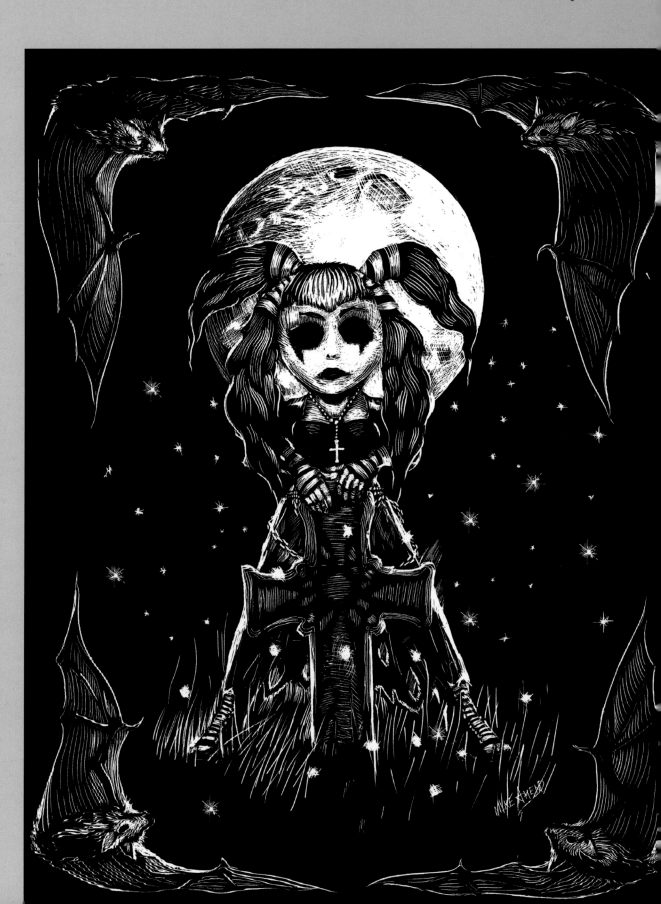

 Willow
Myke Amend
Engraving on Ampersand Claybord
www.mykeamend.com

*A corpse feeds on bodies from
an ancient cemetery in Willow.
"So much did I love my memory
of her, that I could not bear the
thought of what remained of her,
locked in the crypt, starving for
all eternity with the others.
I bound her, with the ancient
warding runes, within the confines
of our ancestral cemetery; there
she feasts at night on the marrow
of my once-hallowed forebearers.
My heritage, a lonely field of
shattered bones and turned
earth, this sad and broken shell
of a man will become her final
meal; this, my final reward,
for this horror I have brought
to the world."*

▶ **Eternal Life**
Greta James
Pencil sketch digitally painted
www.gretajames.com

An enchanting piece by Greta James, combining contemporary elements with traditional spiritual imagery. "Vampires are symbols of eternal life. They represent the understanding that there is something in our blood that is life-giving, everlasting, and ever-evolving. It is a sacred substance in our veins, has lived thousands of lifetimes, and will live a thousand more. For this piece, Eternal Life, I wanted to make an image similar to Tibetan Thangkas, one that represents this spiritual understanding, this million-year-old creature inside of us . . . this part of us that never dies."

► **Venus Flytrap**
Greta James
Pencil sketch digitally painted
www.gretajames.com

*A symbolic digital piece by James.
"The Venus flytrap is a beautiful
example of nature's vampire, a
magnificent carnivorous predator
inside the body of an unassuming
plant. The allure of the predator
Venus flytrap is irresistible to its
prey. Venus seduces the thirsty
creatures to take a drink from
the dew drops on her moist, fleshy,
red leaves, only to snap trap
it and suck the life essence
out of it."*

▶ **Demon Seed 01**
Augie Pagan
Acrylic, ink, and spray paint
on wood
www.augiepagan.com

*A horribly disfigured beast with
razor-sharp teeth opens its mouth
wide in Pagan's Demon Seed
01. One eye is nearly closed while
the other eye remains wide open,
most likely searching for a meal.
Only the grotesque head is shown,
planting a seed in the viewer's
mind that there is much more
to this foul archfiend. A vaguely
human presence is felt, but it is
plain to see that this brute is
much more beast than man.*

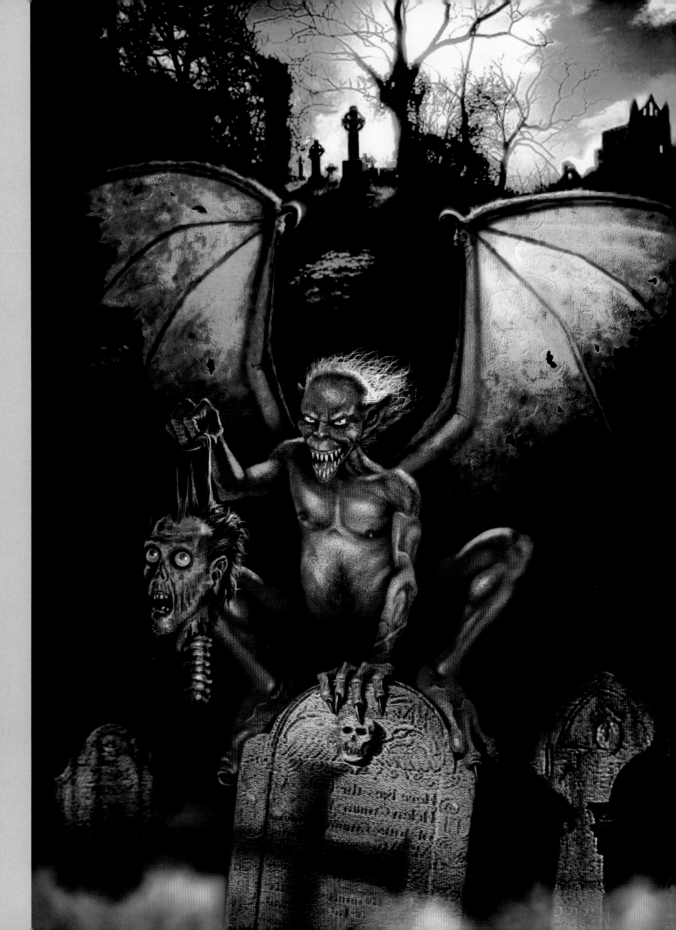

► **Demon**
Santos Garijo
Adobe Photoshop
http://nagualito.epilogue.net

Oh, this little perched freak is a real nasty! Smiling ludicrously while holding a human head in his hands, showing it off proudly, he demands the viewer's disgust. The green lights from behind are caught quite nicely in the translucent wings that stretch the entire width of this digital painting. "This was created in Photoshop. At the time I did not have a Wacom tablet, so as you can imagine it was a real test of my patience."

The Drop Dead Girl
Samuela Araya
Photography, acrylic,
and Adobe Photoshop
http://paintagram.blogspot.com

*A rather gory scene, artist
Araya describes his piece:
"It was inspired by a poem by
British writer/musician Dani
Filth. I tried to counterbalance
the gore (which is actually
an acrylic paintover) with a
static composition and with
the girl's expression (which is
an ex-girlfriend, who, as a
change, doesn't mind posing
as a decapitated corpse)."*

Dreams of Blood
Jarno Lahti
Digital photography
www.kaamos.com

Dreams of Blood *presents a
foul denizen of Hades, recently
released from its mortal coil, who
is either in anguish or ecstacy, or
perhaps a little of both? The
dreamlike reds encompass this
malignant soul and the teeth
protrude with drips of black
blood that roll just beside the
chin. Lahti sheds some light on
the character's thoughts: "Soon . . .
soon I'm ready. I open my eyes
and I can feel how my hunger
is growing stronger. Soon I will
rise from my grave and give
my first bite."*

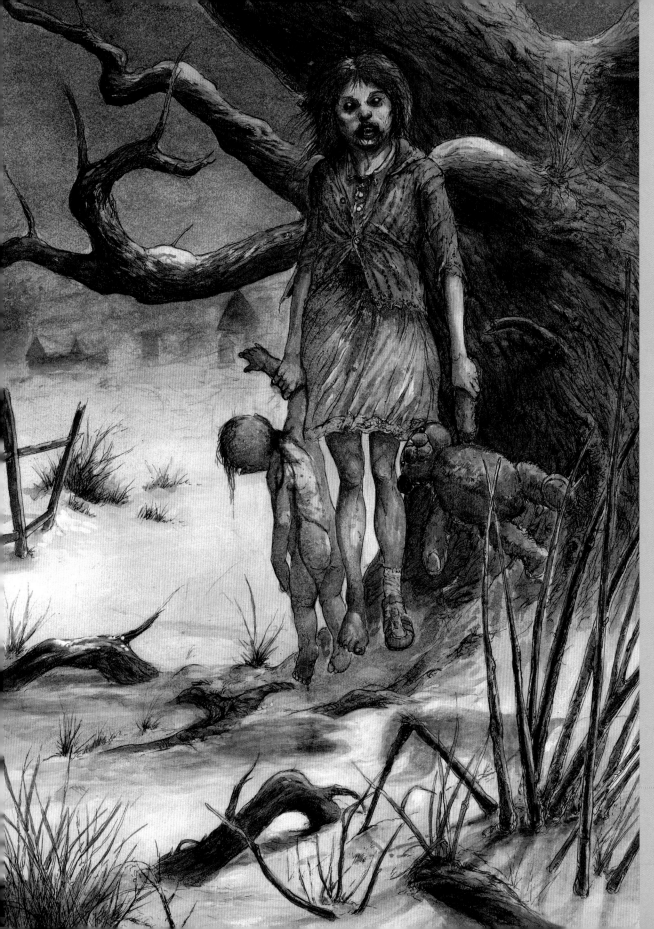

"*Stephen King's Salem's Lot
has always been my favorite
vampire story. Its depiction of
the vampire as a predatory
parasite rang truer than the
sexual predator archetype.
The most potent parts of the
novel involved the corruption
of The Lot's children. So when
approaching the illustration,
children had to be featured.
The baby victim, though brutal,
makes sense from a natural point
of view as baby animals are
usually the first to be targeted
by predators. The book also
features a very young victim,
and in the deleted scenes
this baby returns to feed
on his mother.*"

*A monstrous figure after a recent
attack on a defenseless victim
sneers in a grotesque smirk.
Light is pouring down through
the grates above showing the
gory crime in full view. This is
just one of the many creatures
that crawl through the realms of
Patrick Byers' imagination. The
Sewer Lurker stalks beneath the
city streets waiting to drink the
blood of his unsuspecting victims.*

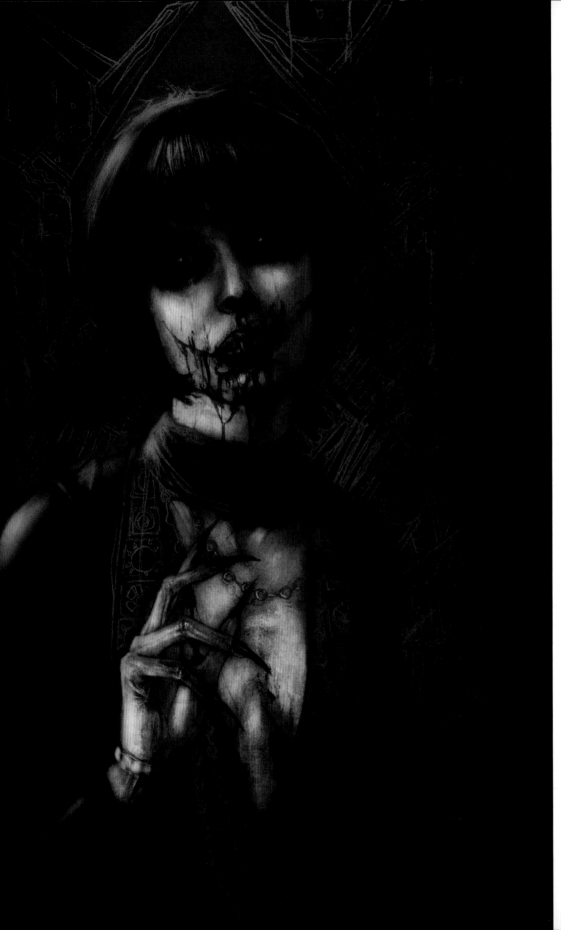

The Beautiful and the Dead
Mark Pexton
Pencil, Corel Painter X,
and PaintShop Pro
http://mark-pexton.daportfolio.com

*The undead girl in this piece
remains very centric as she cocks
her head just slightly. Her look
of longing and loneliness doesn't
seem to have been satisfied by her
last feed. The swirls and patterns
in the background suggest
a certain symmetry. Pexton
explains, "I wanted to give a
1920s Art Deco feel to this."*

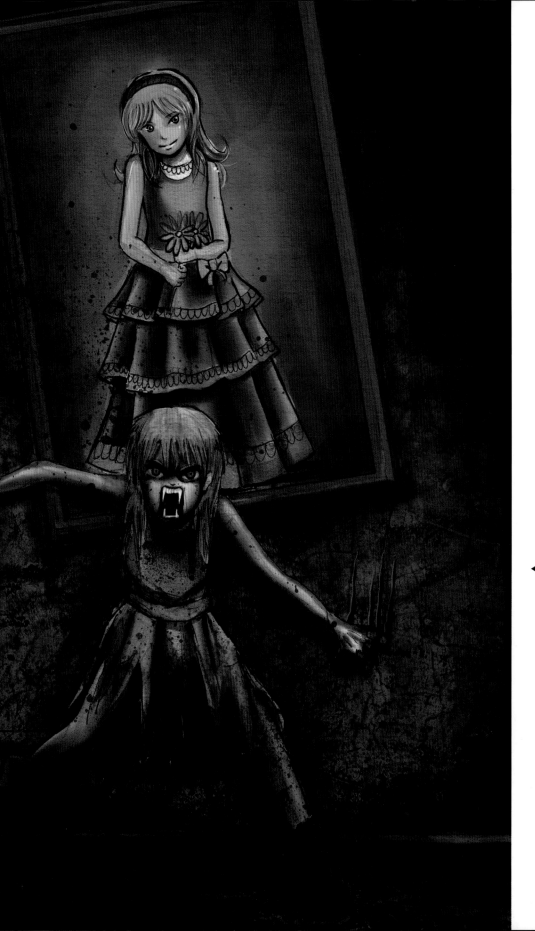

◀ **After and Before**
Fernando Santibáñez
Pencil sketch digitally painted
http://fasslayer.deviantart.com

After and Before *is a rather
tragic story as Santibáñez
describes: "When I created this
character I was thinking about
the contrast of life between
normal people and a vampire.
This is about a little girl who was
living with her wealthy family.
One day she and her family
were attacked by a vampire
clan which killed her parents
but decided to turn the girl into
a vampire. She lost her mind
because she was too young and
innocent to live that kind of life.
And now she has changed into
a ravenous vampire."*

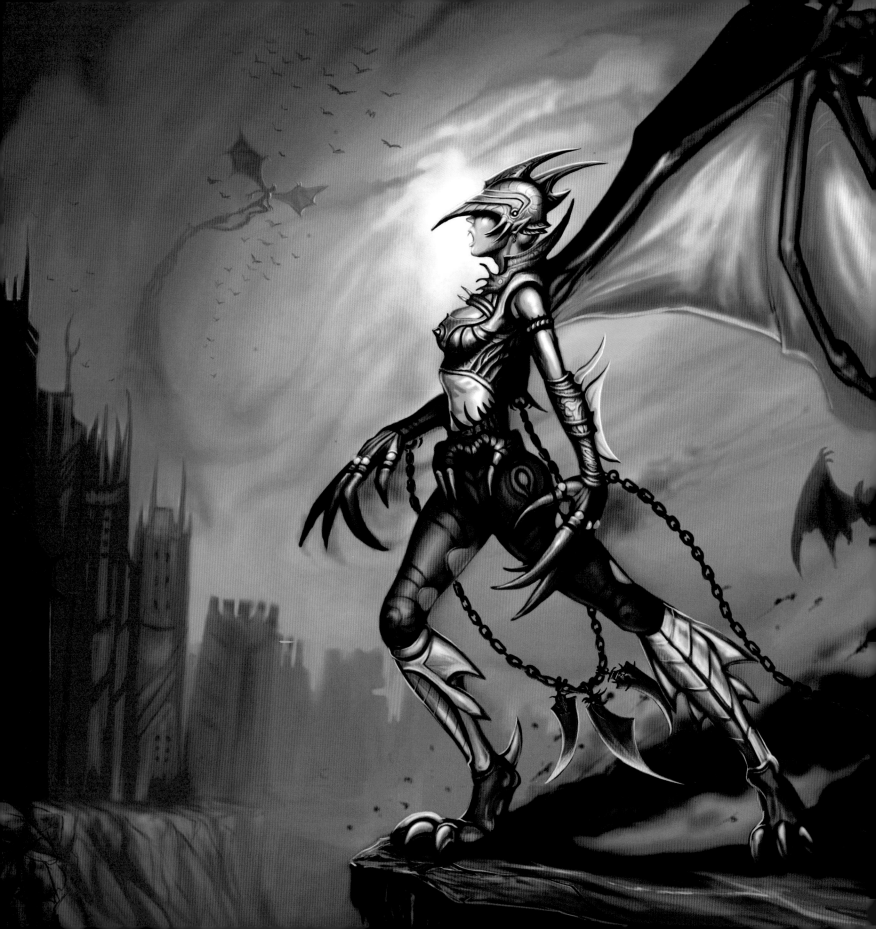

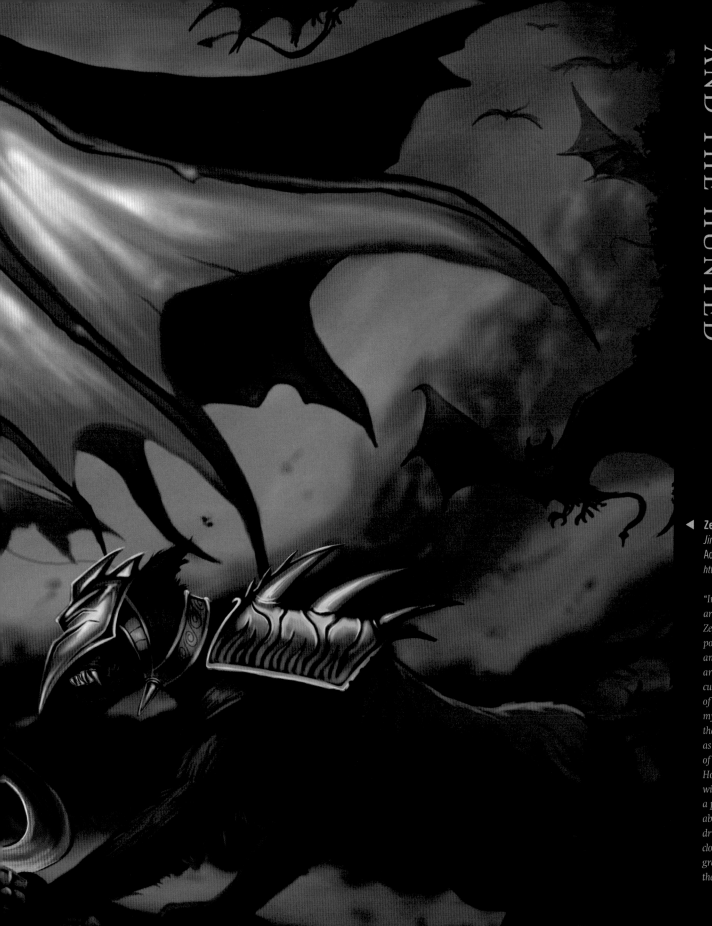

CHAPTER 5

VAMPIRE HUNTERS AND THE HUNTED

◀ **Zephyon Vampires**
Jimmy "Shino" Ling
Adobe Photoshop
http://dreadjim.daportfolio.com

"In all the lands of Vampra, non are as graceful and speedy as the Zephyons of the Vampires, whic possess distinctive feline bodies and wings. Zephyon societies are an interesting and unique culture. They nestle in the tops of homes and spires. Aloof and mysterious, but not cynical like the Dreadlords, Zephyons serve as scouts, transporters, and mos of all, deadly combatants of the House Vampra. They are blessec with extraordinary speed and a plethora of strange natural abilities. Zephyons are like the druids of Vampra, bonding closely with animals and creatin great creatures 'touched' by the flames of Vampra."

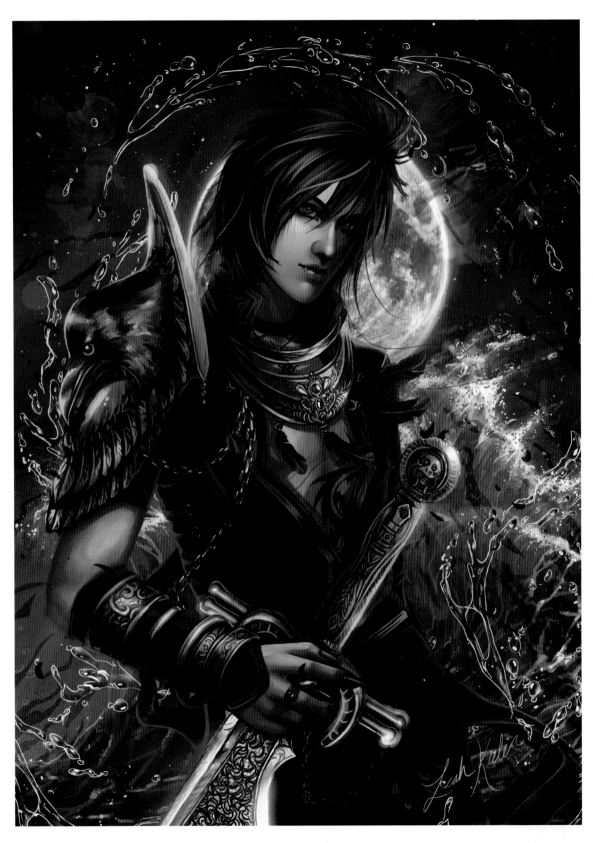

◀ **Golden Tempest**
Leah Keeler
Adobe Photoshop
http://keelerleah.deviantart.com

*"A personal painting I did
for myself of one of my own
characters. Since the character's
'theme' is ravens, I tried to
incorporate them into the
costume design and the overall
look of the work, from the gold
armor to the ghost raven flying
over the moon. This one really
was a challenge to design.
However, all the effort was
worth it as, to this day, this
is one of my favorites."*

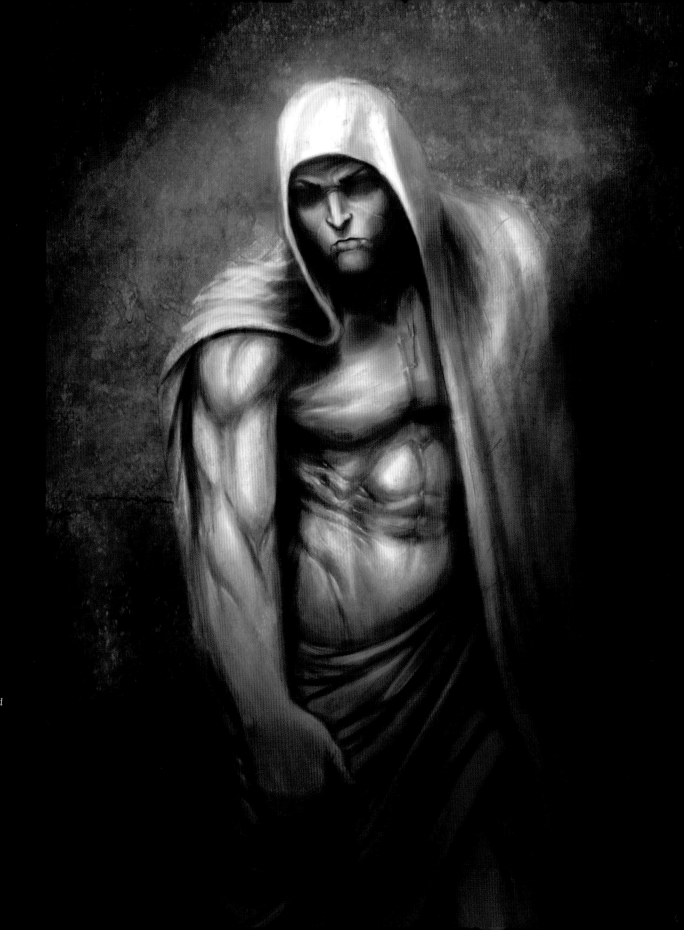

▶ **Rise My Son**
Julien Tainmont-Pierrat
Corel Painter
www.julientainmont.com

*Cold and dead, this once targeted
prey now comes back to life. In
folklore, vampires often enslave
their former meals and they
become hollow shells of the
things they once were. Julien
Tainmont-Pierrat uses this story
as a basis for* Rise My Son. *"In
this picture, done in Painter, I've
painted the corpse of a man as
the vampire who's killed him
comes back to the tomb to
claim his new slave."*

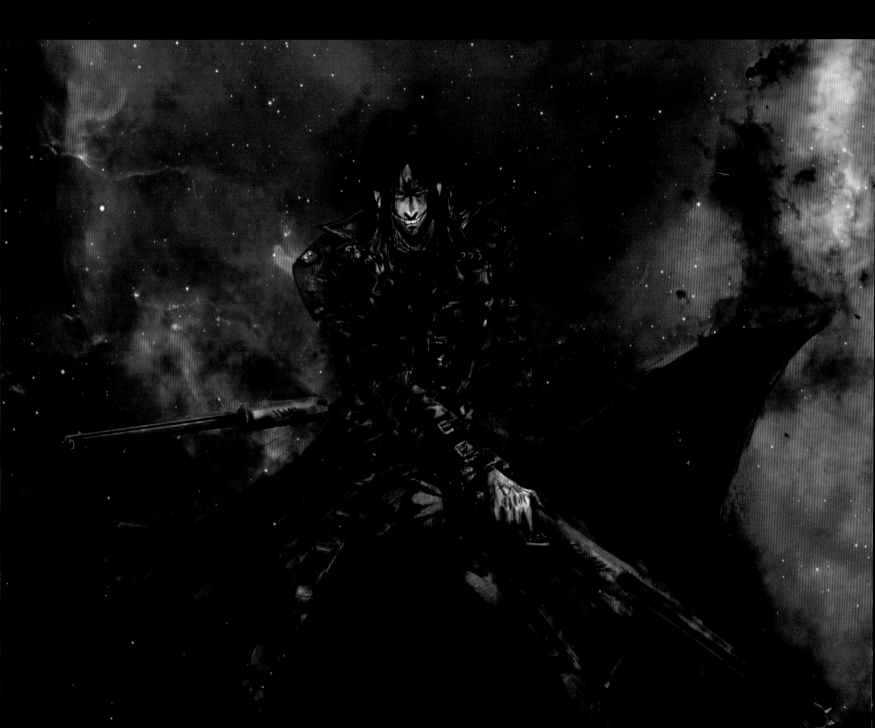

◀ Hitman Vampire
Fernando Santibáñez
Pencil drawing digitally painted
http://fasslayer.deviantart.com

Santibáñez created a lethal gun-for-hire character for Hitman Vampire. *"This is the kind of vampire who has a powerful nature and lives like an assassin. He is conscious about his power and he knows how to use it; he is violent and has no mercy. As a good assassin, he has developed his mental attributes and is incredibly fast and strong. As a result, he can use two shotguns at the same time. The line art was made with pencil and painted in digital media."*

▶ Vlad
Andrew Dobell
Adobe Photoshop
www.andrewdobell.co.uk

"Loosely based on the classic Vlad Tepes Dracula, here he is surrounded by his brides. This was created from scratch in Photoshop, from sketch to finished artwork. Even though there are three figures in this image, I kept the focus on the top figure by creating the area of greatest contrast around the man's head, using black hair against a red sky."

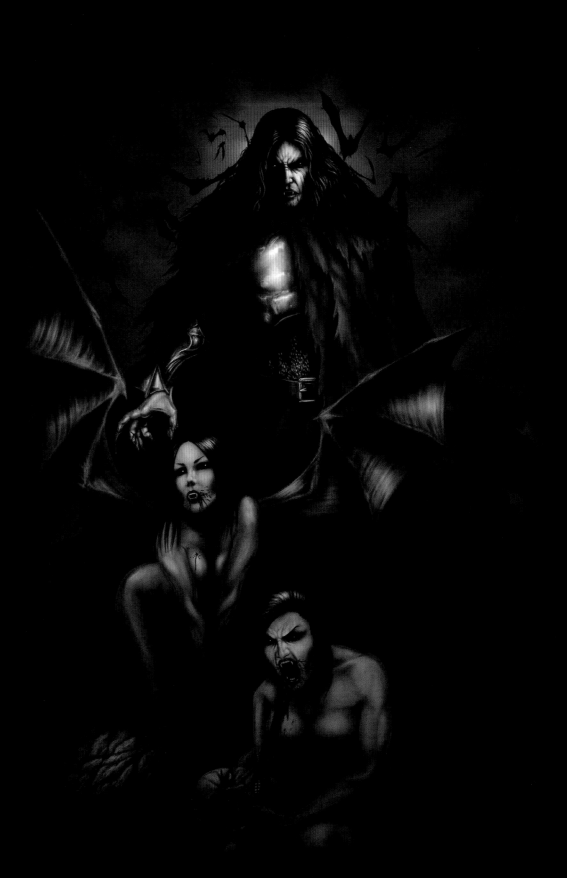

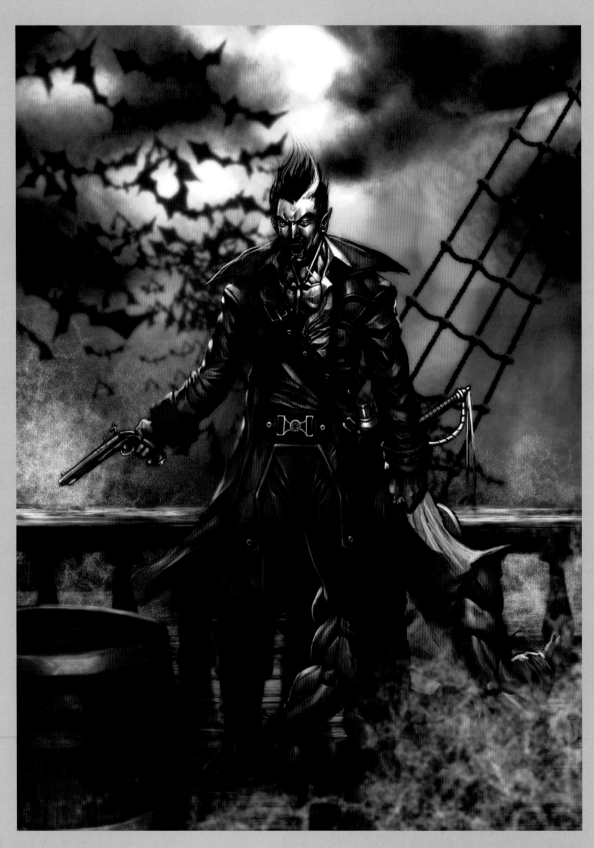

◀ **Vampirates**
Samuel Donato
Adobe Photoshop
http://dxsinfinite.deviantart.com

There is no doubt this sea-dwelling captain is one of the most fierce to ever sail the seven seas! He is wearing all the fancy clothes we associate with piracy, complete with a sword and a pistol by his side. The bats flittering in the distance and the sun not anywhere in sight turns what could be just another nautical scene into an amalgamation of two stylish genres. "This piece was made for an Art Jam challenge, entitled 'vampirates.' The idea was that the pirates are sailing not after treasure but for food, for blood."

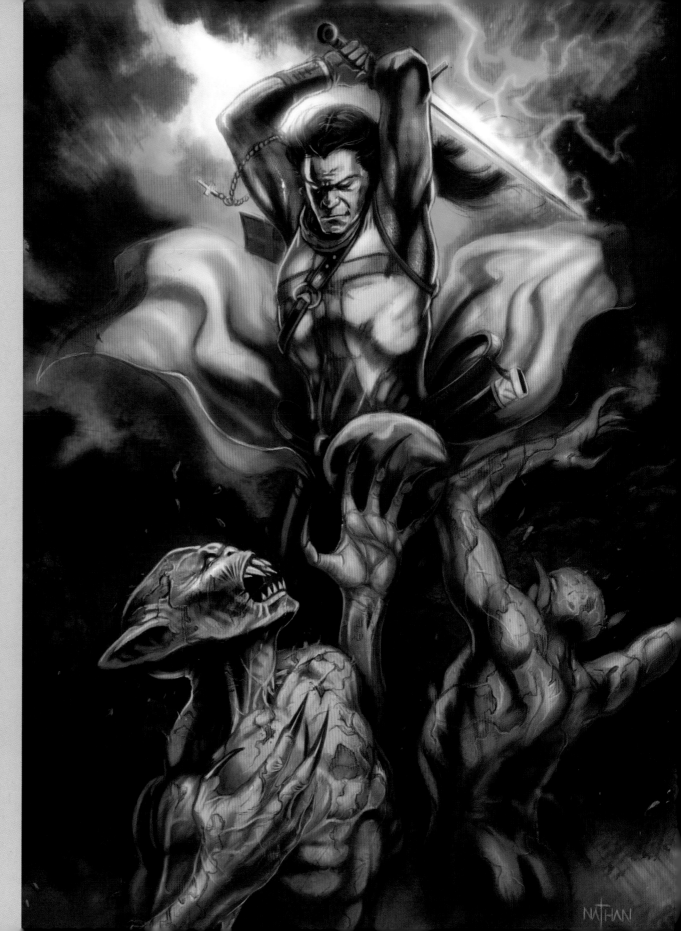

Vampire Slayer-Divine Weapon
Nathan Rosario
Digital painting
http://ancientearthstudios.com

A powerful warrior leaps in midair attempting to deliver a killing blow. "For this illustration, I wanted to show a vampire slayer, in this case, a knight, wielding a divine weapon. This gave me the opportunity to create interesting lighting on the scene, as well as show the effect that the weapon has on the creatures. The idea is that as the weapon emanates power, the very light coming from the sword begins to burn away at the vampires just as if they were exposed to daylight."

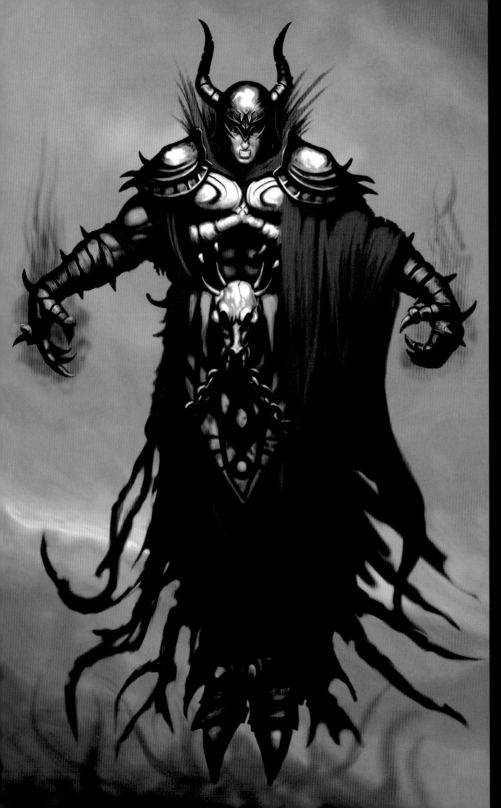

◄ **The Fearsome and Cunning Dreadlord**
Jimmy "Shino" Ling
Corel Painter and Adobe Photoshop
http://dreadjim.daportfolio.com

"The Dreadlords thrive on fear; they relish the sight of mortals trembling and fainting in utter horror, which they absorb as part of their energy. Dreadlords are a peculiar caste of vampires. They tend to levitate around the battlefield draining the life and souls of humans, as they chase down powerful heroes and warriors crying for help. Nothing satisfies the Dreadlord more. They convert enemies to their own kind, with blood spilled from a distance as they slowly drain their lifeforce. This piece was done in Painter, and then touched up in Photoshop with a Wacom Intuos tablet."

 The Punishment
Sabrina Tobal
Adobe Photoshop
http://sabrinanime.over-blog.com

Even vampires must deal with adversity and misunderstandings. The sunlight rips through her soft flesh, yet hooded figures allow the torment to continue. Her eyes are wild and her arms are bound to her back. Her flesh smokes from the sunlight — one of the few things that can harm a vampire. This digital painting was created in Photoshop by Sabrina Tobal, who succinctly sums up this tragic character's story: "A woman is sentenced to die because she's different."

◄ **Kolchak Annual**
Woodrow J Hinton III
Kolchak: The Night Stalker
© Jeff Rice,
published by Moonstone Books
Mixed media on Strathmore
Illustration Board, digitally
colored in Adobe Photoshop
www.wjh3illustration.com

"This was my first of several
Kolchak covers I created for
Moonstone Books. My father
got me addicted to the irreverent
anti-hero from reruns played on
the Sci-Fi Channel, so I jumped
at the opportunity to collaborate
on The Night Stalker lore.
This cover showcases two tales;
the first story has Kolchak
coming face to face with Dark
Shadows' notorious vampire
Barnabas Collins, as you can
tell from the painting over
the mantle."

▶ **The Hunters**
Sara Cappoli
Pen and India ink on paper
and digital touches
http://thewitchspell.deviantart.com

*Crosses, stakes, and unwavering
faith are the tools of the trade as
undead hunters bravely battle
an unseen foe in Sara Cappoli's
piece.* "For this, I wanted to
create an image seen from the
point of view of the vampire.
Black, red, blood-stained clothes,
and foolish stares are often used
to depict the vampire: this time
I overturned the trend, trying to
depict the hunter as cruel and
menacing as the vampire is."

◀ **Nosferatu's Attack**
Fernando Santibáñez
Pen and digital painting
http://fasslayer.deviantart.com

This line art piece depicting a tragic monster was made with pen and painted digitally. "This vampire has assumed the nature of a monster. He lives in dark and hidden places, because he doesn't feel confortable having contact with people. He lives just to survive and drinks all kinds of blood, not just human blood. He is not an excessively violent or evil vampire, but he doesn't want to be bothered, and can get violent if someone tries to touch him."

▶ **Urban Ninja**
Gracjana Zielinska
Adobe Photoshop
www.vinegaria.com

An armed undead ninja complete with tattoos! "This piece was done originally for my friend Taylor Holloway's 'The Living Dead' project. I wanted to depict a girl who's a bit insane, not really alive anymore, but not yet dead either. She is also a bit funny — a tattooed girl running with a katana in the early morning mist through a ruined city? I would enjoy watching a movie with her, preferably directed by Quentin Tarantino. That surely would be a nice one."

◄ **Vampire Mikael**
Neil Que
Adobe Photoshop
http://daa-truth.deviantart.com

In this piece, a freakish smile takes center stage as the winged barbarian revels in all his bloody glory. His twisted expression shows no inkling of compassion or mercy. Ancient symbols and crosses litter the landscape in the foggy red background. "One of my first takes on a wild vampire for the present day. I wanted to show a vampire that's wicked, out of control, and unrelenting. This piece was done completely in Photoshop."

Vampire Alexandria
Neil Que
Pencil and Adobe Photoshop
http://daa-truth.deviantart.com

*An aura of death and gloom
dominate in this dramatic piece
spotlighting a lonely villainess.
Que describes his image: "My
representation of one of the
oldest vampires in existence.
This piece was done in pencil as
line art then colored in Photoshop.
I used the same brush techniques
as when I used to paint with oils
or acrylics. I've also used a
monochromatic color scheme
to add age and darkness to
the piece."*

◄ **In a Glass Darkly**
Patrick Jones
Painted for "Carmilla"
from *In a Glass Darkly*
by J. Sheridan Le Fanu
Corel Painter
www.pjartworks.com

Bats surround a possessed undead character in this nightmarish piece by Patrick Jones. Is she falling or is she flying? The lack of any solid ground conveys a sensation of imbalance, but this fang-bearing phantom seems right at home in the air. Jones has used Painter's Oils and Oil Pastels to great effect. The artist shares some insight: "Painted for the story 'Carmilla' from J. Sheridan Le Fanu's collected stories, In a Glass Darkly. *Considered to be the greatest vampire story ever told, it was also the inspiration for Bram Stoker's* Dracula."

► **No Defence**
Anne Yvonne Gilbert
Featured in *Vampireology*
by Templar Publishing
Acrylic
www.yvonnegilbert.com

With a crucifix in hand, a fearful man takes a stand in Gilbert's No Defence. *"In this illustration we are looking at the victim through the monster's eyes. He is bravely holding his only defense, the crucifix, but his doubt and fear are clearly visible in his expression. The art director, Nghiem Ta, asked for a direct, more graphic approach, hence the limited color palette and comic book perspective. The overall aim was to take Victorian subject matter and inject it with more modern values."*

◀ **Vampire Abduction**
Samuel Donato
Adobe Photoshop
http://dxsinfinite.deviantart.com

The drama in this image is helped by a dramatic puncture wound in the neck of this lifeless, doll-like victim, and further down the neck there seems to be postmortem coagulation. The cause of this horror still holds the lifeless body in his arms, presenting her proudly. The two remain draped in perfectly clean clothing, not marred at all from the earlier altercation. Donato says that he was: "Just illustrating a classic scene, where the vampire is in front of a window, holding his prey, with the wind-blown effect of the curtain."

Welcome to Hell
Ein Lee
PaintTool Sai and Adobe Photoshop
http://einlee.net

Flames dance around wildly as a cutie with glowing eyes draws her sword. Airborne citizens of this apocalyptical madness circle around a tower that reaches high into the sky. For centuries, scholars have hypothesized the existence of hell. Welcome to Hell by Ein Lee may shed a little light. "Raven is giving visitors a warm welcome. The picture is entirely digital: the sketch, inks, and colors were done in Sai, and the post-processing in Photoshop."

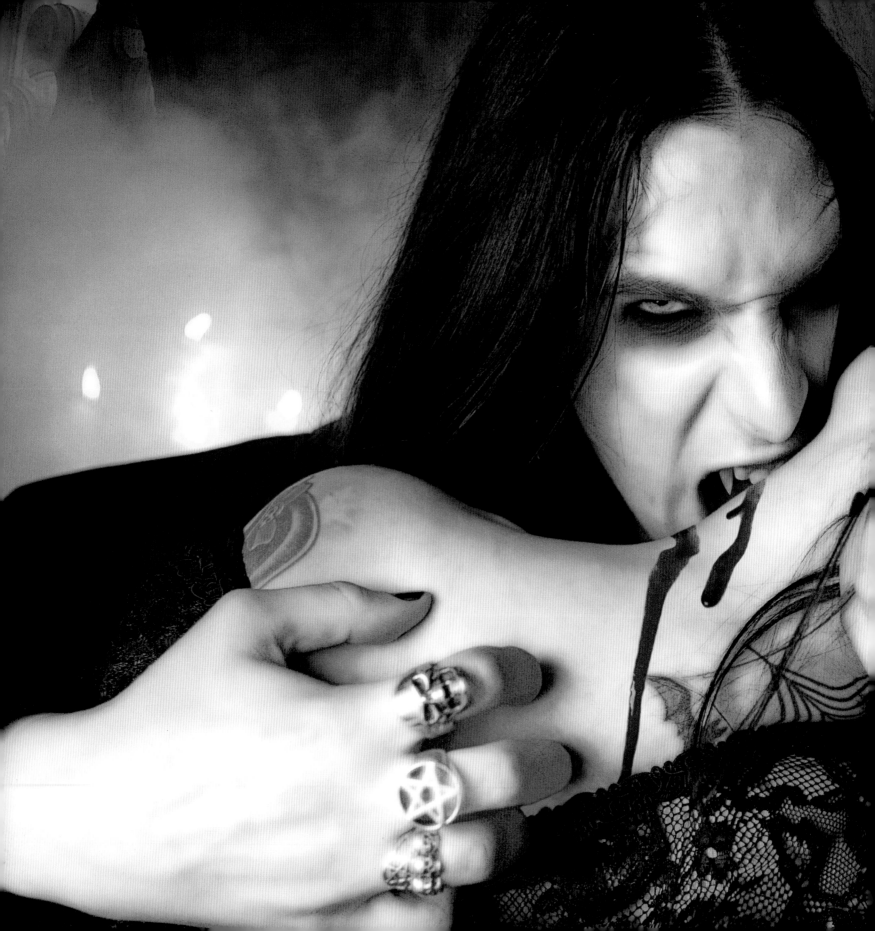

CHAPTER 6
UNDEAD IN THE DARKROOM

◄ **Carpathian Kiss**
Avelina De Moray
Photography and Adobe Photoshop
www.avelinademoray.com

*"Here's one for the ladies!
This artwork has been digitally
edited and drawn on using
my Wacom Intuos tablet. After
staging a four-hour photo shoot
with my beautiful gothic models,
and choosing the best out of 600
photos, I then drew over the top
of the photograph to enhance the
image's detail and depth of field.
The original background has
been replaced with drawn gothic
archways. The candlelight has
been enhanced, and all shades
of reds have been removed with
filters, which were then added
back in around the vampire's
eyes and where the blood is
dripping down the victim's neck
using masks in Photoshop."*

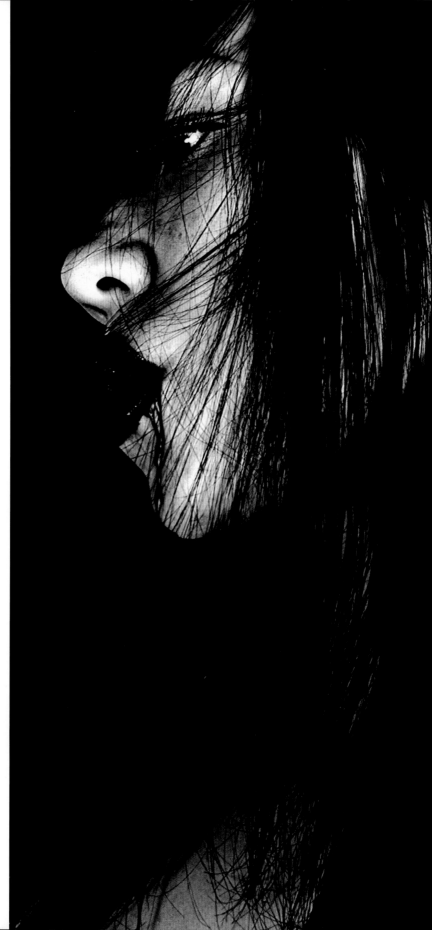

◀ **Elivan**
Viktor Koen
Featured in
Rabid Rabbit Issue 12
Photography and digital
manipulation
www.baranyartists.com

"Elivan *is a multilayered
digital mix of original
photography, vintage family
photos, textures, and ink
splashes. The source materials
are mostly color tinted onscreen
and shadowed dramatically
for a better effect and stronger
overall mood. The character and
composition is inspired by
F. W. Murnau's 1922 classic*
Nosferatu: A Symphony of
Horror, *in my mind a hard act
to follow even now. The image
is part of a two-page graphic
novel treatment titled* Hell-o-
Kitty *for the award-winning
comics anthology* Rabid
Rabbit Issue 12."

▶ **Sinful**
Leslie Ann O'Dell
Photography and Adobe Photoshop
www.shyble.com

*This godless creature is
rethinking her very nature in
this morose piece by Leslie Ann
O'Dell. The black and white
palette portrays a sort of dual
nature, as is common with
vampires. The piece was
created using a combination
of photography and heavy
textures in Photoshop. O'Dell
describes the image as,* "a
portrait of a sensitive female
vampire caught in the moment,
thinking of her latest victim.
She is questioning what she
has become."

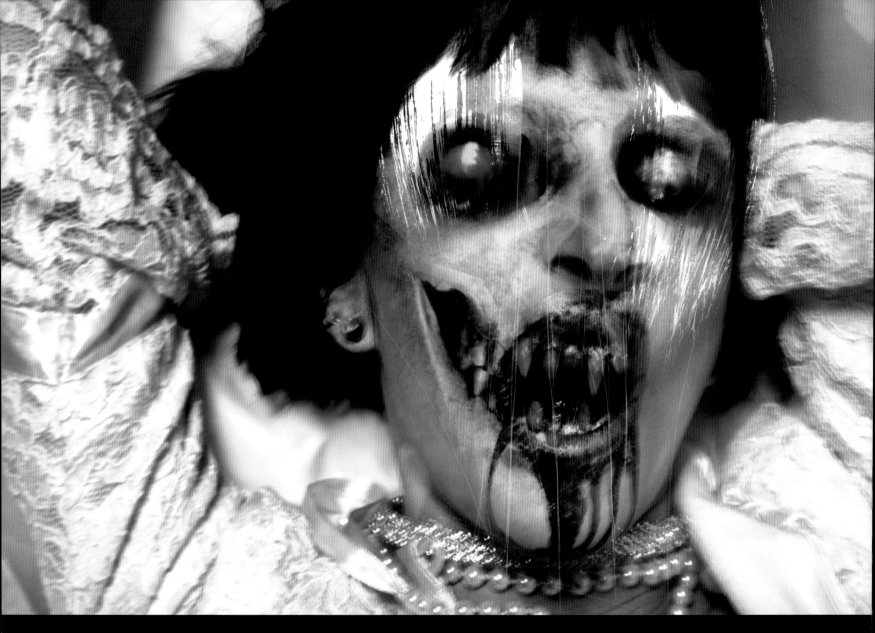

▲ **Awakening II**
Ralph Manfreda
Adobe Photoshop
www.cryptonaut.com

Blood, lace, and fangs prevail in Ralph Manfreda's Awakening II.
*The gash in the face of this figure proves quite disturbing as traces
of an earlier meal pour out sloppily all over her chin. The unearthly
eyes focus on nothing in particular as the hideous creature poses with
mouth agape. She wears a white dress in what could be considered
a mockery of its connotations, for there is nothing pure about*

▶ **Feeding**
Ralph Manfreda
Adobe Photoshop
www.cryptonaut.com

Manfreda has created a truly sinister image in his piece titled Feeding.
*The long fangs and lips are covered in blood as this rogue laps it up from
her dinner plate. The glowing eyes stare with an otherwordly predatory
feel. The pearl necklace hanging down beneath the feeding plate is just
one of a few signs that suggest this wretched thing was once human.*

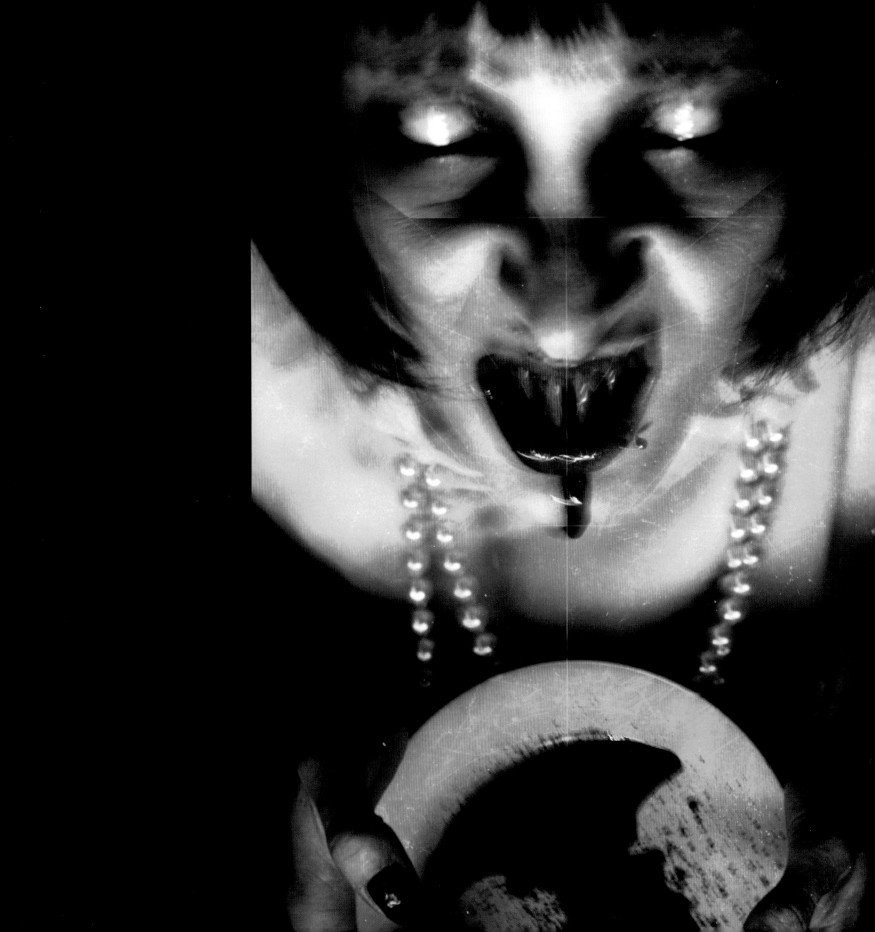

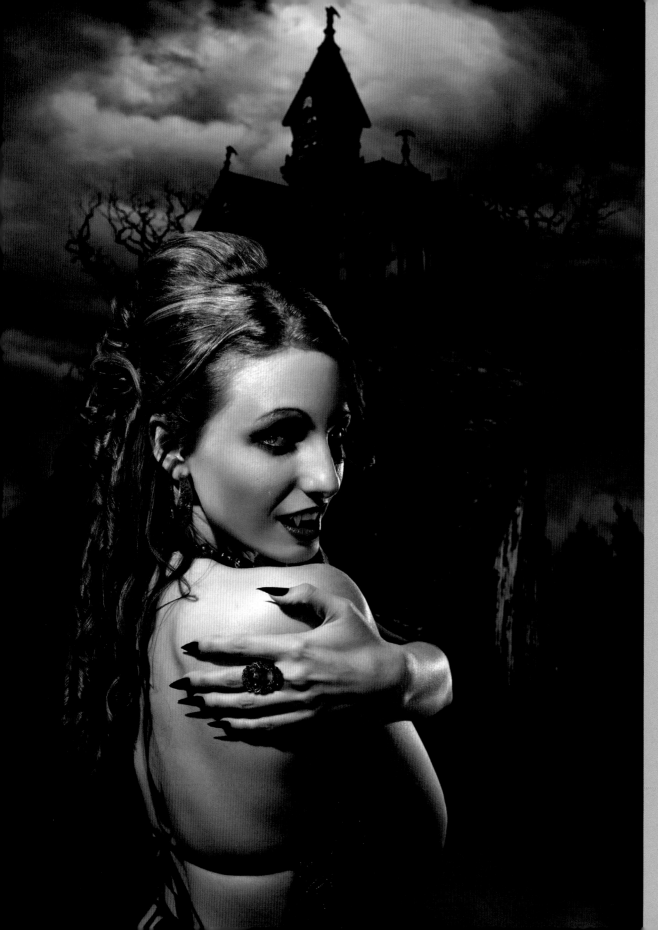

Die Nächtliche
Michael Park
Digital photography
www.darkartdesigns.com

An alluring femme fatale stands in the shadow of an ancient castle in Michael Park's Die Nächtliche (English translation: "The Nocturnal"). "Vampire Duriel is depicted in this scene; she is a newly born vampire made from one of the most sacred and ancient clans, the clan which Lilith started somewhere around 700 BCE. She was made to provide her master with fresh victims in his mansion in the sky. The mansion was built high upon a steep mountain and the only way to get to it is by flight. Human victims cannot resist her exquisite beauty . . . she is truly to die for."

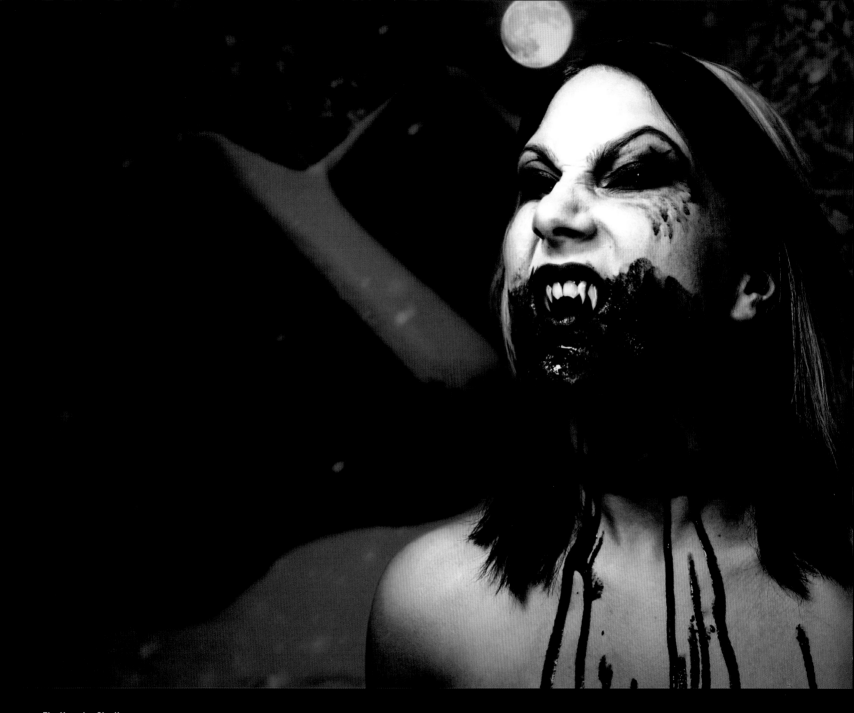

▲ **The Vampire Skadi**
Michael Park
Digital photography
www.darkartdesigns.com

*A horrifically gruesome image from Park. "No one really knows how old
Skadi truly is; she woke about a hundred years ago with no recollection
of her past. She is called Skadi because that is what was etched on her
tomb. She can easily control the weather, which comes in handy when*

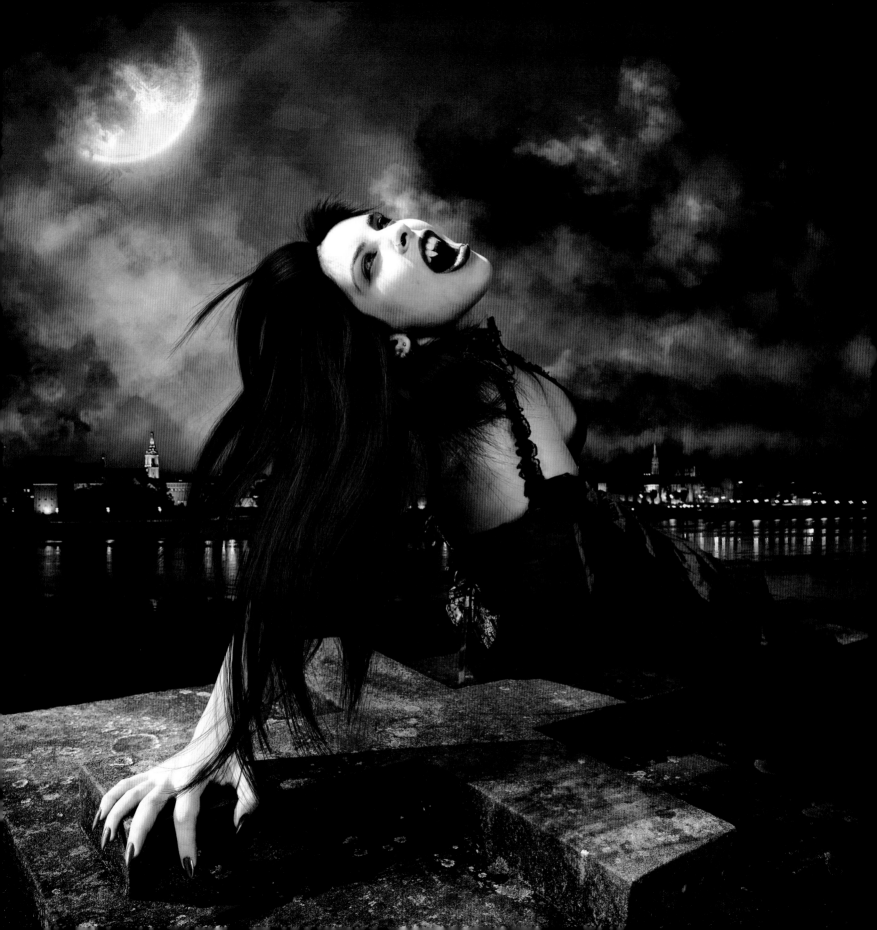

◀ **The Turning**
Avelina De Moray
Photography and Adobe Photoshop
www.avelinademoray.com

A clawed femme fatale basks in the glow of the midnight moon. "This photo was taken at Sydney's infamous Rookwood Cemetery. I have removed the original cemetery background and cropped around the model using a mask in Photoshop. I redrew her hair with my Wacom tablet and edited in the drawn London-esque cityscape. The claws and fangs were digitally drawn as was the large full moon. The red color scheme gives this piece an 'apocalyptic' vibe."

▲ **Lurking**
Leslie Ann O'Dell
Photography and Adobe Photoshop
www.shyble.com

This image of a black skinned demoness staring out from the darkness both captivates and shocks. The contrast of light and shadow are used effectively. The veins in her eyes appear dramatically stark as pupils surrounded by unnatural colors haunt the intended victim in O'Dell's Lurking. O'Dell describes her character: "A close-up portrait of a haunted vampire who lurks in the shadows. She hypnotizes her victims with a powerful gaze."

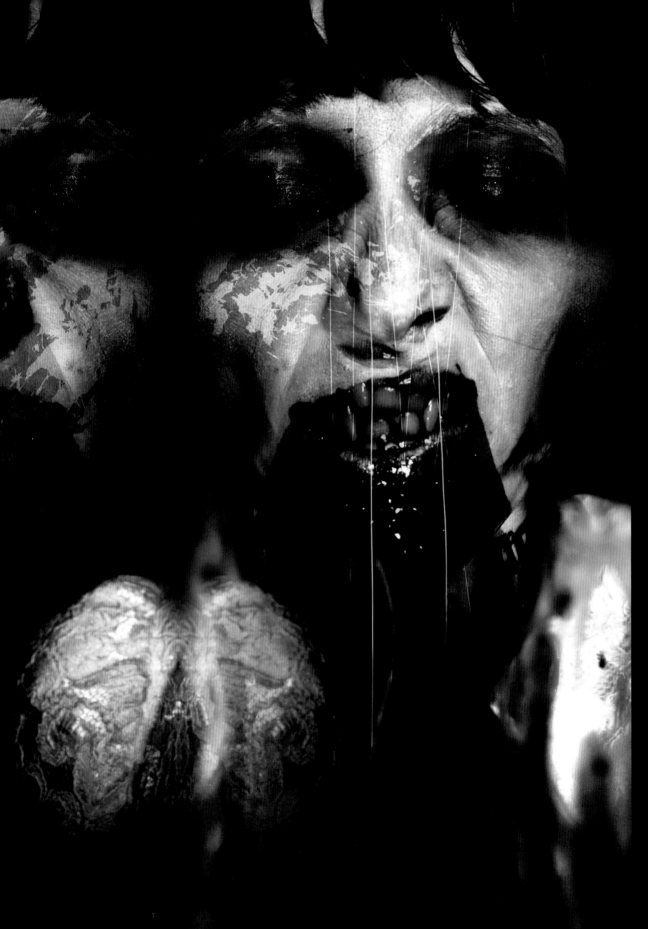

Satisfied
Ralph Manfreda
Adobe Photoshop
www.cryptonaut.com

This ghoulish work by Manfreda features a bloodsucker who appears to be finally full. Her choice of food is caked all over her pale, distorted face.
To one side we see a partial reflection, incomplete and broken. She creates a mere semblance of humanity and tries to share a smile. The deranged eyes are relaxed and there is a striking contrast between the pale skin and dark red blood.

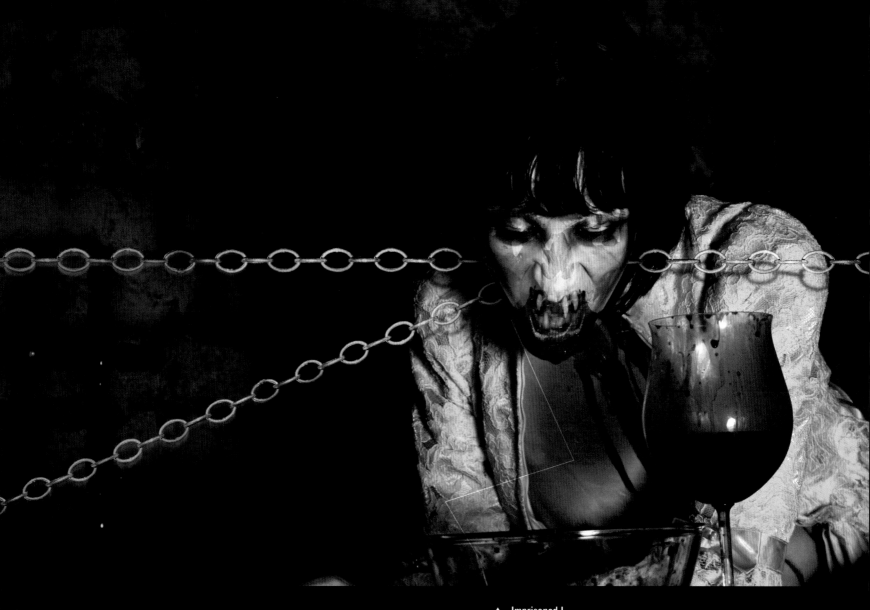

▲ **Imprisoned I**
Ralph Manfreda
Adobe Photoshop
www.cryptonaut.com

*We find this horrible haunt bound and chained in this twisted
image by Ralph Manfreda. Growling and clearly unhappy, she
has been chained here without her permission. Her glass of blood
remains in the foreground — perhaps just enough to keep her alive?
This captive's look of distrust and hate is enough to unsettle the
most ironclad stomach.*

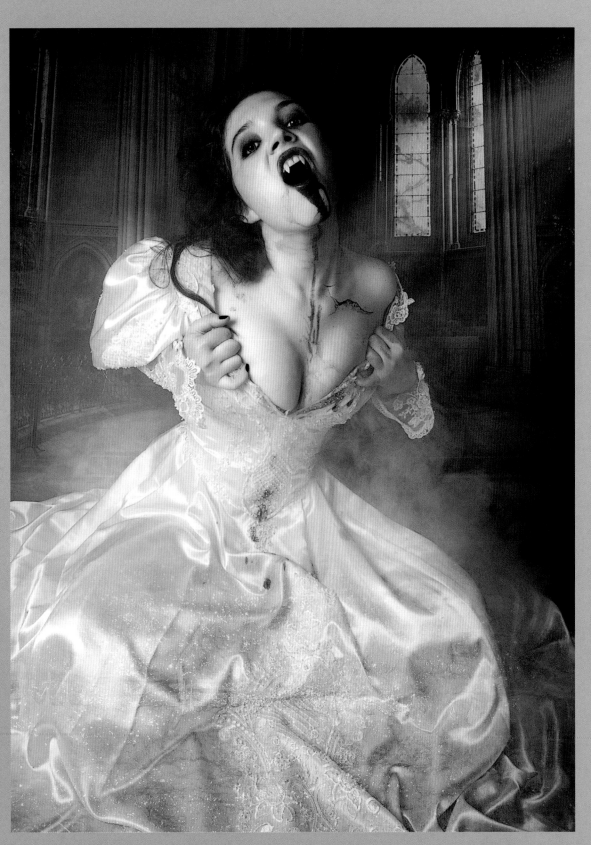

The Deadly Departed
Avelina De Moray
Photography and Adobe Photoshop
www.avelinademoray.com

Fraught with dramatic symbolism and gothic imagery, a beautiful temptress clutches her dress in De Moray's The Deadly Departed. *"This is the second piece from my 'Lucy Westenra' series. I staged a vampiric photo shoot for this artwork, and then drew the background, blood, and her makeup with my Wacom tablet. Many of the colors have been removed from the original photo to enhance the coldness of the image, and the lifelessness of Lucy. The blood on her face and chest has been brightened to draw attention to her mouth."*

Ready to Born Again
Jarno Lahti
Photography and
digital manipulation
www.kaamos.com

Completely wrapped in a world of crimson, a lovely maiden sleeps . . . or does she? Her arms are crossed in a solemn fashion as if she were the corpse at a funeral. The position of the neck and upward lift of the head give a suggestion of an ascension. The bite marks on the neck give a hint to her doom. Lahti summarizes his character's fate: "I will end my life as a feast for a blood hungry creature and now I'm soon becoming one myself. I close my eyes, I can feel how life is slipping away."

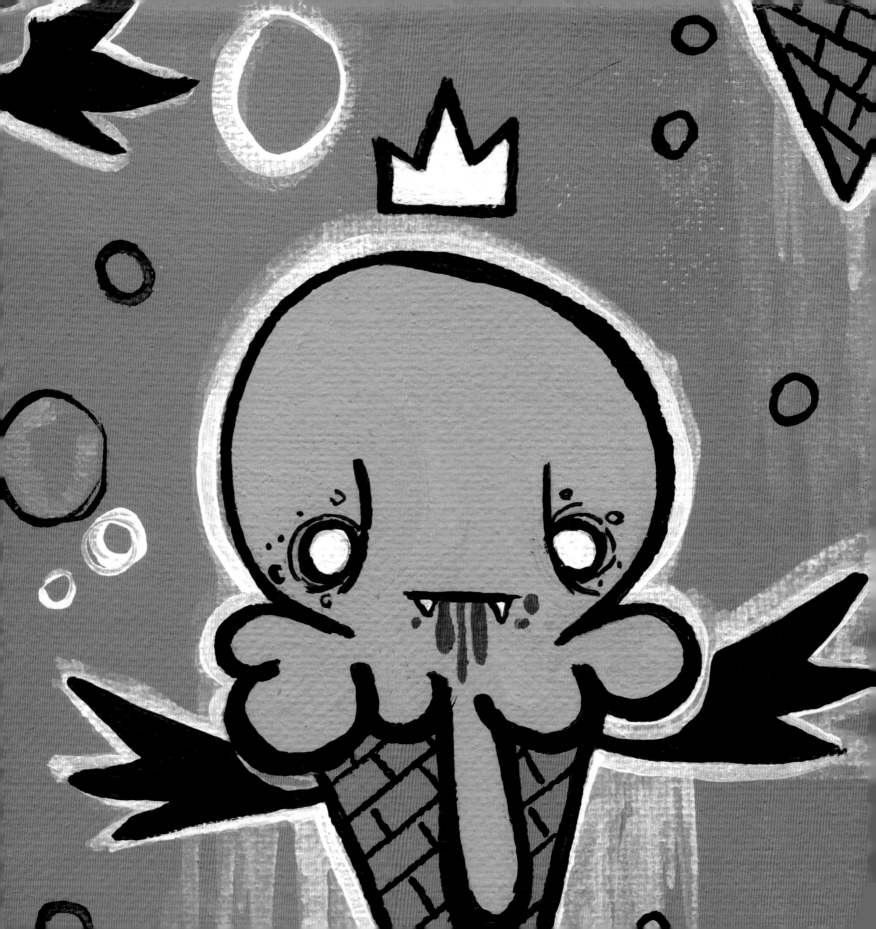

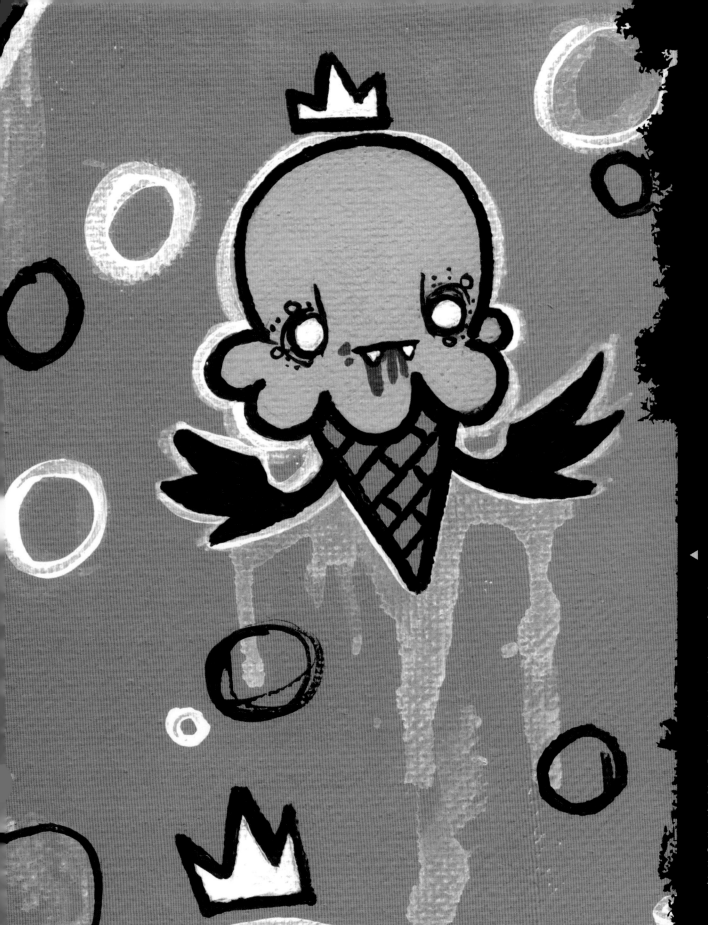

◄ **Blood Thirsty Winged
Ice Cream Cones**
Emi Boz
Ink, acrylic, resin, watercolor
http://creepalicious-inc.com

*"This is the result when a
vampire isn't careful with
what they bite. The Vampire
Ice Cream Cones seek out their
master and make more minion
ice cream cone ghouls along the
way. The more minions, the
more they must feed! Ice Cream
Cone flesh no longer does it for
the horde, so they've turned to
human blood. The only way to
put a stop to the Ice Cream Cone
Vampires is to set a trap, catch
them, and melt them alive; that,
or eat them quickly and suffer
the worst brain freeze of your
pathetic human life!"*

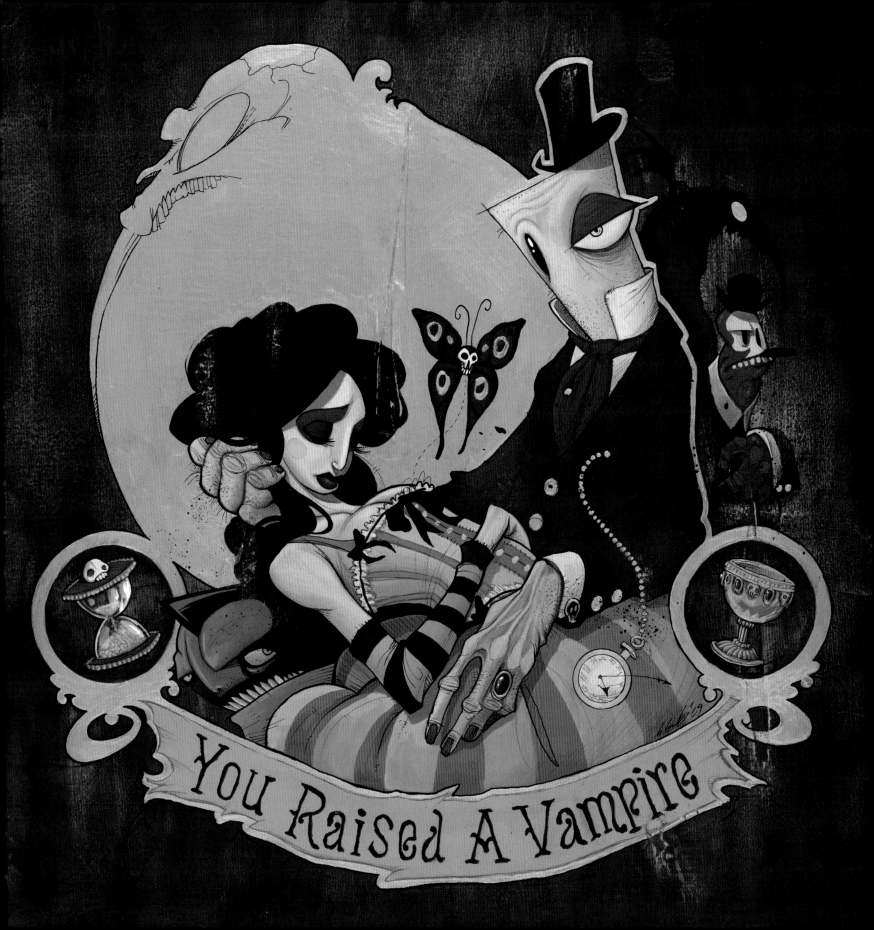

You Raised A Vampire

◀ **Red Stained Lips**
Krisgoat
Digital illustration
www.krisgoat.com

Krisgoat has created a lovely digital scene depicting a young vampiress surrounded by roses. Krisgoat explains, "I designed this illustration in honor of this book! I wanted to create a lovely young vampire drinking a fine glass of wine? Or . . . something else? I like to stay slightly vague for the benefit of wild imaginations."

▶ **Lady Moonlight**
Krisgoat
Digital illustration
www.krisgoat.com

*A maiden journeys out at night
in Krisgoat's digital illustration.
The cemetery is a very gray scene
that really makes the blood-red
color the focus of this piece.
"Lady Moonlight was inspired by
my friend's original character.
Her long tattered dress sweeps
the gravestones on her lonely
walks through the cemetery.
Her only companions are the
bats who flutter like leaves
in the moonlight."*

▶ **Innocent?**
John Battelle
Digital illustration
http://vampireofkhorne.deviantart.com

"This picture was inspired by the classic idea of vampires not visibly aging with time; those who are turned, while they always look young and innocent, in actuality are blood-thirsty monsters. I often use this style of background; drawing it only so far, with bits disappearing then fading into white towards the edge. It prevents the background from stealing the viewers' attention from the character, while still providing the context of their surroundings as well as a nice edge to the drawing."

◀ **First in Flight**
Delphine Lévesque Demers
Acrylic, ink, and colored pencil
on Bristol paper
www.zerick.com

Unaffected by a fear of heights, this winged villain sits high above the city indulging on a late night treat. According to Demers, the image was "inspired by a dark, cold night in the beautiful city of Charlotte, North Carolina (as shown in the background). This vampire is enjoying a well-deserved rest by the city lights, having a sip of his latest victim."

◀ **Little Vampire Girl**
Sara Cappoli
Pen, white tempera paint,
and India ink on paper
http://thewitchspell.deviantart.com

Vampires clearly don't play nicely with others! Mixing the sweet and innocent with the gory is always an excellent recipe for giving one 'the creeps' as displayed in Little Vampire Girl. *"A cute little girl playing happily with her doll, after a good breakfast . . . Oh yes, her breakfast was a man though! This image is somewhat based on opposite extremes: black against white, a young girl next to a dead body. Actually, the vampire girl is a paradox itself, because we see a baby, but maybe she's 100 years old inside!"*

▶ **Big Game**
Sara Cappoli
Pen, white tempera paint,
and India ink on paper
http://thewitchspell.deviantart.com

Two armed men stand over a fallen creature of the night in this black and white image. The once frightful ghoul seems pitiful as it dies, twitching with a stake in its back. "This image is based on the old big question: who is more brutal, the hunters or the beast they prey on? Sometimes people feel free to kill, or to behave as supreme judges, just saying that they do it for a righteous purpose: actually, they're as monstrous as the monsters they want to punish."

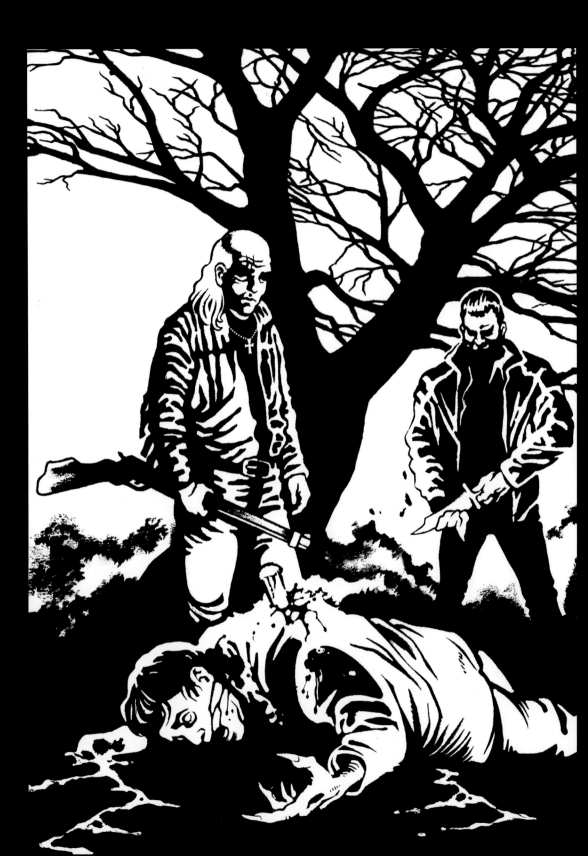

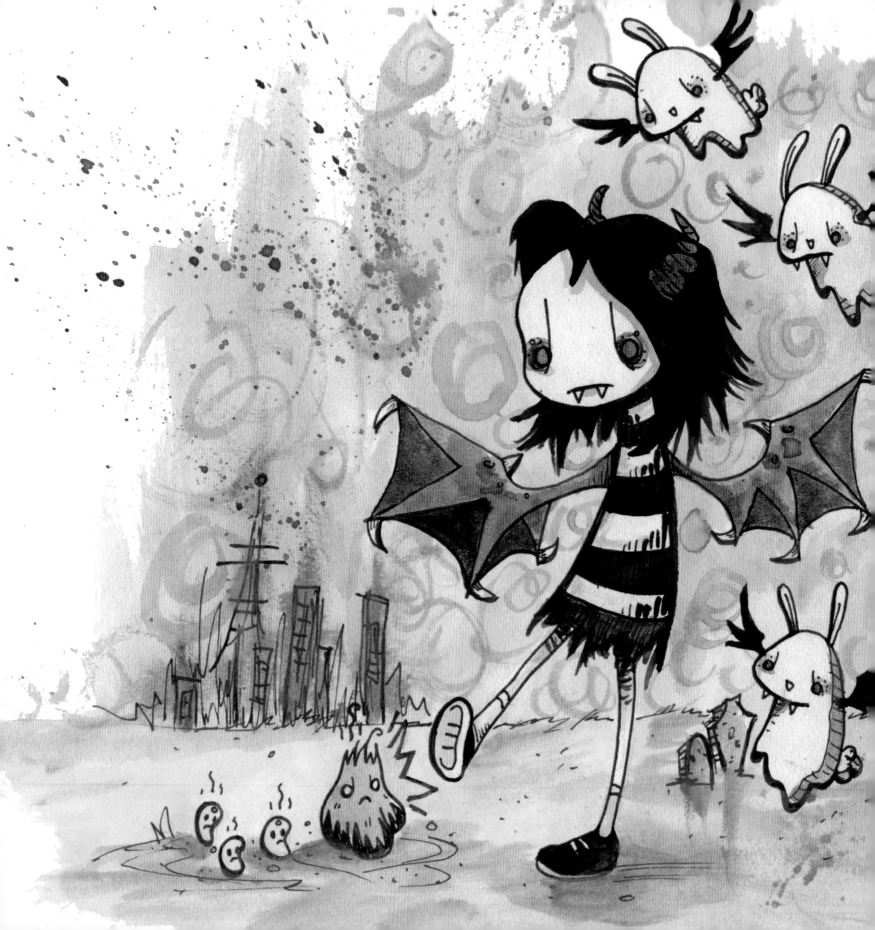

◄ **Melty Vampire Minions Hate Garlic Army**
Emi Boz
Ink, watercolor, pencil, and acrylic on paper
http://creepalicious-inc.com

"In the land of Snygorlok the melty vampire bunnies lived in fear of the Garlic army. The Garlic army hated the melty vampire bunnies for drinking the juice out of their prime minster, Carroting Von Roots, and his entire family. Starved and hungry, the melty vampire bunnies dreaded that the ever-growing Garlic army would eventually find their secret hideout. That was, until Onkla, the winged vampire girl, found the melty vampire bunnies first. 'Put your war paint on, my melty bunny friends, tonight we take down the Garlic army!' she exclaimed. That night, the melty vampire bunnies and Onkla met the Garlic army in gruesome battle."

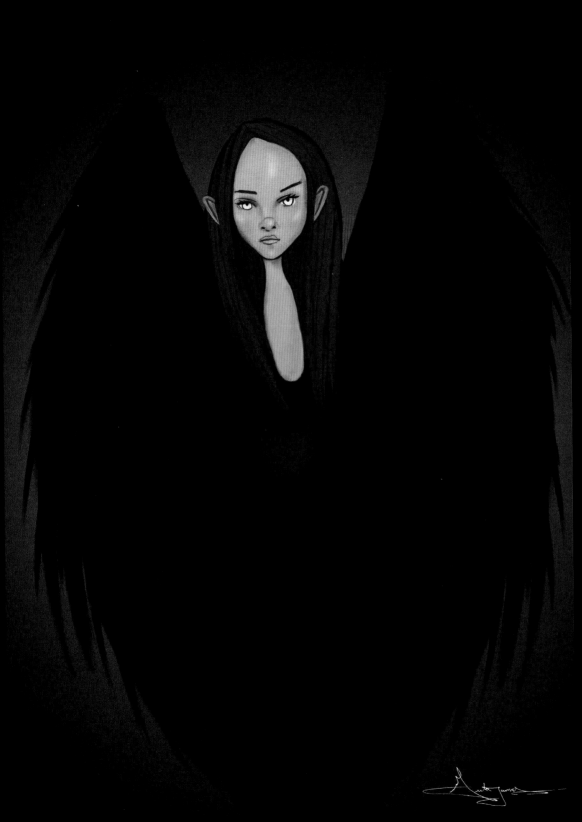

◄ **Turkey Vulture**
Greta James
Pencil sketch digitally painted
www.gretajames.com

James's sullen character in her piece titled Turkey Vulture *is inspired by the eponymous birds, which she describes as "nature's winged vampires." She says, "The blood-red head of the Turkey Vulture symbolizes its life purpose: to serve as winged angels of mercy in the last hours of a creature's life, transforming the life-giving blood from one body about to die into life nourishment for another. They are shamanistic symbols that represent the transformation from life to death to life once more."*

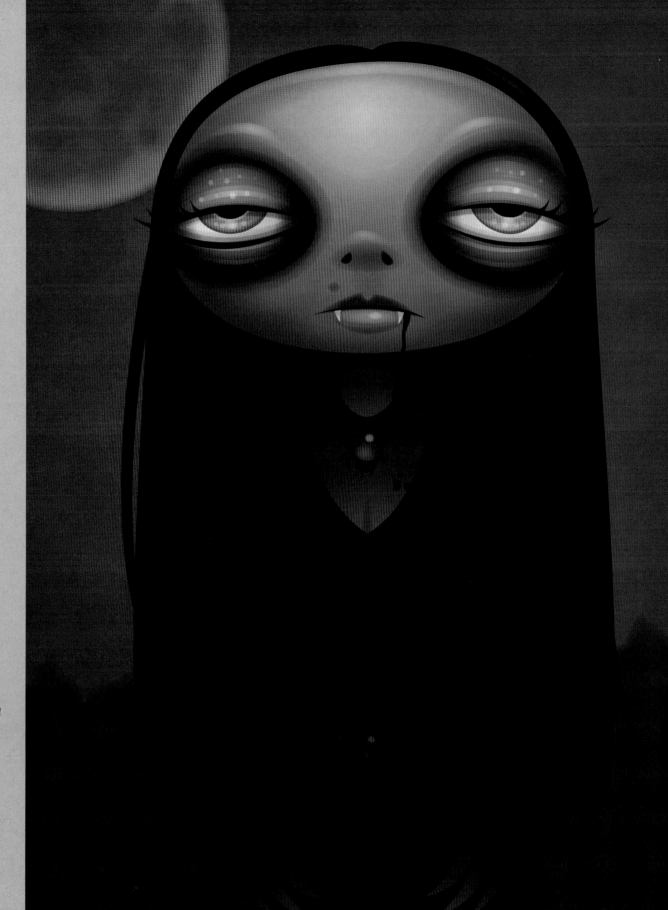

▶ **Blood Red Sky**
John Schwegel
Adobe Illustrator
www.johnschwegel.com

This cartoonish ghoul is the creepy creation of John Schwegel. "Cute, but creepy vampire girl under a blood red sky. I wanted to give her a sullen look as though she was getting bored with immortality. This image was created in Adobe Illustrator using the Pen, Pencil, and Shape tools. Highlights and shading were added with various semi-transparent layers. I used some feathering on the moon and background scenery to make them appear out of focus."

▶ **Vampire Hive**
Gus Fink
Graphite, ink, and
watercolor on paper
www.gusfink.com

*A group of ghastly figures
convened by Gus Fink using
graphite, ink, and watercolors.
"Most vampires like to be solo,
but theirs is a rare society that
lives amongst each other in their
own hive. They stick together
and help one another out when
they crave adventure. There are
rumored to be hundreds of them
and they often move from town
to town, sucking the meatiest of
the meat available. This started
making populations thinner;
humans were in fear that they
would be devoured if they grew
too obese. The Hive would rather
go out and take one body, than
take three or four for the same
amount of flesh and blood. So
if you aren't sure if The Hive is
near you, it might be best to hit
the gym at least once in a while."*

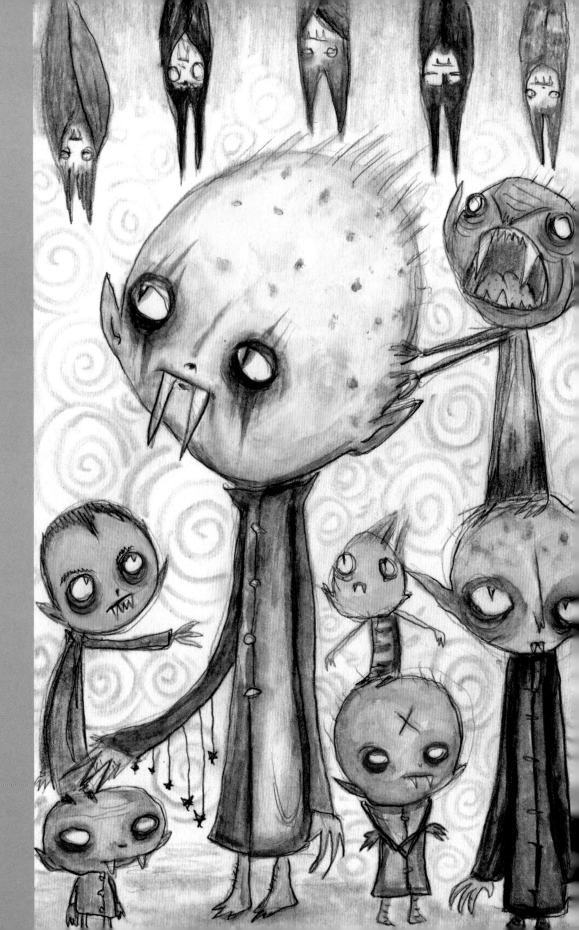

► **Vampress and Fiends**
Gus Fink
Graphite, ink, and
watercolor on paper
www.gusfink.com

*Bloodsuckers need friends too,
as shown here in* Vampress and
Fiends *by Gus Fink. "Like most
evil girls, she doesn't gain many
friends. Instead she keeps a nice
gathering of fellow fiends to look
after and protect her while she
sleeps. Sure they don't listen to
her every command, but it's a
nice back and forth flow where
things get done. The Vampress
loves her unique fiends and so
she often gifts them with roses
and fairy tales that she makes
up on the spot. Maybe this will
all change when she finds the
right one, but for now she is
satisfied with the misfits that
surround her."*

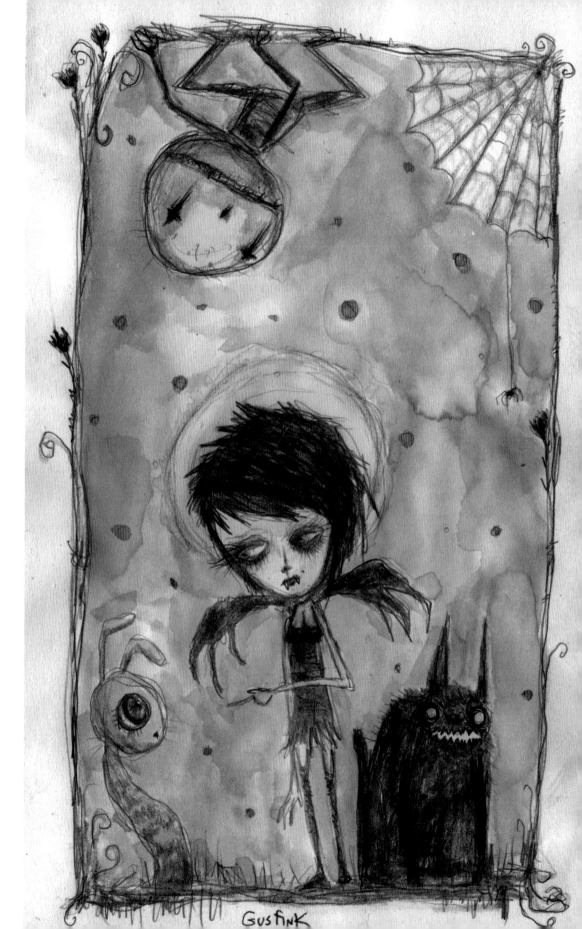

▶ **Minerva,
Goddess of the Graveyard**
Emi Boz
Pencil, watercolor,
and ink on paper
http://creepalicious-inc.com

Boz created Minerva,
Goddess of the Graveyard
*using pencil, watercolor, and ink.
She describes the backstory to the
piece: "Minerva sat on her tomb
stones at night, waiting for a
tasty human to come along to
bite. She sat alone, she always
was, a lack of companionship
was the cause. Who needs love
to keep you warm? She's always
had a cold heart since she was
born. Maybe one day, she'll
bite Mr. Right, until then, she
remains alone in the night."*

▶ Vivian Moon Pinup
Bill Maus
Brush and ink
on comic illustration board
www.billmausart.com

"The scene is a mysterious one, as no one suspects Vivian Moon's true nature. She justifies tonight's sacrifice as a necessary evil, since it has been her habit to only prey upon those who would do harm to others. She sees the hypocrisy of two wrongs not making a right, but, in her case, her thirst must be satisfied . . . and this is how she justifies it so that she can live with herself, with what she has become. Lucky for her, the world is full of evil people for her to feed upon."

▲ **Dark Angel**
Pierre Carles
Adobe Photoshop
www.pierrecarles.com

This digital piece, created with Photoshop and a Wacom Intuos tablet, features a gothic, winged nymph surrounded by shades of violet. Seemingly gentle and calm, she relaxes near a batch of purple flowers that perhaps her lofty travels have led her to. Her pale skin and sharp eyes are a reminder of what she really is. Still, this Dark Angel stays silent and looks into the beyond, showing no signs of doubt, worry, or savagery.

▶ **Red Eye**
John Schwegel
Adobe Illustrator
www.johnschwegel.com

Sometimes it is difficult to tell if we should hug or hide from the undead, as illustrated in this piece by Schwegel. "Red Eye was created for Halloween. I just had the urge to draw a really cute little vampire bat boy in a simple style. I chose the red and brown colors to give the image a classic look of an old photo. This image was created in Illustrator using the Pen, Pencil, and Shape tools. Highlights and shading were added with various semi-transparent layers."

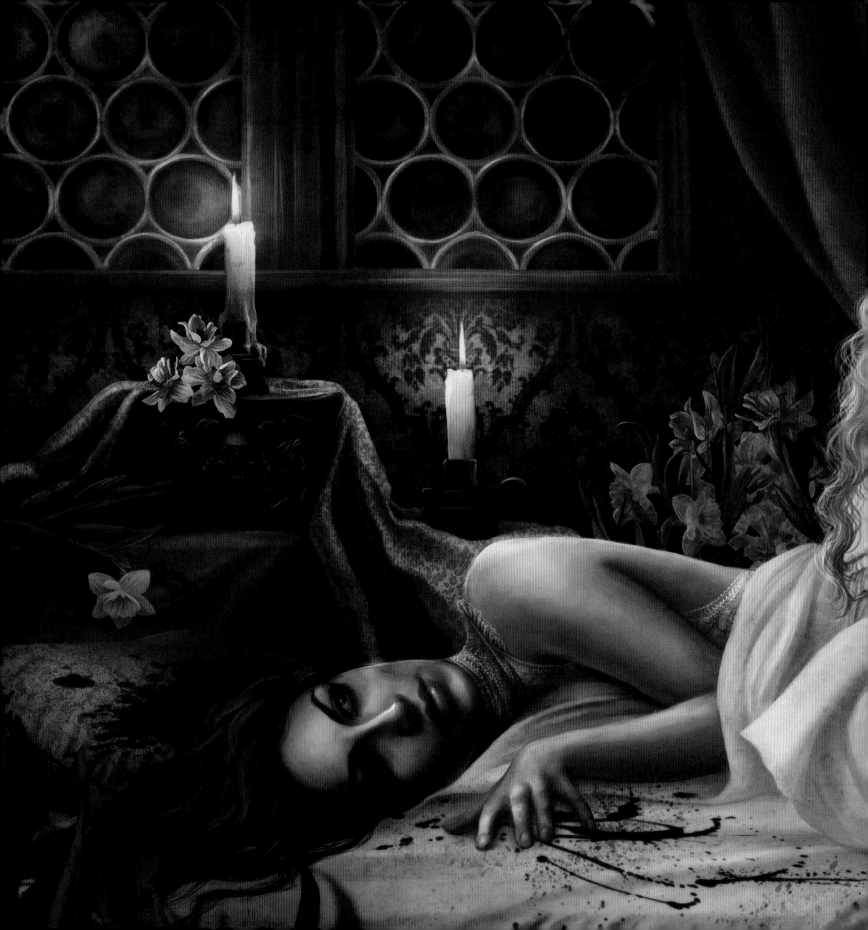

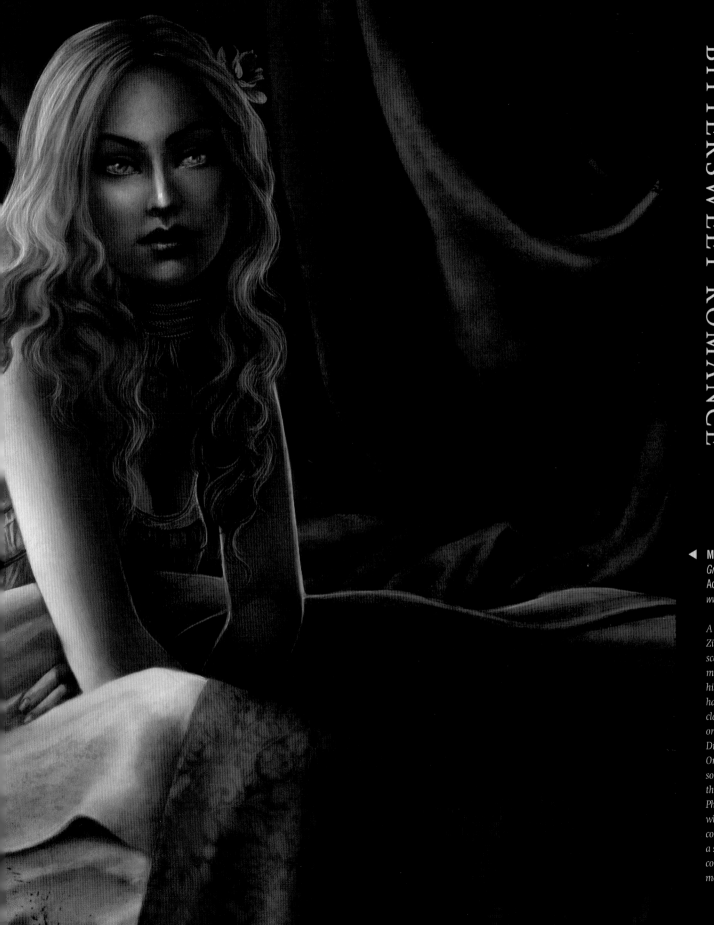

CHAPTER 8

BLOODLUST AND BITTERSWEET ROMANCE

◄ **Midnight Affair**
Gracjana Zielinska
Adobe Photoshop
www.vinegaria.com

A sensual digital piece by Zielinska. "I wanted to depict a scene which shows an uncertain mood, so the viewer can invent his or her own story of what has happened there. I didn't want to clarify which girl is a vampire or what exactly has happened. Did one just seduce the other? Or maybe they are waiting for someone who has just entered the scene? It was painted in Photoshop. I started in black and white to get all the shadow values correct, which can be easily lost in a scene that operates on a lot of contrasts. I added colors using mostly color and soft light modes."

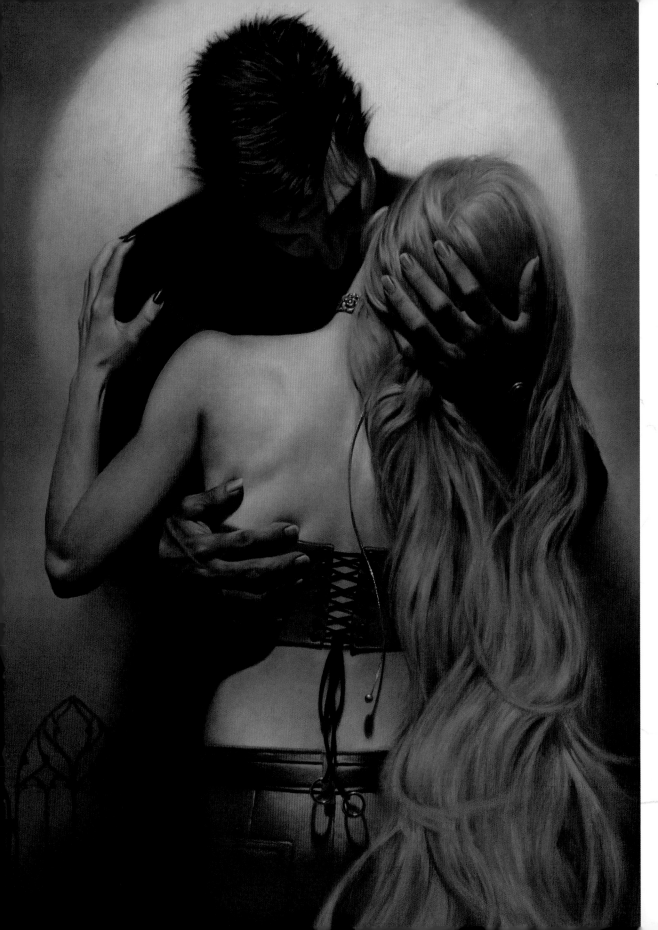

◀ **A Hunger Like No Other**
Vince Natale
Book cover for the *Immortals After Dark* series
Oil on gessoed board
www.vincenatale.com

A classic and romantic painting created in oils by artist Vince Natale. A book cover for "one of the Immortals After Dark series dealing with vampires and werewolves, and the forbidden love that develops between the two main characters. As there is a strong romantic side to the story, I needed to display that in the painting via the clinch — but at the same time I needed to make it moody, dark, and atmospheric to capture the danger and otherworldliness of the characters and the story."

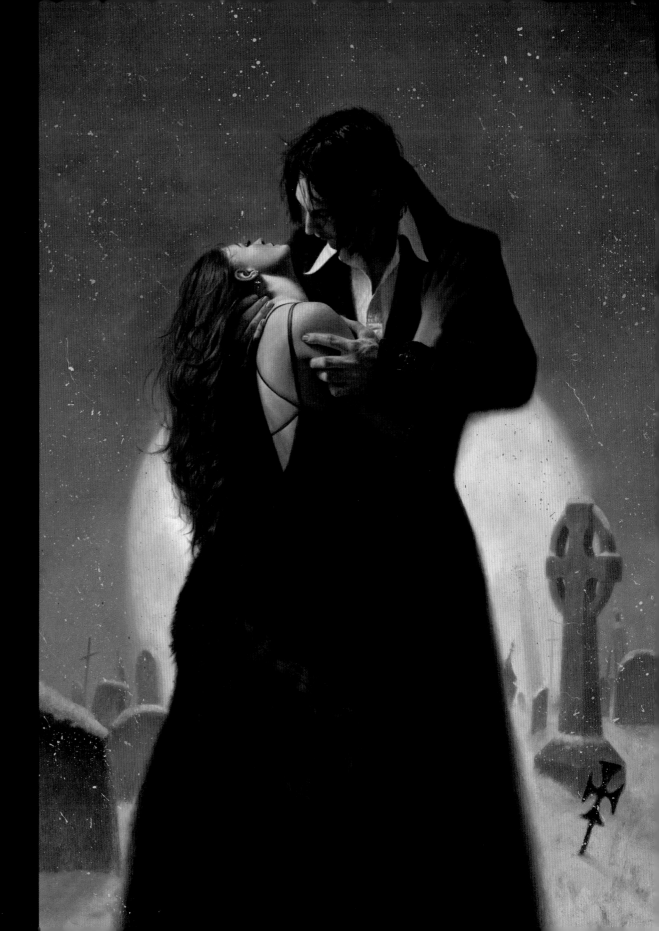

► **Wicked Deeds on a Winter's Night**
Vince Natale
Book cover for the *Immortals After Dark* series
Oil on gessoed board
www.vincenatale.com

Wicked Deeds on a Winter's
Night *features a woman held
in a vampire's embrace. Again,
"one of the* Immortals After
Dark *series dealing with
vampires, werewolves, and
witches, and the forbidden love
between the characters. The
romance is depicted in the clinch,
but the danger is conveyed with
his hand's position and the
direction of his gaze — at her
throat. I used cool colors and a
higher contrast in this painting
to evoke a 'chilly' atmosphere to
indicate that all is not 'warm
and fuzzy' here."*

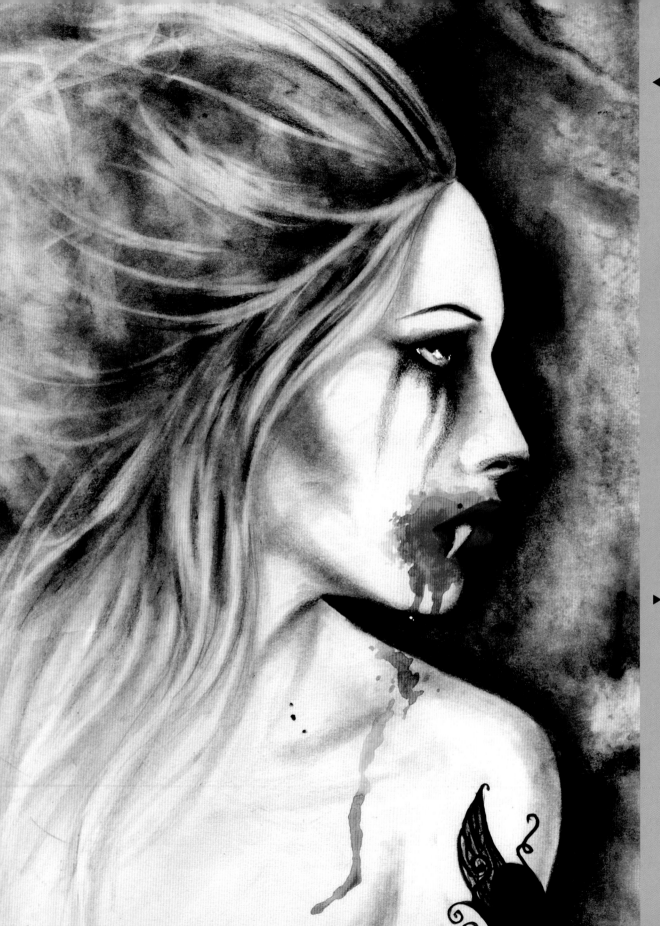

◀ **Midnight Thirst**
Elisabete Nascimento
Pencil and watercolor on paper
www.elisabetenascimento.co.uk

Nascimento illustrated a dark beauty in black and white, with a splash of contrasting red used for the blood and the lips. She describes the backstory to the piece: "Daray rose at midnight with a horrendous gasp, time had come to quench her thirst once again."

▶ **Thirty Days of Blood**
Mark Pexton
Pencil and PaintShop Pro
http://mark-pexton.daportfolio.com

A once unmarred face is now stitched and bloody. If any life exists in the eyes, it can only be that of the supernatural, since the gouge out of the neck is surely lethal. Tender lips contrast with inhuman teeth spaced in a grotesque manner. For all the beauty that lies in this creature, there is an equal amount of malformation and decay. Has this dead-eyed wonder reached a cruel end? Or is this just the beginning of something much more sinister?

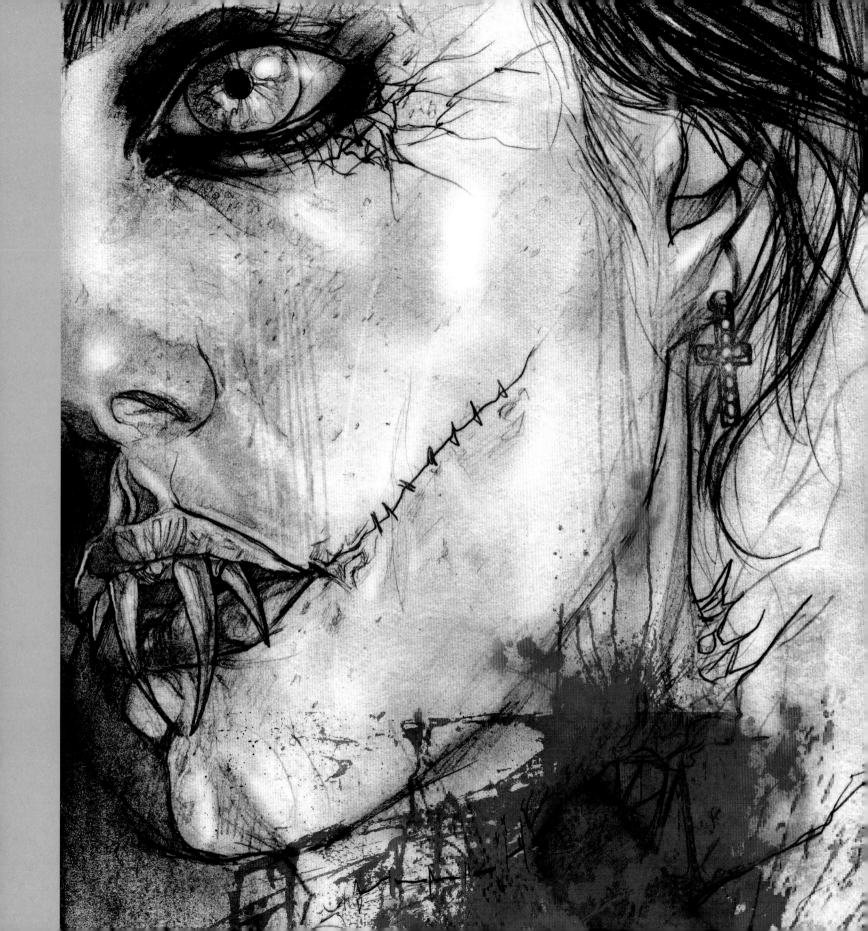

▶ **Her Love**
Armand Baltazar
Pen, ink wash, and digital finishing
www.armandbaltazar.com

Baltazar's Her Love *depicts
two characters experiencing the
sensation of life being drained
and consumed. The feeling of
the blood being emptied from
this victim's body seems to
provoke as much satisfaction
for her as it does for the vampire.
No malice is present here, as both
individuals appear willing in this
image. "This piece was inspired
by the paintings of Gustav Klimt.
A depiction of two lovers in the
throes of vampiric ecstacy."*

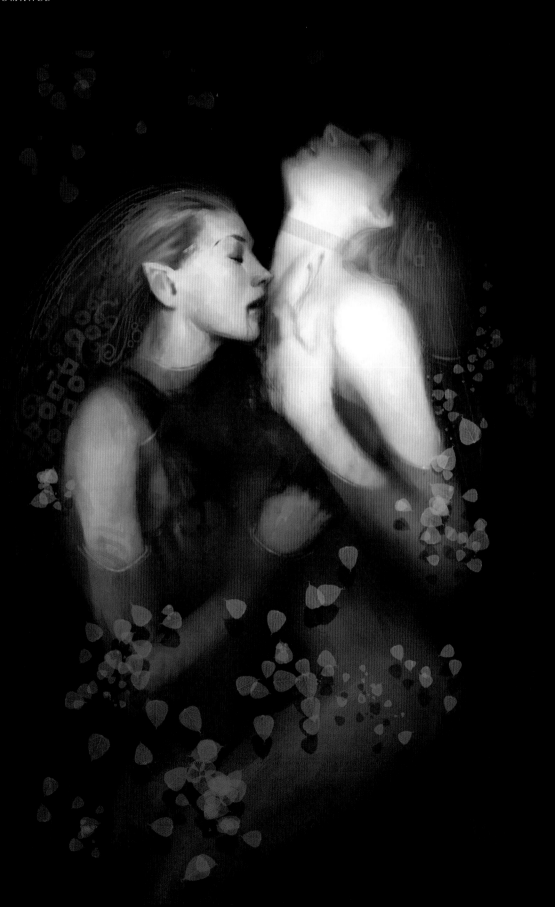

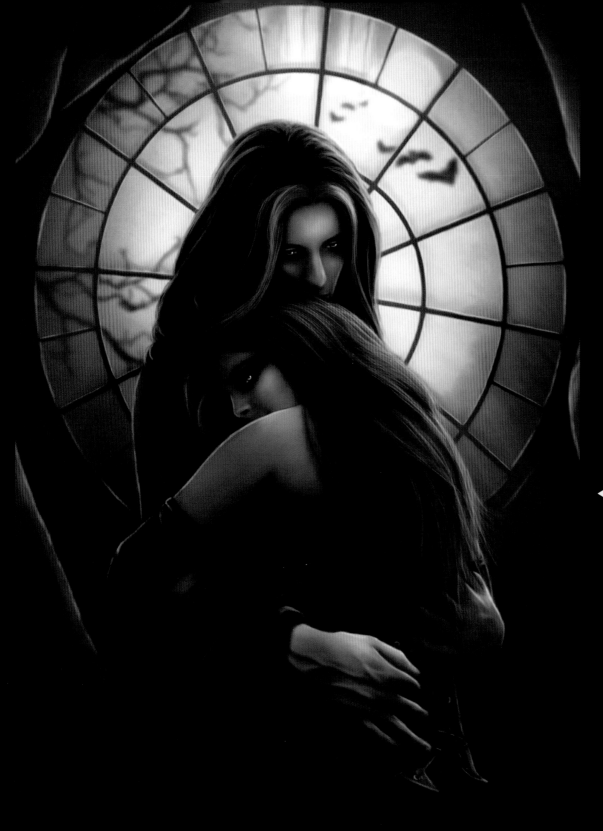

◄ **If I Was Your Vampire**
Joana Dias
Adobe Photoshop
www.shinobinaku.net

*In an eternal embrace these two
vampires hold each other and at
this moment they feel very human.
If I Was Your Vampire by
Joana Dias demonstrates the
softer side of vampires, their
ability to love. "I am greatly
inspired by various forms of
art, and I try to channel that
inspiration in my work. This
one in particular is based on
music. Unlike my other vampire
artwork, this one is focused on
the notion of eternal romance
and undying love. This was also
the first appearance of my
character Sunset."*

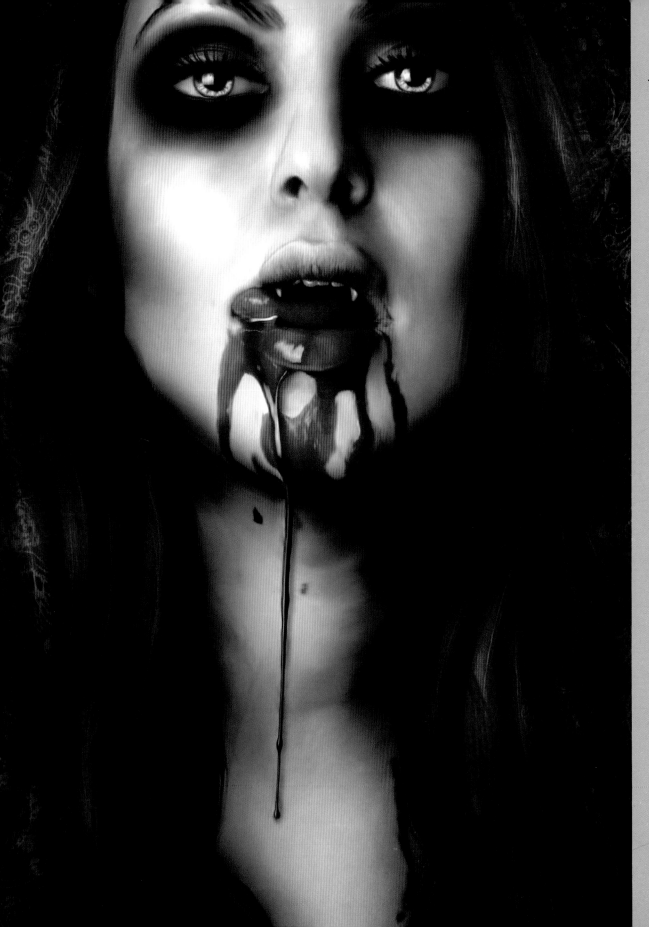

Sunset
Joana Dias
Adobe Photoshop
http://www.shinobinaku.net

The character Sunset displays
a bloodthirsty appetite as scarlet
rivers of blood drip down her
lips, contrasting against her pale
skin. Gore-loving nymphs always
make the most heinous acts look
sensual. Dias says: "I wanted to
create a portrait of Sunset, as
she is a centerpiece in my cast of
original characters. In order to
create her more faithfully to my
vision, I drew her from scratch,
unlike the majority of my work,
which is photomanipulation."

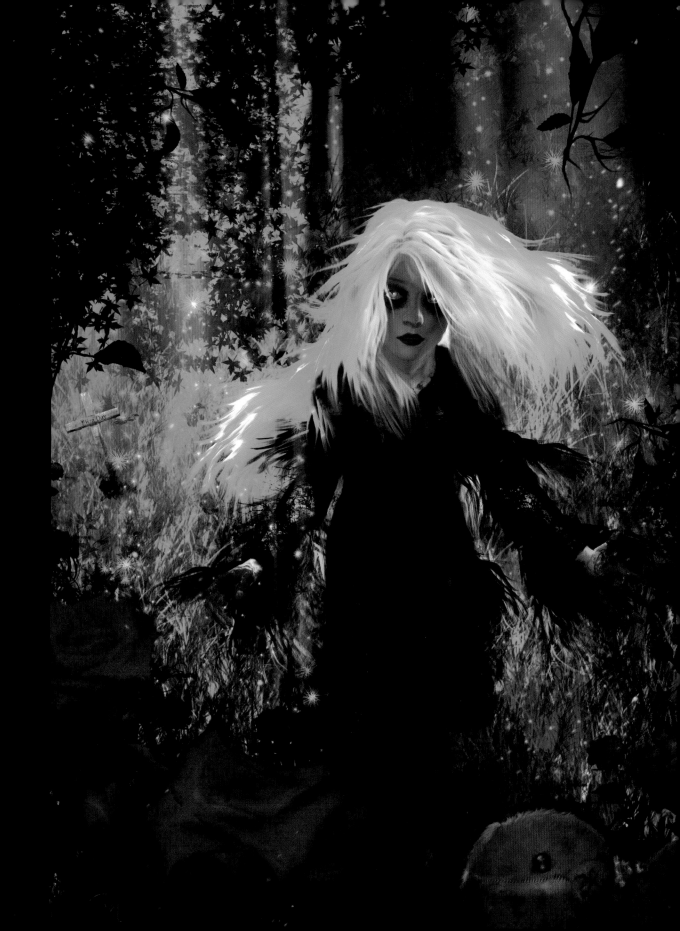

▶ **Wild Rose**
Myke Amend
Adobe Photoshop
www.mykeamend.com

An immortal beauty moves
through the night flowers in
Amend's Wild Rose. "By the
light of the moon she appears,
forever waiting for the handsome
boy who led her to this clearing
by the stream. Death, to her, is
a stranger—she does not know
of her own passing; she does not
understand the harm caused
by her embrace; she does not
remember exactly what he
looked like . . . she only wonders,
'where have you been?'"

◀ **Death's Door**
Leslie Ann O'Dell
Photography and Adobe Photoshop
www.shyble.com

In Death's Door, *O'Dell shares with us the last moments of a victim of a vampiric attack. The gash at the neck and the heavy reds in this piece are a good indication that she doesn't have much time left. Her hair is coated in blood that spreads from her neck like ocean waves and merges with the Victorian print she appears to lie on. The soft look of solace worn on her face is evidence of a merciful kill. "A dark portrait of a vampire victim silently suffering with her last breath."*

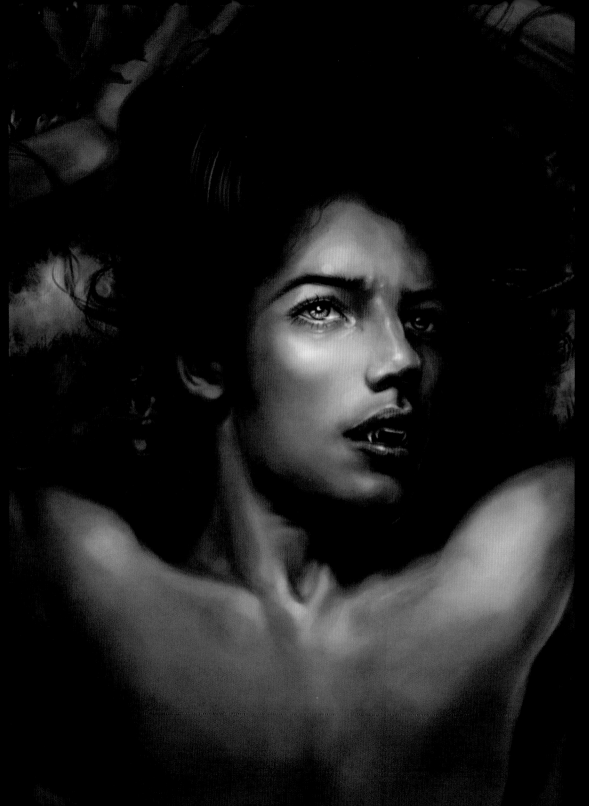

My Vampire Eyes
Christine M. Griffin
Adobe Photoshop
http://christinegriffin.artworkfolio.com

This romantic, ethereal portrait offers a soft representation of the traditional vampire. Griffin shares her technique for My Vampire Eyes: *"Pale skin can be tricky. It's easy to want to simply add white to everything, but that can either turn bland and chalky or, with digital media, look overexposed. The key is to keep color in there; in this case, very subtle greens and pinks. Green with red is my favorite complementary pairing. I added cool pink to my highlights and a warm green to my shadows. It's all about hidden opposites!"*

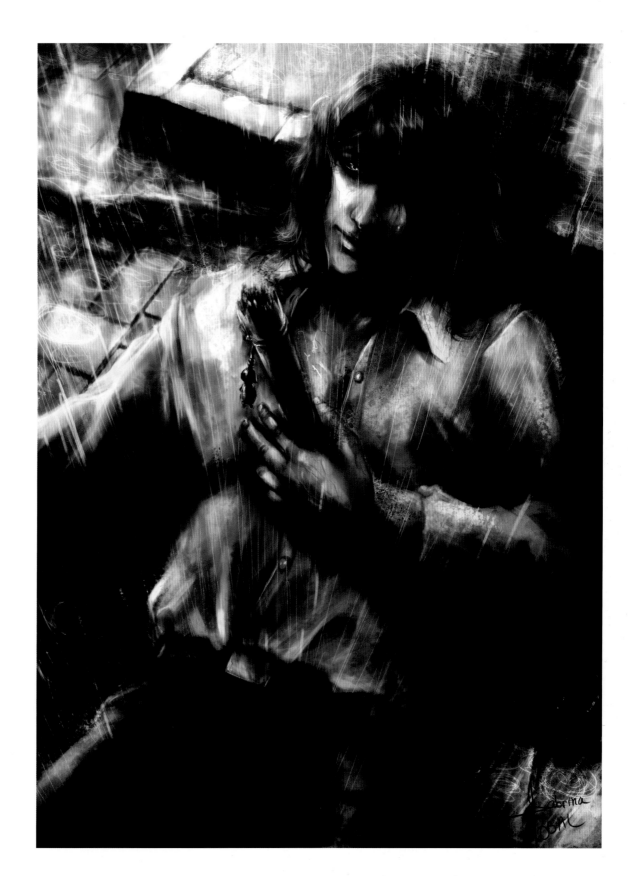

▶ **I Miss You, Daddy**
Sabrina Tobal
Adobe Photoshop
http://sabrinanime.over-blog.com

In this sensitive, bittersweet painting, a vampire lays in a cemetery breathing his last breath. Tobal explains how this piece titled I Miss You, Daddy came about: "I chose this title because it inspired me a lot. I thought about this scene and I imagined a father transformed into a vampire, a monster . . . and his daughter who had no choice but to kill him. The vampire dies, finally calm, finding a moment in his soul to thank his daughter."

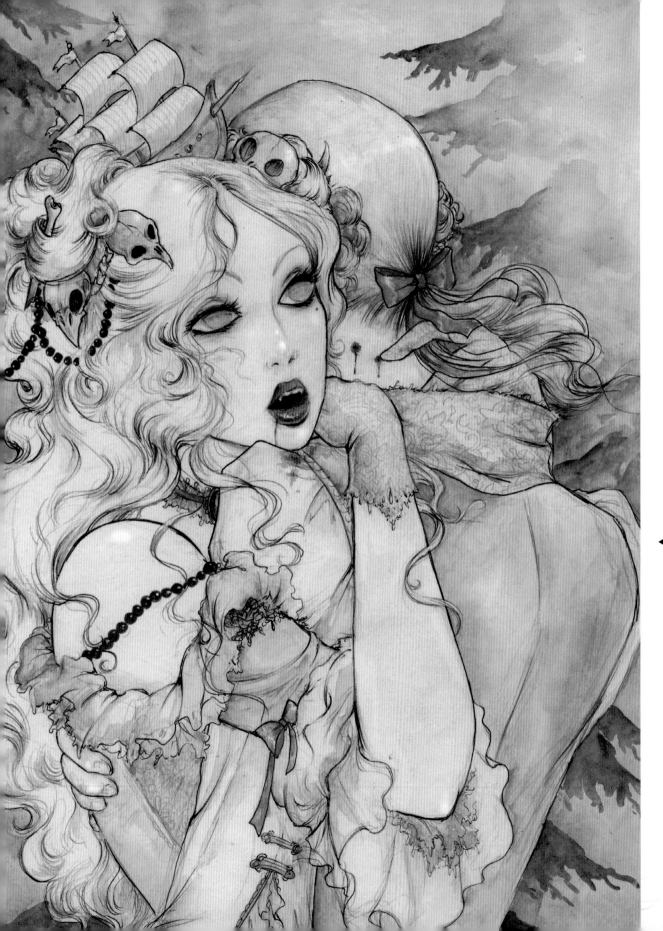

◄ **Our Last Embracement**
Gina Wetzel
Watercolor with digital highlights
www.tanuki.de.vu

An immortal and her prey entwine in this delicate watercolor piece with digital highlights. "I am very passionate about the Rococo era and its beautiful fashion. Oodles of lace and ruffles and colossal hairstyles—that's just my thing. This opulent and morbid age is the perfect setting for vampire stories. And I also love the sixties, so I thought of the young Brigitte Bardot while drawing the girl's face. Usually I prefer the nostalgic look of completely hand-painted pictures, but in this piece I added some Photoshop highlights to bring out the vampire maiden's porcelain skin."

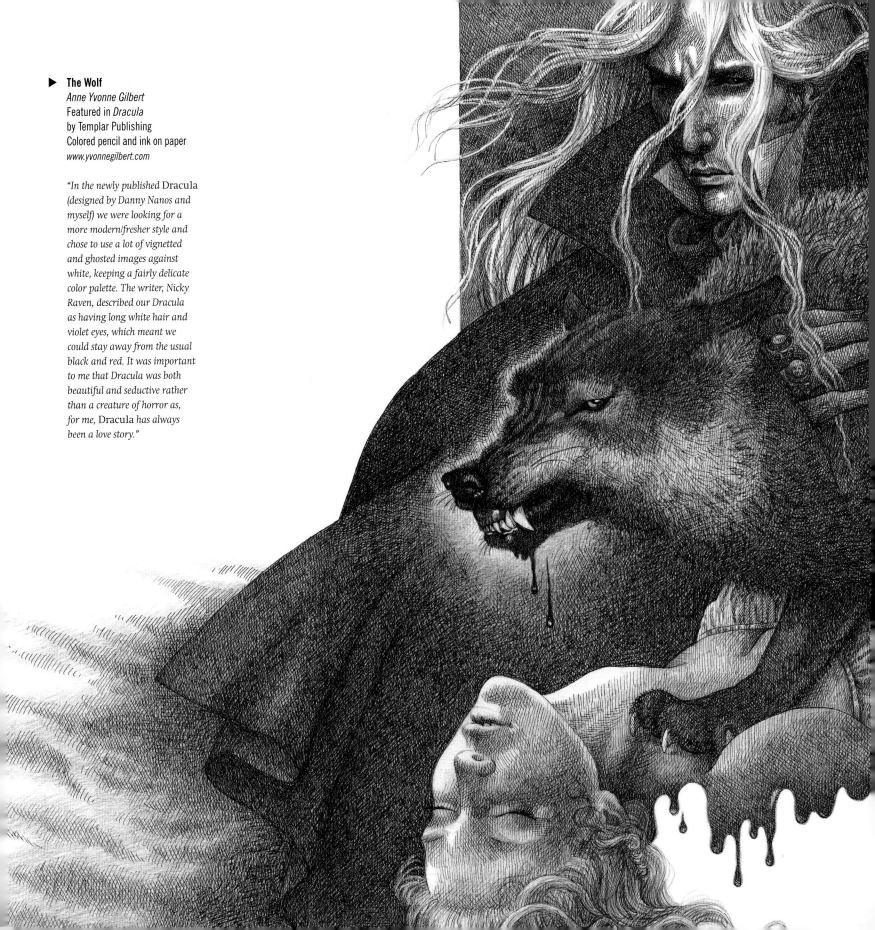

▶ **The Wolf**
Anne Yvonne Gilbert
Featured in *Dracula*
by Templar Publishing
Colored pencil and ink on paper
www.yvonnegilbert.com

"In the newly published Dracula
*(designed by Danny Nanos and
myself) we were looking for a
more modern/fresher style and
chose to use a lot of vignetted
and ghosted images against
white, keeping a fairly delicate
color palette. The writer, Nicky
Raven, described our Dracula
as having long white hair and
violet eyes, which meant we
could stay away from the usual
black and red. It was important
to me that Dracula was both
beautiful and seductive rather
than a creature of horror as,
for me,* Dracula *has always
been a love story."*

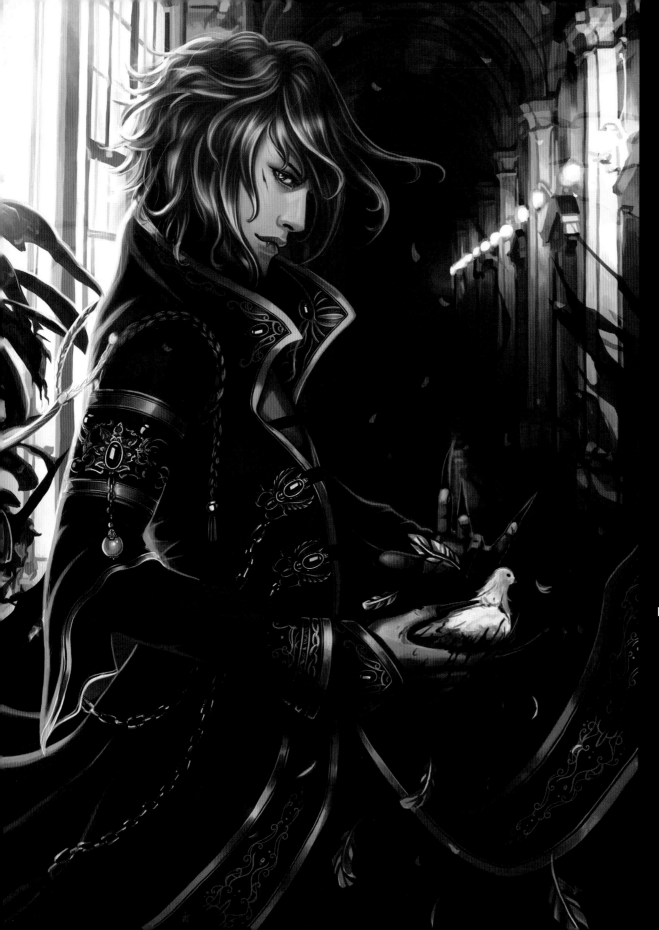

◄ **Broken Desires**
Leah Keeler
Adobe Photoshop
http://keelerleah.deviantart.com

In Broken Desires, *a spiteful haunt taints a symbol of purity.* "A broken but still powerful vampire is lost in thought, yet still aware of the watcher's presence, petting a dove a bit too roughly for its own good. To this day, I am immensely pleased at the outcome of this work. From the lighting to the large amount of details and ornaments on the coat, everything turned out as I had wanted it . . . a big feat in my books."

► **Blood Roses**
Leah Keeler
Adobe Photoshop
http://keelerleah.deviantart.com

In the midst of falling leaves, a gorgeous bloom is held by a long-haired dandy in Leah Keeler's Blood Roses. "An attractive male vampire holding a rose; is he attempting to lure you in or is he offering you the rose? This is a slightly altered version of a painting I did for an online ball-jointed doll contest, hence the jointed hand. I was really pleased with the outcome and I had a great response to the finished work."

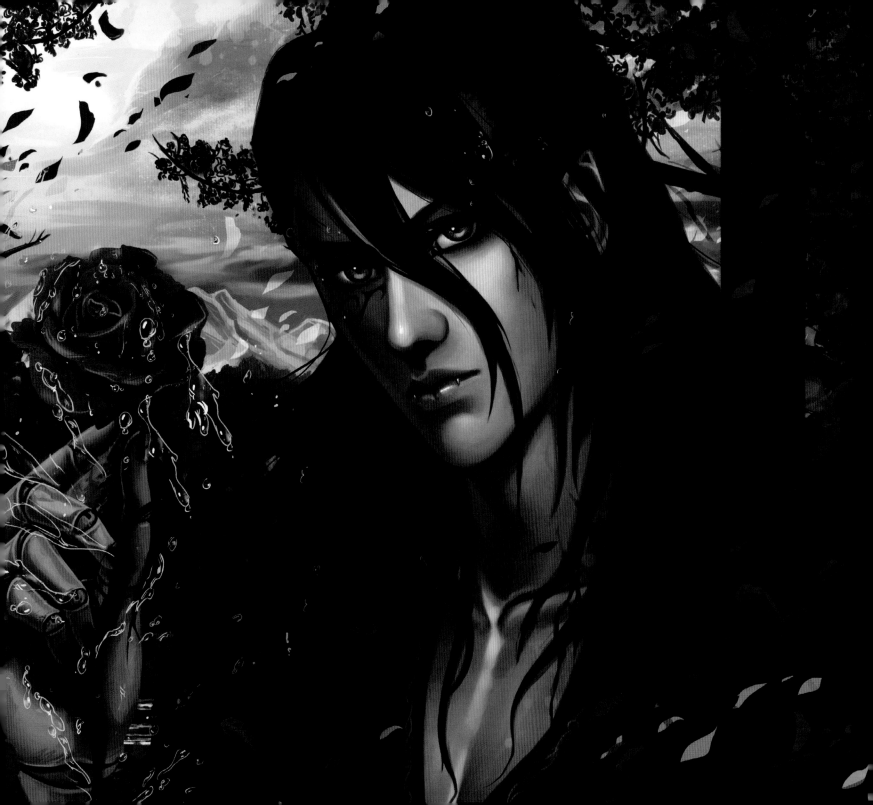

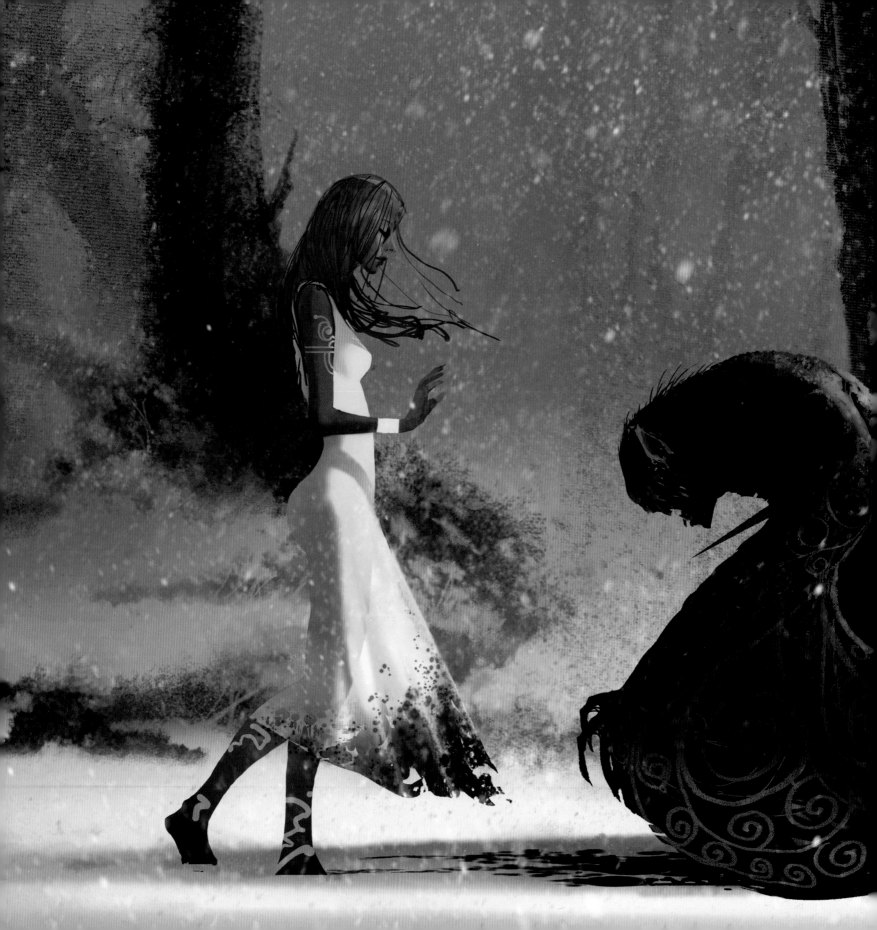

CHAPTER 9

DRACULA AND HIS DISGUISES

◀ **Death of the King**
Armand Baltazar
Pen, ink wash, and digital finishing
www.armandbaltazar.com

A tragic defeat? A touching and cold image with a dying beast hunched over in blood; it is impossible not to notice the still elegance of this image. The snow is covered in blood and although the foul demon may have deserved his death, it is difficult not to feel a sense of pity. Baltazar describes his piece: "The painting depicts the last moments of the dying Vampire King who stands before his human daughter, who has slain him."

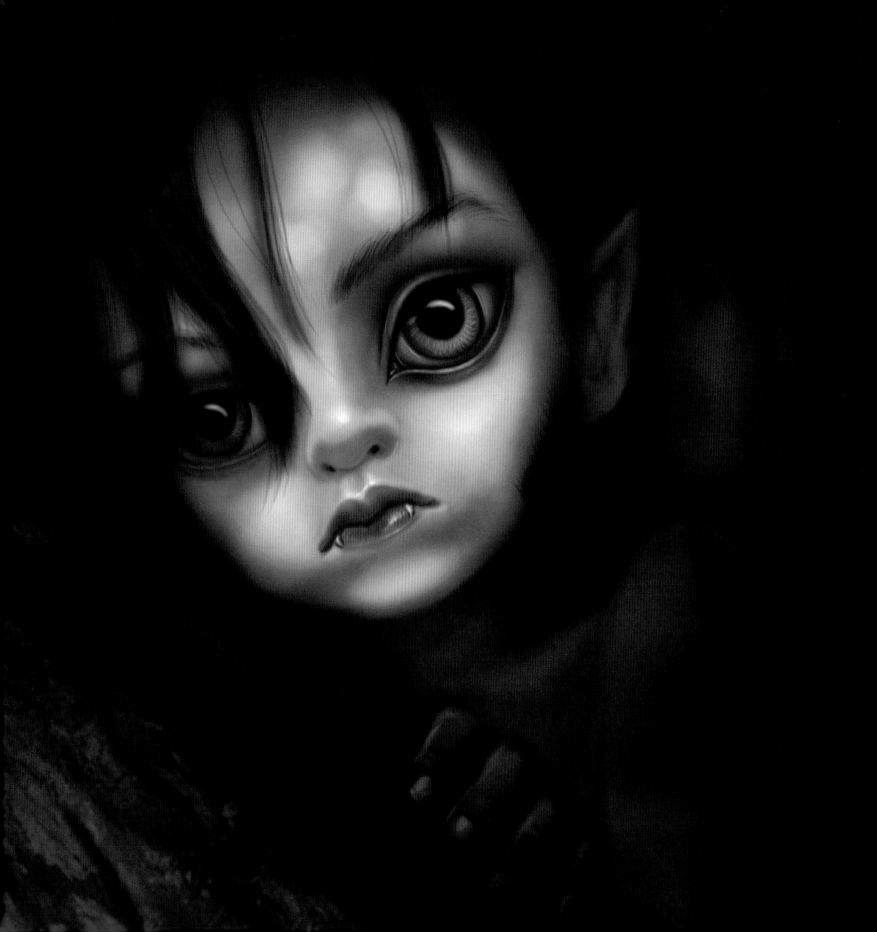

◀ **Bat Boy**
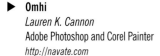
Bob Doucette
Digital painting
www.bobdoucette.com

Bob Doucette has created this wonderfully big-eyed little devil. "This feral creature was left in the woods and hides in the trees to attack whatever prey he can find at night. I wanted to paint a sympathetic figure that works from instinct, like a wild animal that has no control of his actions. A bat may be scary by nature, but in fact it is no scarier than a bear or a squirrel for that matter, and they are rather cute when you get past the fangs and the intense gaze that they cast."

▶ **Omhi**
Lauren K. Cannon
Adobe Photoshop and Corel Painter
http://navate.com

Cannon's Omhi *depicts a young man with flowing hair, whose beauty may be only skin deep. "The concept of the vampire fascinates me, and I have appropriated much of its core ideas. I'm not interested in the romanticism that's usually connected with them in modern times — instead, I am interested in the isolation and monstrosity; the parasite that possesses the corpse. Many of my characters literally rot from the inside out, consumed by their own powers. This character's Gothic look is inspired by the idea of the noble monster that embodies the classic vampire myth."*

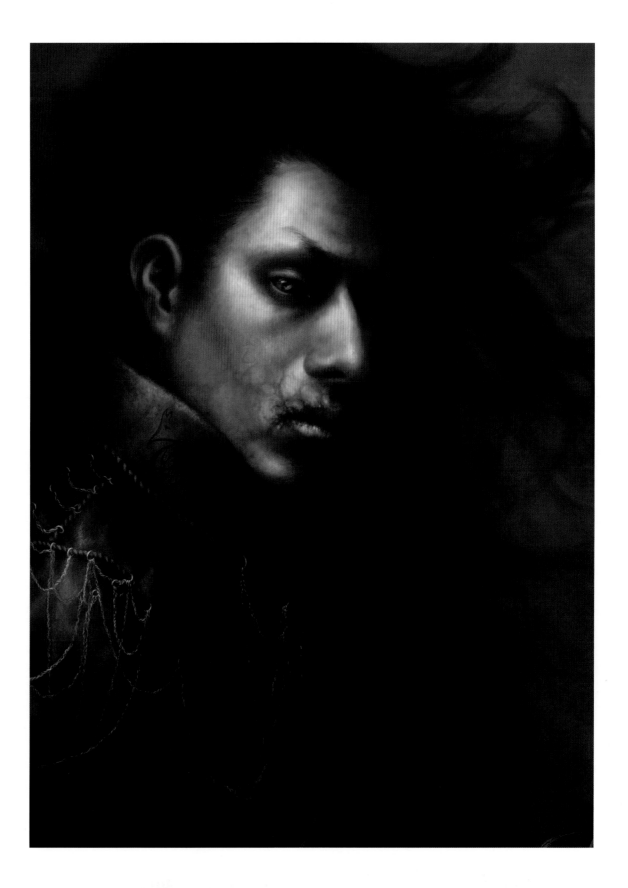

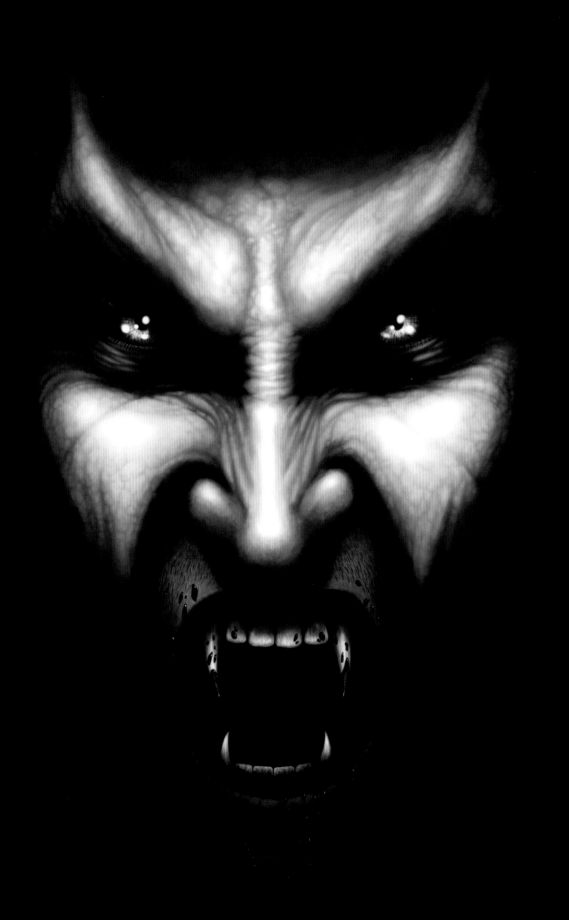

◀ **Shadow Vampire**
Andrew Dobell
Digital painting
www.andrewdobell.co.uk

A tense piece showing a bloodsucking savage peering out from a veil of darkness. This hidden ghoul possesses an element of surprise, resulting in a sad end for the intended victim. Dobell alludes to the challenges in creating shadow and light: "The result of several failed attempts to create a vampire face emerging from shadow; this was the most successful. I used a black and white palette with red as the only color to really bring out the blood on the vampire's face. I feel it makes for a striking image."

▶ **Feral**
Chad Savage
Graphite and Adobe Photoshop
www.chadsavage.com

A nasty hellion slashes out at the viewer with large claws that complement his huge fangs, which no doubt seek tender flesh. Feral is a study in the most animalistic side of vampirism. Savage explains, "A magazine asked me to illustrate an F. Paul Wilson short story about vampires feeding a traitor to a feral vampire revenant. The description of the rabid vampire coming out of the dark was truly horrifying, so that's what I drew."

◀ **Sir Desmodus Rotundus**
Chris Ayers
Pencil and digital painting
www.chrisayersdesign.com

"*Classic movie monsters had a huge influence on me as a kid and were part of the reason I moved to Los Angeles to pursue work as a character designer in the entertainment industry. After being treated for leukemia in 2005, I combined two of my lifelong passions — art and animals — and began drawing an animal each day as part of my healing process. I called the project The Daily Zoo and it has proved to be so therapeutic that I'm currently in year five. For Day 1,537, of the Daily Zoo, I created Sir Desmodus Rotundus.*"

▶ **Nosferatu**
Thomas Kuebler
Life-size bust, silicone, and mixed media
www.thomaskuebler.com

"*Vampirism, like all mythology, has some basis in reality, though it is anyone's guess as to what happened to inspire these stories of the living dead. Vampires make delicious characters with the experience of many horrible lonely lifetimes to draw on, and the memory of their own humanness slowly fading. I believe it would be the eternal loneliness more than the unquenchable thirst that would turn a face from human to demon. Unquenched loneliness over centuries would become hate: ravenous and passionate. What chilling tales are born out of that? Delicious . . .*"

▲ **Incubus**
Jeannette Landrau
Corel Painter
http://mistressj.epilogue.net

Long-haired, handsome, and (as far as the viewer can tell) completely
naked! This incubus is every bit as frightening as his vampiric
counterparts who are more direct in their method of attack. He still
has claws and deadly fangs, the only difference is that his prey are
much less able to resist. Landrau describes how she created her piece:
"This technique was very simple, after a sketch I used the airbrush
and in light layers began to render until completion, using only black."

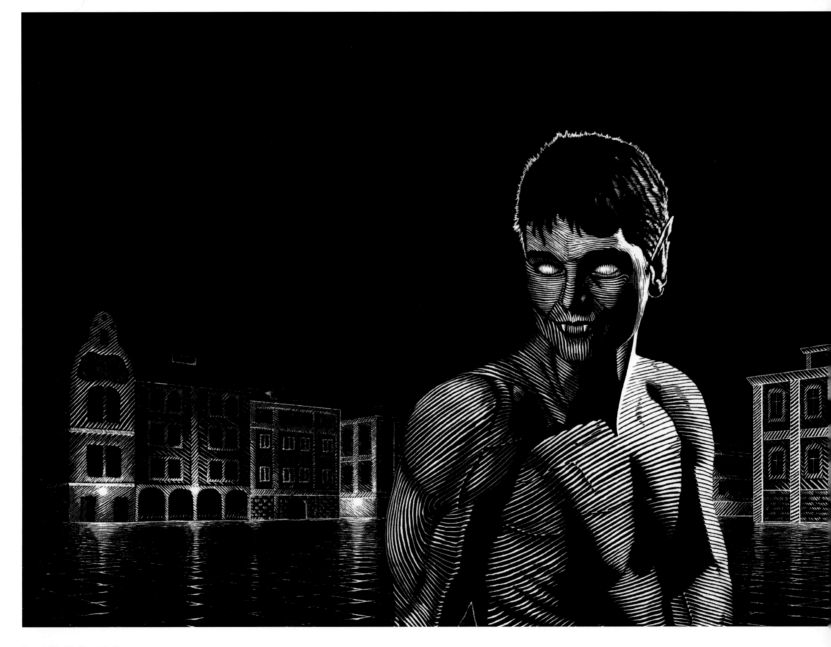

▲ **Count Vlad is Back in Town**
Pierre Carles
Scratchboard
www.pierrecarles.com

*Artist Pierre Carles gives us a little history to this piece created using
scratchboard: "A journey to the heart of Romania in the Carpathian
Mountains inspired the typical 19th-century Transylvanian architecture
in the background. When professional model Jason Baca from Los Angeles
commissioned me for a fantasy portrait, the image of a sexy, deadly
modern Count Dracula unfolded before my eyes."*

◄ Seducer
Lydia Burris
Acrylic, oil, and ink on panel
http://lydiaburris.com

The statement, "Tell me this will last forever" is inscribed on a wall behind a devilish Victorian figure wearing a top hat in this Lydia Burris piece. "Seducer started with an abstract background. Layers and layers of acrylic paint were carefully rubbed in, removed, and scraped away. The portrait is in oils. I wanted to depict a mysterious stranger, focusing on the feel of a 'vampire' — the alluring, seductive gaze that hooks you in, and captures your mind and heart."

► Rise
Patrick Byers
Photomanipulation
http://www.101industries.ca
http://www.baranyartists.com

A shadowy figure lurks through streets adorned in grand clothing. His eyes appear to be two beams of glowing crimson and fog rolls around his sweeping cloak, keeping him well hidden. The stained glass in the background glows an ominous blood-red in this dark piece titled Rise by Patrick Byers. He adds: "At dusk, the village prepares for slumber as this cloaked monster rises to commence his bloodthirsty butchery."

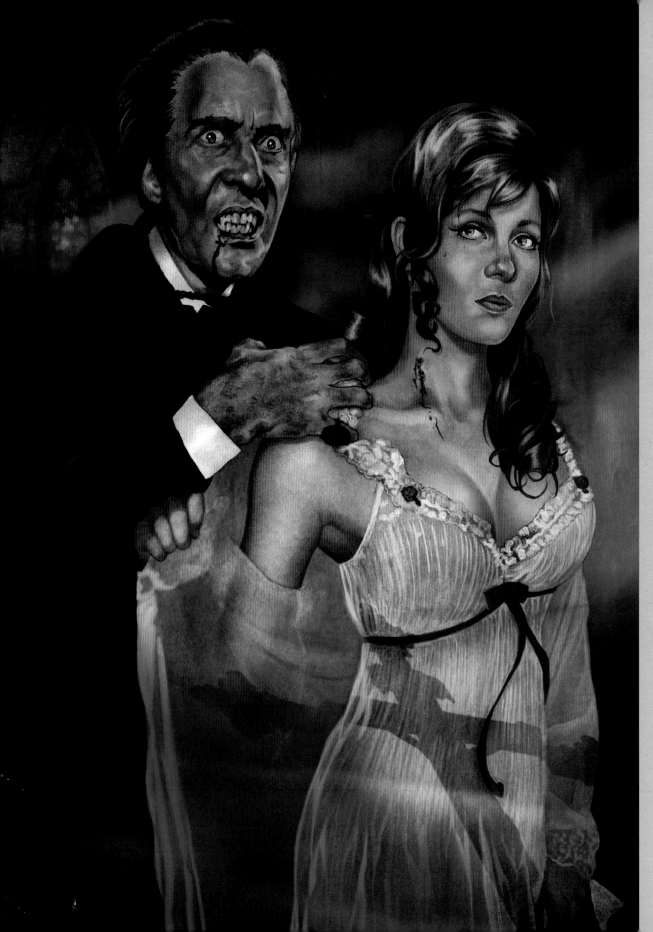

◀ **Dracula's Pitt**
Woodrow J. Hinton III
Paints and mixed media
on Strathmore Illustration
Board, digitally colored in
Adobe Photoshop
http://www.wjh3illustration.com

*The classic horror genre has a
huge fanbase in modern culture,
and among these horrific
creatures, of course, is the
legendary vampire. Woodrow
J. Hinton considered it an honor
to create this look into the past
titled, Dracula's Pitt. "This
commission was originally an
editorial piece that allowed me
to pay homage to two of my
favorite classic horror vamps,
one of which in my opinion is
by far the sexiest undead to ever
put on a pair of fangs. I'll let
you decide which I mean."*

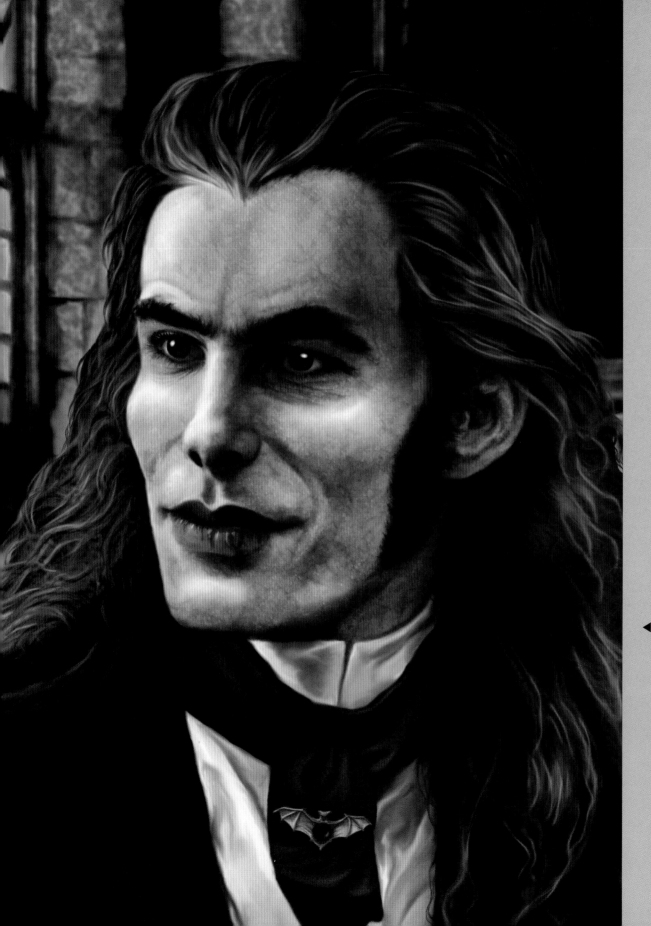

◀ **Vampyre**
Malcolm Brown
Digital painting
www.mbfantasyworld.co.uk

In a digital portrait by Malcolm
Brown, a regal immortal poses.
"I have always been fascinated
by the traditional Gothic vampire,
and in this image I tried to
create a figure both attractive
and repellent. I wanted to avoid
showing the conventional bared
fangs, but retained the blood on
the lips to suggest the horrors of
his feeding habits. I created the
initial image in black and white,
then added color and texture."

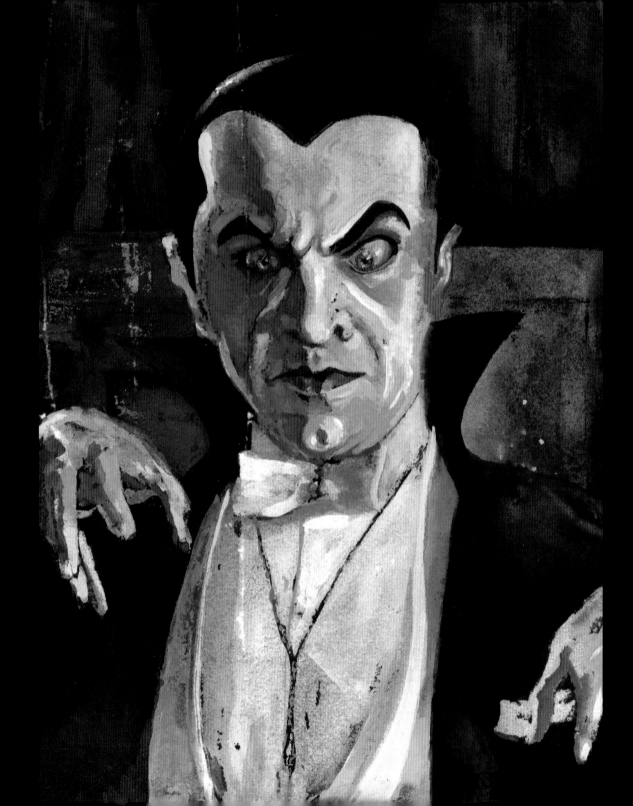

Bela Lugosi as Count Dracula
Thomas Webb
Gouache and ink resist
on illustration board
www.webbitup.com

Old Hollywood reaches out beyond the canvas in Webb's Bela Lugosi as Count Dracula. "My thought when painting these famous vampires was to distort them to match the images I have of them in my memory. Somehow the real thing wasn't what I remembered. Color was also something I wanted to investigate as a more personal memory. Being influenced, when it comes to monsters, by Basil Gogo, I was reminded to explore color without fear."

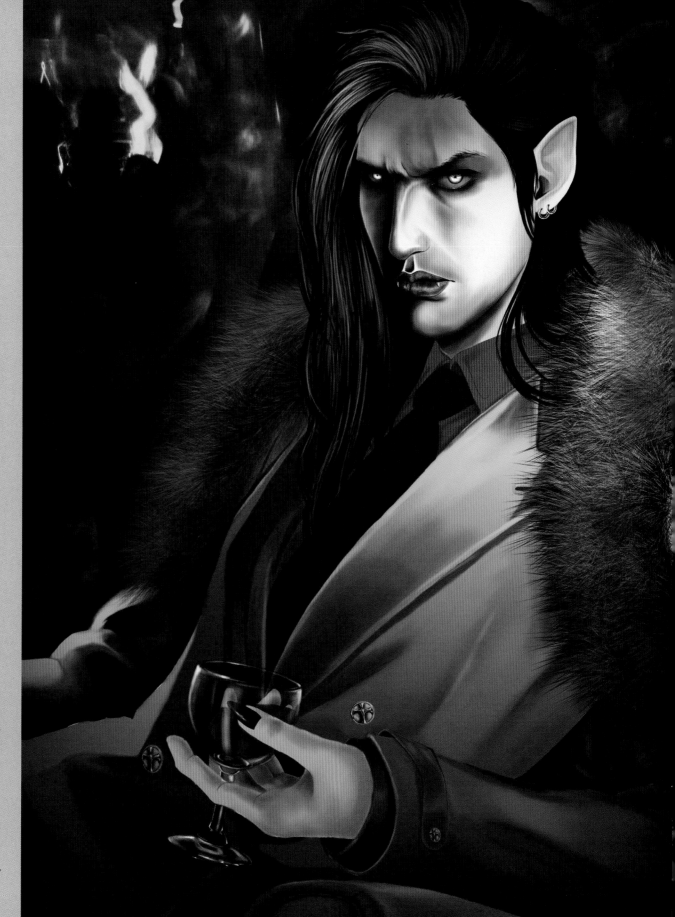

▶ **Headmaster**
Jeannette Landrau
Corel Painter
http://mistressj.epilogue.net

This sharp-toothed headmaster is quite debonair and sophisticated. His eyes have a fixed, cold stare as he gently swirls his wine glass. The artist describes her technique: "For this image, after the sketch was drawn out and rendered with the Airbrush tool, I lit the image using the various lighting options available in Painter and played with the various modes and transparencies of the layers."

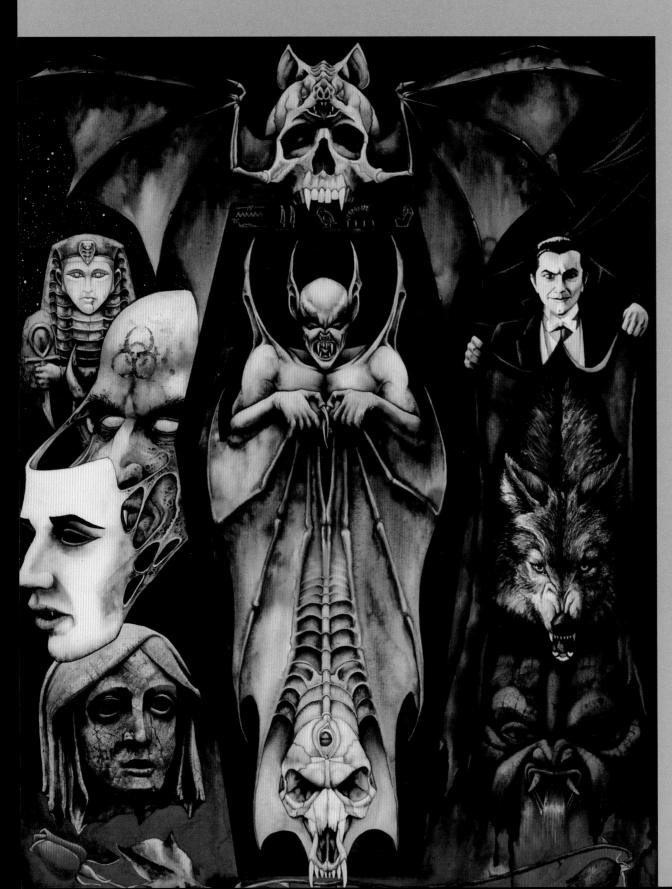

◄ **Penangglan**
Chad Savage
Watercolor
www.chadsavage.com

Penangglan *is a delightful medley of the almighty bloodsucking haunt in various forms throughout the ages. This image shows the true range of the vampire, featuring its depiction in ancient cultures through modern cultures. In the center, a bat-like creature smiles grimly from his coffin.* "After researching the vampire in literature and non-fiction for years, I decided to do a single image/painting that incorporated a variety of concepts, folklore, and mythologies all at once. The result was Penangglan."

▶ **Dracula**
Gonzalo Ordóñez Arias
Adobe Photoshop
http://genzoman.deviantart.com

Delighting in all his glory and reveling in his own power, we find Dracula in this image giving a toast amid a field of bodies skewered by large spikes. Arias says, "This piece is heavily influenced by video games like Castlevania (I'm a big fan) or Devil May Cry. I like a lot of vampire-related games; there is a whole horror pop culture in which vampires and Dracula are the main protagonists."

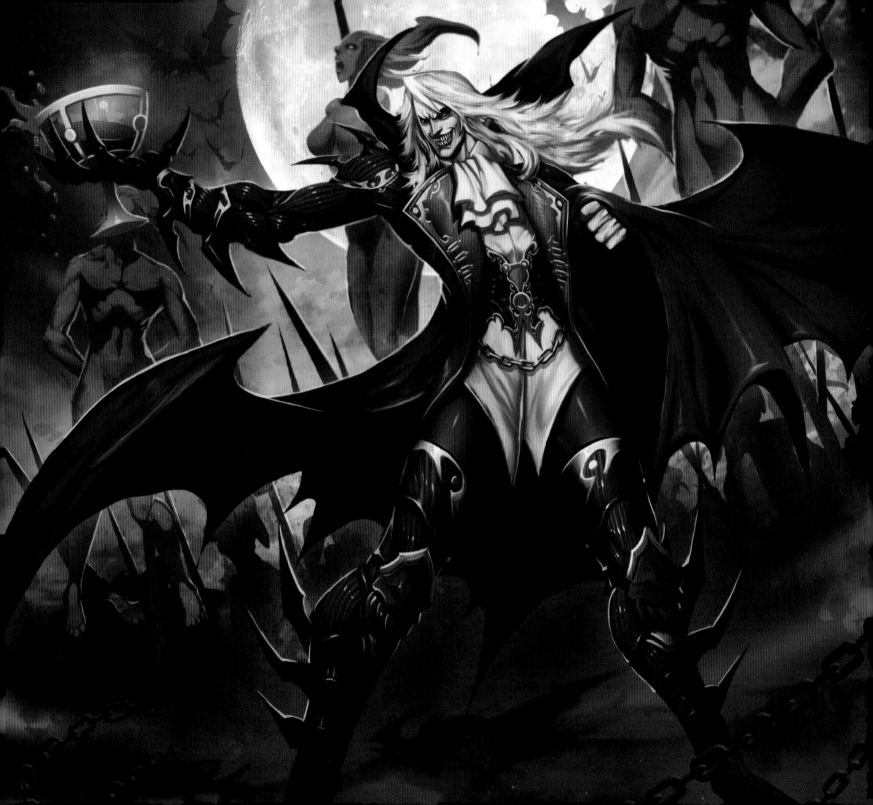

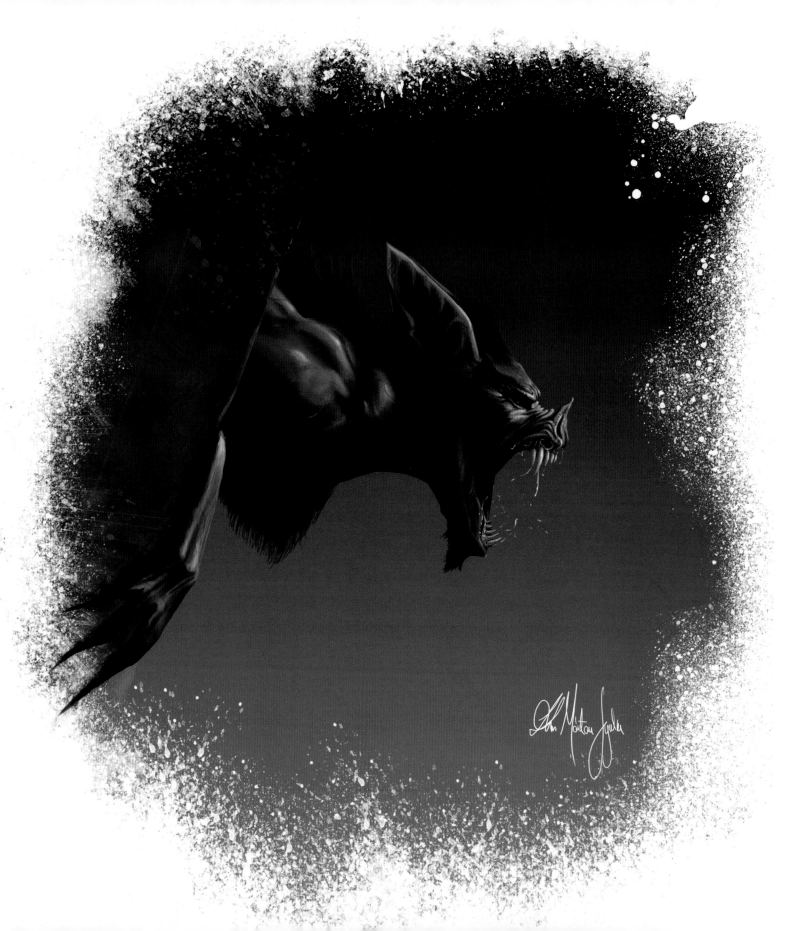

◀ **Battle Form**
Kimagu
Graphite and Adobe Photoshop
www.artofkimagu.com

A formidable bat-like creature shrieks in the night. "The vampire in this picture has transformed into his most powerful and dangerous martial form. He is similar to a bat, however he remains humanoid. The main purpose of the painting is to evoke feelings, even if those are of fear or disgust. It does not have a story, because the impression is the key matter of the picture. I like when a picture appears as a splash and does not fill up the whole canvas."

▶ **Beast**
Christine M. Griffin
Adobe Photoshop
http://christinegriffin.artworkfolio.com

It isn't quite clear if this horrid thing is bringing a finger to his lips in thought or in thirst! "Sometimes it's just fun to wallow in the expected: a top hat, lots of blood, a flock of crows, ravens, and blackbirds, demonic eyes. But what you get is greater than the sum of the parts. The blood was particularly tricky. I started with using Bevel and Emboss in Photoshop, then just painted over the whole mess. I looked at many grisly photos to get the glop just right. Good thing I'm not squeamish."

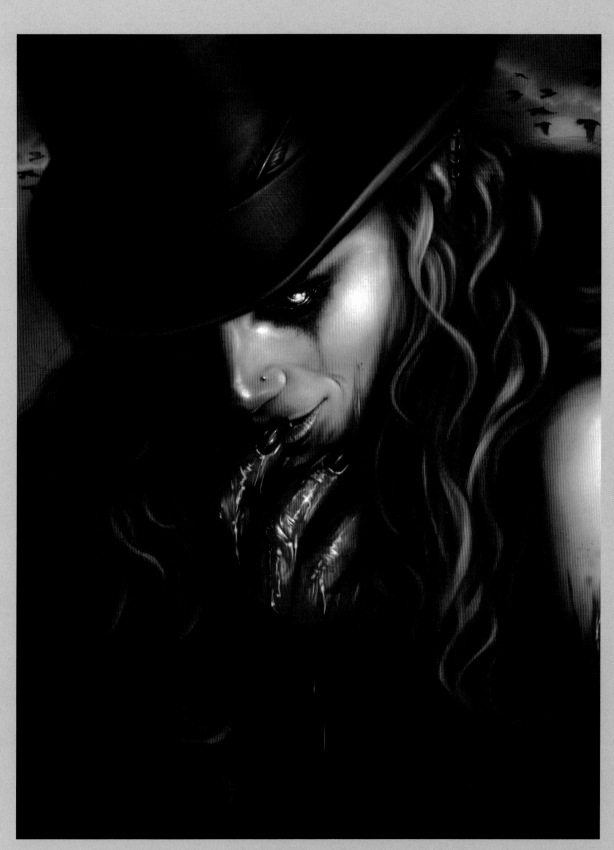

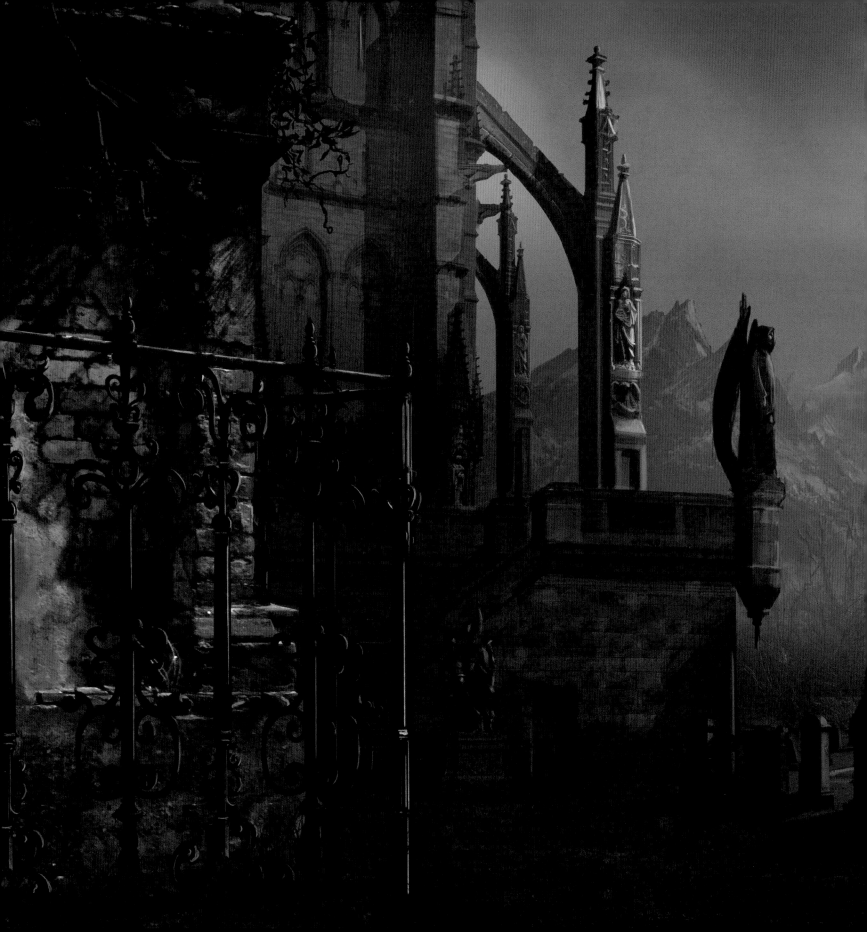

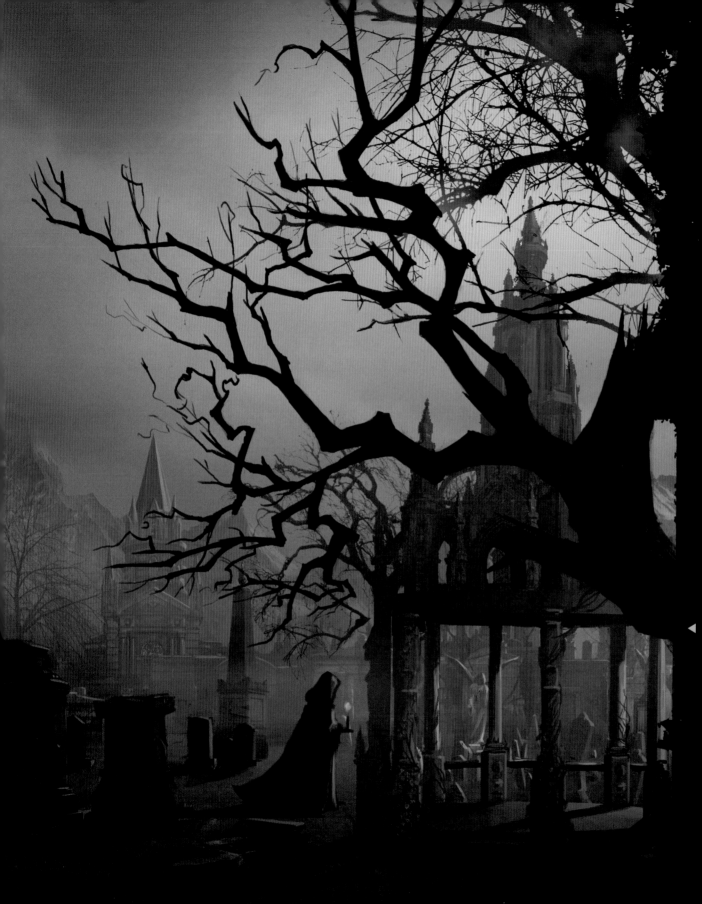

CHAPTER 10
GOTHIC QUARTERS

◄ **Garden of Evil**
Akiko Crawford
Adobe Photoshop
www.signal2noiz.com

A lone figure carries a candle just outside the castle walls in this digital piece titled Garden of Evil. Akiko Crawford explains the background story: "You finally escape out of his castle, but now the garden of evil awaits. Death is in the air, and the lurking warm breeze yearns to tell the stories of the lost souls beneath the earth, yet the garden is strangely beautiful. All you can do now is wait for the sun to rise."

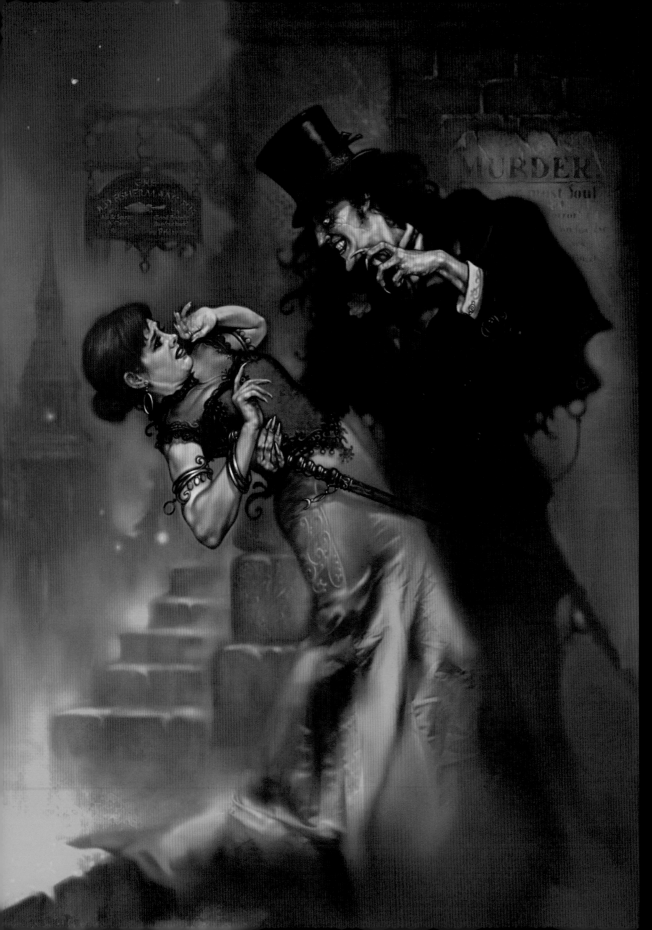

◀ **London After Midnight**
Patrick Jones
Corel Painter
www.pjartworks.com

In turn-of-the-century London, a woman fights off a blood-drinking denizen of hell! His foul smile is matched by her fearful look and reaction of repulsion as they struggle. While they quarrel, the viewer's eye wanders to a sign just above the monster's shoulder that reads "Murder." Patrick Jones created London After Midnight *using Corel Painter's Oils and Oil Pastels. He shares a brief summary of the scene: "Evil stalks the London dockside."*

▶ **The Exorcism of Lucy Westernra**
Avelina De Moray
Photography and
Adobe Photoshop
www.avelinademoray.com

Avelina gives a little history to her piece titled The Exorcism of Lucy Westernra: *"This gothic artwork is dedicated to the character Lucy Westenra from Bram Stoker's* Dracula. *After staging a vampire photo shoot, I enhanced the character's eyes to make her appear even more 'vampy.' The fangs, smoke, and flames were all drawn with my Wacom tablet, and the church background and face scarring were all digitally edited and drawn in Photoshop."*

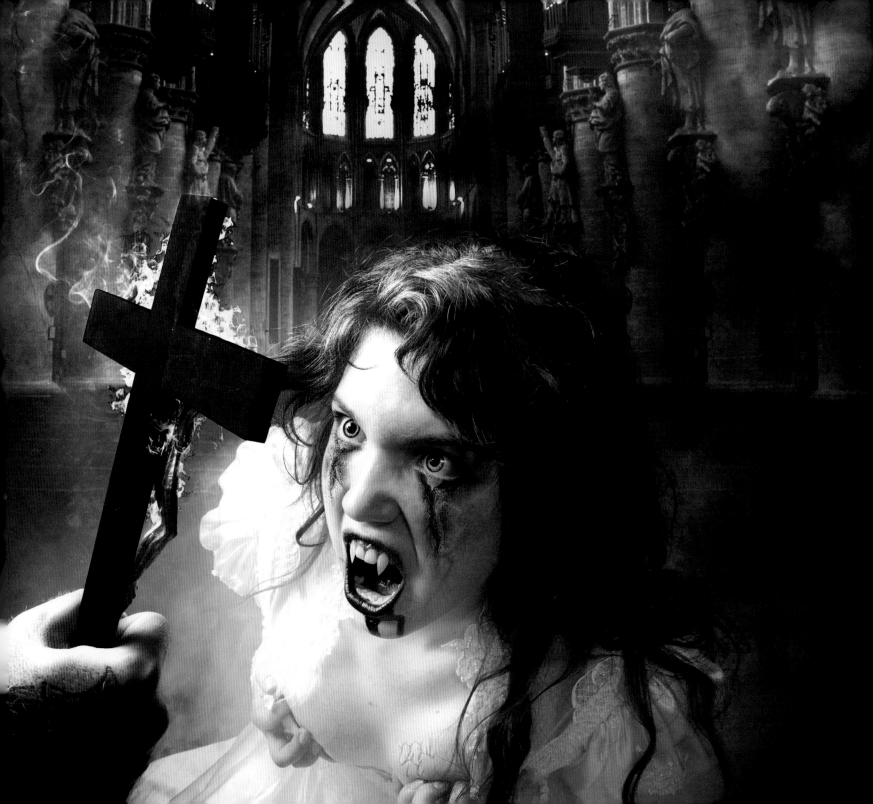

◀ **Sacrificial Sanctum**
Watchrin Hanshin
Adobe Photoshop
http://watchyh.blogspot.com

*An immortal overlord stands
tall before a kneeling maiden.
"I wanted this painting to have an
unholy feeling, but be beautiful
in contrast, so I mainly used dark
tones for the overall values. I
approached the two characters
differently by applying the 'light
against dark' and 'dark against
light' technique to make them
stand out from one another. Red
was applied to her dress to create
a stronger focal point and I gave
the vampire a darker shape for
a stronger silhouette."*

◀ **The Night to Forget**
Erlend Mørk
Digital photography
www.erlendmork.com

Erlend Mørk's The Night
to Forget *is both remarkably
gothic and vampiric. A gray-blue
corridor is filled with handsome
ghouls drinking blood from wine
glasses and playing music. The
victim in the forefront presents her
neck to a dandy devil wearing a
top hat during a fancy dance
move. The other vampires,
seemingly in a trance, prove
that for some this may truly
be "the night to forget."*

▶ **Building Rome**
Dan Seagrave
Album cover
for the band Building Rome
Acrylic on board
and digital finishing
www.danseagrave.com

*Dan Seagrave discusses his
technique: "I use acrylic, and
spend 25 percent of the creative
time on the design and idea
before committing to the
artwork. I use the paint in thin
washes (glazing) to build up the
art, it may be a few basic color
layers, and then twenty more
glazing washes to achieve the
effect I like. The final art is shot
on film — scanned film creates
a deeper range, which in turn
publishes better than digital
for flat art. Final touches are
made in Photoshop."*

▶ **Spark of Sentiment**
Bruno Werneck
Digital painting
www.filmpaint.com

*A night-dweller carries a victim lovingly; a magnificent palace sits
amid a mountainous landscape in the background. Werneck adds:
"After toying with the idea for a few days, perhaps suffering from
information overload or feeling a touch melancholic at the time,
I decided to focus on simple shapes where less is more. So I slowed
down the pace a bit, depicting a more serene atmosphere, somewhat
eerie, but looking to show beauty in the most uncommon situations."*

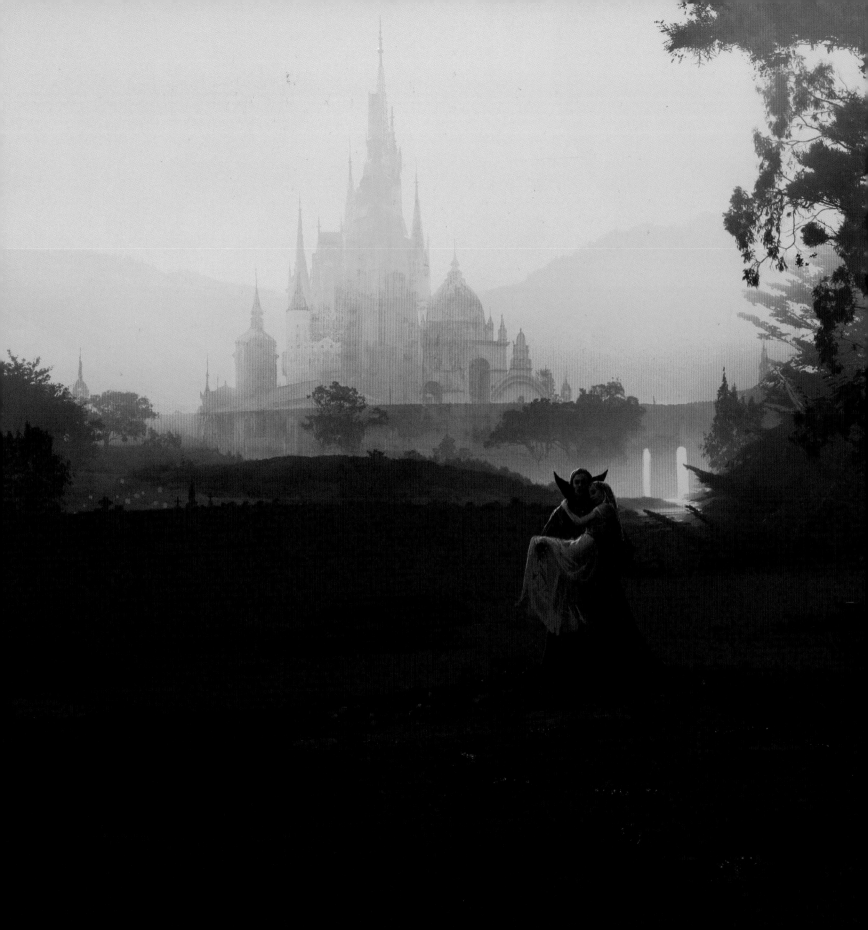

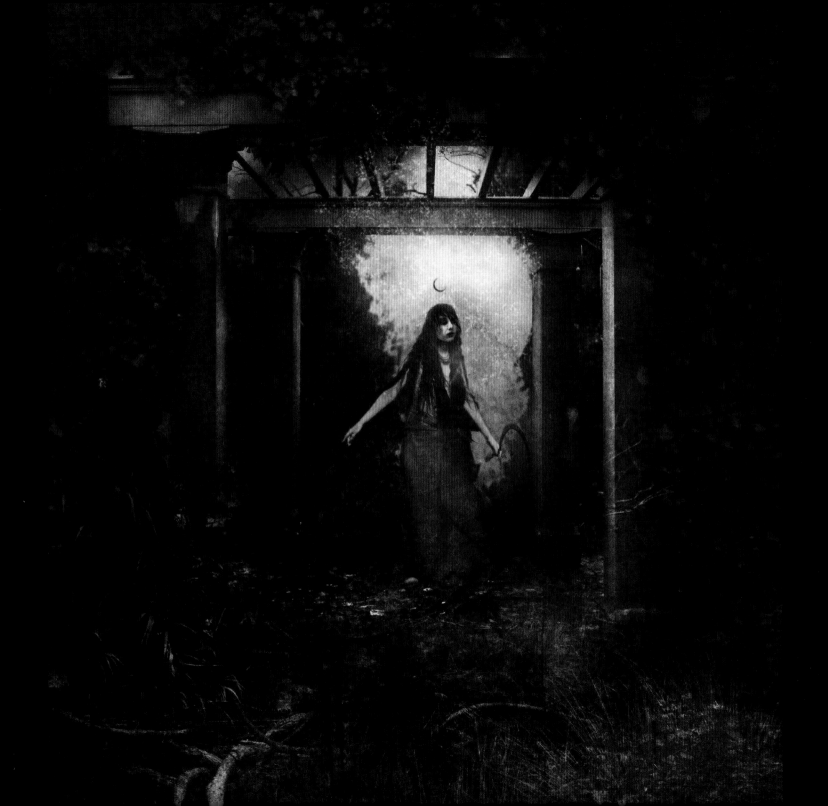

◄ **Luna**
Samuela Araya
Photography and Adobe Photoshop
http://paintagram.blogspot.com

An ethereal image from Araya.
"I actually thought of Lilith and
the vampire mythos, but named
the image Luna in the end, go
figure. The image was constructed
in Photoshop, adding elements
of sigil magic and consciously
trying to add that 'Victorian
photography' flare in both
lighting and composition. Most
of the photos were taken in
Barcelona, which is my favorite
vampire city, after Prague and
London, of course. "

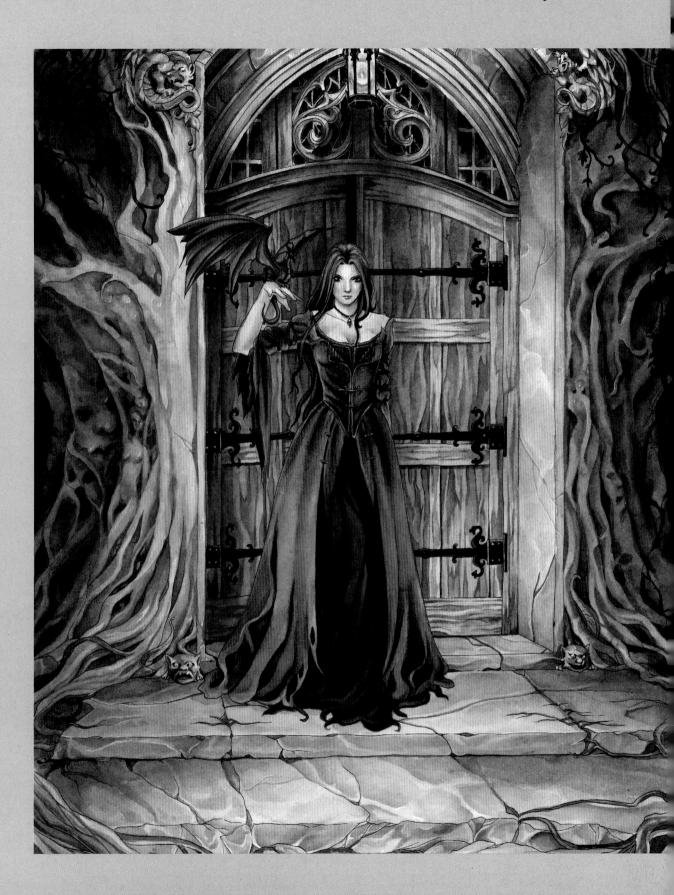

▶ **Forbidden Doorway**
Meredith Dillman
Pen, ink, and watercolor
www.meredithdillman.com

A nocturnal demoness stands with
a tiny dragon friend before an
ornate wooden door in Meredith
Dillman's Forbidden Doorway.
"This image was inspired by a
door I photographed at a local
Neo-Gothic style church. The
gargoyles around it caught my
eye and I thought it would make
a great setting for a painting.
I painted it with watercolor over
a pen and ink drawing. I used
gold highlights on parts of the
lady's dress."

▲ **The Pit**
Kimagu
Graphite and Adobe Photoshop
www.artofkimagu.com

▶ **Draconis**
Dan Seagrave
Album cover for the band Draconis
Acrylic on board
www.danseagrave.com

A child of the night is caught in a hopeless situation. "This artwork was inspired by the book Interview with the Vampire *by Anne Rice. Vampires punish the betrayal of their own kind. The young vampire girl is tied up before a rising sun, which is starting to burn her skin. She wants to escape, but there is no getaway. I wanted to use a plain background to put the focus on the face and body's movement, expressing fear and despondency."*

Dark silhouetted figures view an immense castle from above. This layered effect gives the painting a nice range of depth. "A ragged, armored company raid the darkened halls of an impossible structure, in search of a slumbering evil that dwells within. The presence of an unknown force lays shadows amongst them. The murk of the dying sun spells a hint of entrapment."

◀ **London**
Gina Wetzel
Watercolor on paper
www.tanuki.de.vu

Moths flutter in the light of an English street in this very gothic piece by Gina Wetzel. "I had this idea of the Queen of Moths strolling through the Victorian streets of London in the dark, only watched by the eyes of Big Ben. She could be a character from a gothic novel that has never been written. I love this painting very much. It is actually one of my most popular pictures, and people keep telling me how much they like it. I have been asked to sell it several times, but I just can't part with this picture!"

▶ **Ravenloft**
©Wizard of the Coast
Jesper Ejsing
Art for Castle Ravenloft
board game
Acrylic on watercolor board
www.jesperejsing.com

"I had difficulty settling on this image. I tried having a female victim in the vampire lord's grasp, but she always took too much attention away from the main figure. I started painting a different pose before abandoning it. In my mind I could see it lacked action and punch, so even though the first one had been accepted by the art director I submitted another sketch that he gladly approved. I masked out the bats and the main figure by covering them with a transparent Frisket Film, using a scalpel to cut around them, and peeling away the rest of the film before painting the background. This technique allowed me to use looser brushstrokes for the background and helps the sense of depth."

All work in this book is
the copyright property of
the named artist, unless
stated otherwise.

MYKE AMEND
www.mykeamend.com
myke@mykeamend.com
Red Queen p52
ID p70
Willow p71
Wild Rose p145

SAMUEL ARAYA
http://paintagram.blogspot.com
paintagram@gmail.com
The Coming of Tears p8
The Drop Dead Girl p76
Luna p184

GONZALO ORDONÓÑEZ ARIAS
http://genzoman.deviantart.com
genzoxd@gmail.com
Lilith p48
Dracula p102

CHRIS AYERS
www.chrisayersdesign.com
chris@chrisayersdesign.com
Sir Desmodus Rotundus p160

BETHALYNNE BAJEMA
www.bethalynnebajema.com
ettadiem@gmail.com
The Lounge p12
Music Room p38

ARMAND BALTAZAR
www.armandbaltazar.com
dobiebaltazar@hotmail.com
Seine p46
Her Love p142
Death of the King p154

JOHN BATTELLE
http://vampireofkhorne.
deviantart.com
batelljo@hotmail.com
Innocent? p122

JASMINE BECKET-GRIFFITH
www.strangeling.com
jasminetoad@aol.com
I Vampiri: La Sorelle p14
I Vampiri: Pieta p49
I Vampiri: Lupi p15

EMI BOZ
www.emiboz.com
http://creepalicious-inc.com
emiboz@hotmail.com
Melty Vampire Minions Hate
Garlic Army p126
Lord Finkelstein Loves His
White Snow Flake p118
Bloodthirsty Winged Ice Cream
Cones p116
Minerva, Goddess of the
Graveyard p132

KELLY BRIGHTBILL
www.kellybrightbill.com
arulbo@yahoo.com
Moth To The Flame p44

MALCOLM BROWN
www.mbfantasyworld.co.uk
mbfantasyworld@yahoo.co.uk
Vampyre p167

LYDIA BURRIS
http://lydiaburris.com
lydiaburris@gmail.com
Seducer p164

PATRICK BYERS
www.101industries.ca
www.baranyartists.com
patrick_byers@hotmail.com
Sewer Lurker p79
Rise p165

MICHAEL CALANDRA
www.calandrastudio.com
mcalandra@calandrastudio.com
Nightfall p36
Bloofer Lady p39
Siren Song p45

LAUREN K. CANNON
http://navate.com
lkcannon@comcast.net
Omhi p157

SARA CAPPOLI
http://thewitchspell.
deviantart.com
saracappoli@gmail.com
The Hunters p93
Little Vampire Girl p124
Big Game p125

PIERRE CARLES
www.pierrecarles.com
pierre@pierrecarles.com
Dark Angel p134
Count Vlad is Back in Town p163

FERNANDO CASAUS
http://fercasaus.deviantart.com
fernando_casaus@hotmail.com
Queen of Darkness p34
Bloody Innocence p43
Animal Instinct p58

PAULINA CASSIDY
www.paulina.ws
info@paulina.ws
Arachtoinette p28
The Bloodrose Countess p29

JHONEIL CENTENO
www.jhoneil.com
jhoneil@verizon.net
Rainy Day Dinner p35

AKIKO CRAWFORD
www.signal2noiz.com
akikocrawford@gmail.com
Garden of Evil p174

DELPHINE LÉVESQUE DEMERS
www.zerick.com
delphine@zerick.com
Le Portrait du Vampire p26
Le Portrait du Vampiress p27
First in Flight p123

AVELINA DE MORAY
www.avelinademoray.com
avelinademoray@hotmail.com
Immortal Beloved p59
Carpathian Kiss p102
The Turning p110
The Deadly Departed p114
The Exorcism of Lucy Westenra
p177

DESEO
www.deseoworks.com
info@deseoworks.com
RRRR p57

JOANA DIAS
www.shinobinaku.net
joana.namida@gmail.com
Anima Vorax p32
If I Was Your Vampire p143
Sunset p144

MEREDITH DILLMAN
www.meredithdillman.com
mere@meredithdillman.com
Forbidden Doorway p185

MATT DIXON
www.mattdixon.co.uk
mail@mattdixon.co.uk
All in Vein p11

ANDREW DOBELL
www.andrewdobell.co.uk
art@andrewdobell.co.uk
Serpent Queen p41
Vlad p87
Shadow Vampire p158

SAMUEL DONATO
http://dxsinfinite.deviantart.com
donato_vs@yahoo.com
Vampirates p88
Vampire Abduction p100

BOB DOUCETTE
www.bobdoucette.com
tobo@earthlink.net
Bat Boy p156

JESPER EJSING
www.jesperejsing.com
ejsing@illustration.dk
Ravenloft p189

GUS FINK
www.gusfink.com
gusfink@hotmail.com
Vampire Hive p130
Vampress and Fiends p131

SASHA FITZGERALD
http://sashafitzgerald.com
ziggyorange@hotmail.com
Dinner and a Show p24
Midnight Stroll p25

SANTOS GARIJO
http://nagualito.epilogue.net
donosti62-moskis@yahoo.es
Demon p75

ANNE YVONNE GILBERT
www.yvonnegilbert.com
gilbertandnanos@rogers.com
Arabian Vampire p42
No Defence p99
The Wolf p151

CHRISTINE M. GRIFFIN
http://christinegriffin.artwork-
folio.com
alizarin_griffin@yahoo.com
Beauty to Die For p40
My Vampire Eyes p148
Beast p173

ABRIL ANDRADE GRIFFITH
www.abrilandradc.com
abrilandrade@yahoo.com
Jarumy p192

GRIS GRIMLY
www.madcreator.com
grisgrimly@madcreator.com
You Raised a Vampire p119

WATCHRIN HANSHIN
http://watchyh.blogspot.com
watchrin.hanshin@gmail.com
Sacrificial Sanctum p178

ANN HARPER
www.harpershanks.com
harpershanks@comcast.net
White Witch p30

WOODROW J HINTON III
www.wjh3illustration.com
woodrow@cinci.rr.com
Kolchak Annual p92
Dracula's Pitt p166

GRETA JAMES
www.gretajames.com
greta@gretajames.com
Eternal Life p72
Venus Fly Trap p73
Turkey Vulture p128

PATICK JONES
www.pjartworks.com
deanjo@pjartworks.com
In A Glass Darkly p98
London After Midnight p176

JASON JUTA
www.jasonjuta.com
jason@jasonjuta.com
Vampiric Nobility p23
Bathory p61

LEAH KEELER
http://keelerleah.deviantart.com
lordoftheringsfan_979
@hotmail.com
Golden Tempest p84
Broken Desires p152
Blood Roses p153

DAVE KENDALL
www.rustybaby.com
dave@rustybaby.com
The Lot p78

KIMAGU
www.artofkimagu.com
zoroazter@yahoo.com
Battle Form p172
The Pit p186

INESSA KIRIANOVA
www.ineska.com
info@ineska.com
Camilla p4

VIKTOR KOEN
www.baranyartists.com
viktor@viktorkoen.com
Elivan p104

KRISGOAT
www.krisgoat.com
krisgoat@krisgoat.com
Red Stained Lips p120
Lady Moonlight p121

THOMAS KUEBLER
www.thomaskuebler.com
tom@thomaskuebler.com
Nosferatu p161

JARNO LAHTI
www.kaamos.com
kaamos@kaamos.com
Eternity in Hunger p51
Dreams of Blood p77
Ready to Born Again p115

JEANETTE LANDRAU
http://mistressj.epilogue.net
lady_j_66@yahoo.com
Incubus p162
Headmaster p169

EIN LEE
http://einlee.net
ein@einlee.net
Give and Take p31
Candyapple Vampire p54
Welcome to Hell p101

JIMMY "SHINO" LING
http://dreadjim.daportfolio.com
dreadjim@gmail.com
Zephyon Vampires p82
The Fearsome and Cunning
Dreadlord p90

RALPH MANFREDA
ralph.manfreda@chello.at
www.cryptonaut.com
Awakening II p106
Feeding p107
Satisfied p112
Imprisoned I p113

D.L. MARIAN
www.darkcreation.com
dlmarian@comcast.net
Angelica p67

BILL MAUS
www.billmausart.com
billmausart@gmail.com
Vivian Moon Pinup p133

ERLEND MØRK
www.erlendmork.com
nihil@erlendmork.com
The Night to Forget p180

PAM MORRIS
www.labyrinth-creations.com
labyrinthcreations@hotmail.com
Children of Nosferatu p66

K.E. MYATT
www.hismajestyintears.com
majesty@hismajestyintears.com
Frenzy p62
Ending Sun p18

ELISABETE NASCIMENTO
www.elisabetenascimento.co.uk
chicards@hotmail.co.uk
Midnight Thirst p140

VINCE NATALE
www.vincenatale.com
vnatale@hvc.rr.com
A Hunger Like No Other p138
Wicked Deed's on a Winter's
Night p139
The Damned p64

LESLIE ANN O'DELL
www.shyble.com
shyble@hotmail.com
Sinful p105
Lurking p111
Death's Door p146

AUGIE PAGAN
www.augiepagan.com
augiejp@gmail.com
Demon Seed 01 p74

MICHAEL PARK
www.darkartdesigns.com
michaelparkart@gmail.com
The Widow p6
Die Nächtliche p108
The Vampire Skadi p109

MARK PEXTON
http://mark-pexton.
daportfolio.com
mark_pexton@yahoo.co.uk
La Diaboilque p37
The Vampyre p55
The Beautiful and the Dead p80
Thirty Days of Blood p141

DAVID PROCTER
www.david-procter.co.uk
hello@david-procter.co.uk
Look At Those Cherries p16

NEIL QUE
http://daa-truth.deviantart.com
njque@hotmail.com
Vampire Mikael p96
Vampire Alexandria p97

VIRGINIE ROPARS
http://vropars.free.fr
virginie.ropars@gmail.com
Carmilla and the Queen of
Spades p20
Victorian Succubus p21
Scarlet Heart p22

NATHAN ROSARIO
http://ancientearthstudios.com
nathan@ancientearthstudios.com
Vampire p69
Vampire Slayer-Divine Weapon
p89

NEI RUFFINO
http://rebelstudios.proboards.com
rebelartvigil@aol.com
Bloodwine p47

FERNANDO SANTIBÁÑEZ
http://fasslayer.deviantart.com
fasslayer@gmail.com
Hitman Vampire p86
Nosferatu's Attack p94
After and Before p81

CHAD SAVAGE
www.chadsavage.com
savage@sinistervisions.com
Feral p159
Penangglan p170

ERIC SCALA
www.ericscala.com
ericscala@yahoo.com
It's Oh So Quiet! p60

JOHN SCHWEGEL
www.johnschwegel.com
john@johnschwegel.com
Blood Red Sky p129
Red Eye p135

DAN SEAGRAVE
www.danseagrave.com
dan@danseagrave.com
Suffocation p2
Building Rome p181
Draconis p187

CHARLI SIEBERT
www.unimaginative.org
http://pharie82.deviantart.com
charli@unimaginative.org
Vampyre Portrait p10
Molly p58

BILLY TACKETT
www.billytackett.com
billy@billytackett.com
Born to Lose p63

JULIEN TAINMONT-PIERRAT
www.julientainmont.com
julien_tainmont@yahoo.fr
Rise My Son p85

SABRINA TOBAL
http://sabrinanime.over-blog.com
contact@sabrinanime.fr
The Punishment p91
I Miss You, Daddy p149

TIM VIGIL
http://rebelstudios.proboards.com
rebelartvigil@aol.com
Bloodwine p47
The Countess p50
The Welcoming p68

THOMAS WEBB
www.webbitup.com
thomas@webbitup.com
Bela Lugosi as Count
Dracula p168
Lon Chaney as The Vampire p19

BRUNO WERNECK
www.filmpaint.com
contact@brunowerneck.com
Spark of Sentiment p183

GINA WETZEL
www.tanuki.de.vu
tanukihime@googlemail.com
Wine p17
Our Last Embracement p150
London p188

GRACJANA ZIELINSKA
www.vinegaria.com
vinegaria@gmail.com
Urban Ninja p95
Midnight Affair p136

Acknowledgments

Jasmine:
I would like to thank my husband Matt for all of his help! I would also like to thank Desmodus Rotundus, the cutest vampire out there!

Matthew:
I, of course, thank my lovely wife Jasmine. Her work ethic alone evokes inspiration. Most of all I thank Mom and Mr. Lugosi, without you two there would be no vampire for me.

▶ **Jarumy**
Abril Andrade Griffith
Acrylic, oil, and printed
papers on paper
www.abrilandrade.com